THE THEORY OF THE AVANT-GARDE

Renato Poggioli

translated from the Italian by Gerald Fitzgerald

The Belknap Press of
Harvard University Press
Cambridge, Massachusetts
London, England

Translated from the original Italian edition, *Teoria dell'arte d'avanguardia* (Società editrice il Mulino, 1962)

Library of Congress Catalog Card Number 81–81482

ISBN 0–674–88216–4

Printed in the United States of America
10 9 8 7 6

CONTENTS

Je juge cette longue querelle de la tradition et de l'invention
 De l'Ordre de l'Aventure
Vous dont la bouche est faite à l'image de celle de Dieu
 Bouche qui est l'ordre même
Soyez indulgents quand vous nous comparez
A ceux qui furent la perfection de l'ordre
Nous qui quêtons partout l'aventure

Nous ne sommes pas vos ennemis
Nous voulons vous donner de vastes et d'étranges domaines
Où le mystère en fleurs s'offre à qui veut le cueillir
Il y a là des feux nouveaux des couleurs jamais vues
Mille phantasmes impondérables
Auxquels il faut donner de la réalité
Nous voulons explorer la bonté contrée énorme où tout se tait
Il y a aussi le temps qu'on peut chasser ou faire revenir
Pitié pour nous qui combattons toujours aux frontières
De l'illimité et de l'avenir
Pitié pour nos erreurs pitié pour nos péchés.

<div align="right">

—Guillaume Apollinaire,
from "La Jolie Rousse" (Calligrames)
copyright 1956 by Editions Gallimard

</div>

[This long quarrel I judge: tradition—invention
 Order—Adventure
You whose speech is made in the image of God's speech
 Speech equal to order's own self
Be easy on us when you are comparing
Us and those who were the perfection of order
Us looking all around for adventure

Us not your enemy
Who want to present you strange mighty lands
Where flowering mystery surrenders itself to the takers
Where new fires are and colors unseen
Phantasms by the thousands weightless
Which need to be given reality
And we want to explore bounty's enormous land all stillness
Where time is to banish to call back
Pity us battling always at the limits
Of limitlessness and tomorrow
Pity our errors pity our sins.

<div align="right">

—translated by Gerald Fitzgerald]

</div>

1. THE CONCEPT OF THE AVANT-GARDE

Prologue

To begin with, few thinkers, historians, or critics have deigned to study one of the most typical and important phenomena of modern culture: so-called avant-garde art. Critics have not paid much attention to its essence, let alone its manifestations, and valid attempts to interpret the concept implicit in such a term as "avant-garde" are rare in the compendia of aesthetics and the handbooks of art history. Rare indeed are the philosophical dictionaries, cultural encyclopedias, and outlines of "great ideas" which include this item or attempt to give it a useful definition, even as a mere dictionary entry. As for the innumerable incidental and casual references that ritually accompany the phrase as it constantly recurs in the written or spoken criticism of modern art, it would certainly not be unjust to claim that these are almost always limited to a picturesque use of the image etymologically or metaphorically contained in the term itself. In line with the prevalent tendency of literary journalism, this term, like many others of its kind, is treated with the literal-minded verbalism that takes the word for the thing.

Of course there are some works that reveal a profound comprehension of the phenomenon in question, written from specific points

of view, within particular frameworks. One of these, certainly, is the famous essay by José Ortega y Gasset, *The Dehumanization of Art*, which singles out for investigation certain social effects of avant-garde aesthetic doctrines and considers them above all in terms of the psychological content of avant-garde poetics. We shall often return to Ortega's essay in the following pages, since many of the ideas he suggests may initially serve as guides or models for other meditations and other hypotheses, sometimes parallel to his, sometimes divergent. We may say the same of the articles that Massimo Bontempelli, step by step, over the course of a vast experience as a writer "of exception" and an instigator of movements, dedicated to the same theme. These articles, in the eventide of his career, he collected into *L'Avventura novecentista: Selva polemica*, which has the special advantage of offering to the studious or curious reader the testimony of an actor in the avant-garde itself, rather than that of a spectator like the ultra-perceptive Ortega. Georg Lukács offers the testimony of a highly specialized observer, an interpreter solidly anchored to the ideological presuppositions of the Marxist view of history and culture. In his most recent writing (first published in Italy), *Significato attuale del realismo critico*, he tends to confound the avant-garde with the decadent and to give to the former the negative value inherent in the latter, distinguishing the two only as different aspects of the degeneration of bourgeois culture. Considering the authority of the witness, such a judgment must be taken seriously even by one who dissents from it; we shall re-examine it when we discuss the leftist interpretation of avant-garde art.

While making continuous and prominent use of these works and of others like them, we shall not neglect the more primary documents in Bontempelli's collection. These, taken as a whole and especially taken with the glosses and postscripts later added to the original articles, ultimately give the effect of retrospective evidence. Exactly for this reason we shall also study the various programs and manifestos which give expression to the avant-garde spirit as it works and is formed, its becoming as well as its being. The terms "programs" and "manifestos" will often, if not always, be employed

as a kind of technical nomenclature: "manifestos" to indicate documents giving aesthetic and artistic precepts, "programs" to indicate the more general and wide-ranging declarations, visions, or overviews. We shall use these documents and declarations especially because, as in the case of autobiographical and psychological testimonies, there are so many of them. For if it is true, as Paul Goodman has said, that Stephen Dedalus' passwords, "silence, exile, and cunning," express the self-imposed code of the avant-garde artist, it is no less true that the first of these commandments is seldom obeyed.

Finally, even the negative and hostile attestations of less authoritative adversaries are highly useful, and we shall naturally not neglect them; often incoherent, but almost always significant, they tend to illuminate our subject with rays of what might be called reflected light. The only evidence of which we shall as a rule make but little use (especially since it is not evidence in the real sense of the word) is precisely the rather large body of writings which carry in their titles either the phrase "avant-garde art" or an equivalent phrase, such as "the art (or literature) of exception," used by Vittorio Pica, one of the first Italian observers of the phenomenon. In these works one is nearly always dealing with something that is not analytical or synthetic, but anecdotal or eclectic, with works more partial than partisan, more like chronicles than histories; they serve, at best, as sources of useful factual matter.

It is my intention in these pages to study avant-garde art as a historical concept, a center of tendencies and ideas. I want to outline its anatomy or biology: the aim is diagnosis and not, as with severe adversaries and the more indulgent would-be reformers, therapeutic treatment. In one sense, this study means to be a vivisection or a spectroscopic analysis. I use these figurative terms to emphasize that this investigation is scientific in character, not practical or critical, and also to call attention to its synthetic and analytic method. Avant-garde art, in this essay, will be considered both as a manifold and as a general phenomenon. In the case of a phenomenon belonging to the history of art, this means treating it not so much as an aesthetic fact as a sociological one.

In other words, we shall here examine avant-garde art not under its species as art but through what it reveals, inside and outside of art itself, of a common psychological condition, a unique ideological fact. By psychological I mean that part of avant-garde art which remains a fact of nature (if only historically). I mean the instinctive forces and primary currents, what Pareto would call "residues": psychic seeds or roots, often to be perceived under the form of irreducible or unsuppressable idiosyncracies. And by ideology I mean the rationalization of these forms, currents, or residues into formulas of logic: their translation into theory, their reduction to programs and manifestos, their hardening into positions or even "poses." In fact, an ideology is not only the logical (or pseudological) justification of a psychic state, but also the crystallization of a still fluid and suspended sentimental condition into a behavioral code even before it has crystallized into work or action.

The psychic state directly controlled and expressed by an ideology is not so much individual or collective as it is the psychic state of a group: otherwise, we should have had to call it a philosophy or a religion. Ideology, therefore, is always a social phenomenon. In the case of the avant-garde, it is an argument of self-assertion or self-defense used by a society in the strict sense against society in the larger sense. We might even say that avant-garde ideology is a social phenomenon precisely because of the social or antisocial character of the cultural and artistic manifestations that it sustains and expresses. How so complex a relation between the avant-garde and society came about is a problem we shall try to resolve when we deal with the relations between avant-garde art and fashion, and when we study that special and complex phenomenon called alienation.

This same avant-garde psychology, precisely because it is a group psychology, is here subjected to a sociological rather than to a literary, cultural, or artistic study. Therefore, the technical and plastic doctrines of the avant-garde will be studied primarily in terms of psychology and ideology. An appropriate chapter, one of the longest in the book, is dedicated to the question of avant-garde aesthetics and poetics; yet, in the economy of our investigation,

that chapter itself is only a minor part of the whole. Thus even the pages on the subject of the criticism of avant-garde arts (and I mean analytical, not descriptive, pages) remain subordinate to the general idea of the book: the attempt to say what avant-garde criticism is *not*, but ought to be, tends to show indirectly (indeed, *ad absurdum*) what avant-garde art *is* in the minds of certain individuals or groups.

On the problem of avant-garde aesthetics and poetics we may further say that, inversely to the classical tradition and more extremely and intensely than in the romantic movement, it is precisely these ideological and psychological characteristics that make a unified, permanent substratum for a poetic and an aesthetic which, from an analytical point of view, would form a complex so chaotic as not to seem reducible to a lowest common denominator. The particular poetics of various movements in the avant-garde do not lend themselves to study under the species of a single aesthetic concept, and the difficulty is even greater because of the lack of temporal distance necessary to establish a fair historical perspective. They are to be examined, if at all, case by case. Yet, contrariwise, what I might call a theoretical or synthetic poetic can easily be reconstructed as a series of aesthetic corollaries that follow from the general psychology and ideology of avant-gardism. Such a poetic is always in direct relation to that psychology and ideology, often identical with them.

Terminological ups-and-downs

The term "avant-garde art" (perhaps the critical concept as well) belongs almost exclusively to the Neo-Latin languages and cultures. For example, the term is used with some frequency in Spanish and Spanish-American culture. Guillermo de Torre used it as the motto of a book studying, with notable perspicacity, many movements and aspects of the literary avant-garde. But Ortega y Gasset, perhaps the one author to date who has faced the problem of avant-garde art in its totality (even if from a particular point of view), always avoided the term. He preferred "dehumanized art," "abstract art," "the new,

or young, art"—perhaps he meant to underline on one hand its intellectual radicalism and, on the other, its coincidence with the advent of a new generation.

That the term struck deeper roots and better acclimated itself in France and Italy than elsewhere perhaps shows that a sensitivity to what the term implies is more alive in cultural traditions which, like the Italian, are alert to theoretical problems in aesthetics or which, like the French, are particularly inclined to view art and culture from the viewpoint of its social disposition or its sociability (or "antisociability"). The Latinity of the phrase and the concept is perhaps equally to blame for the difficulty or resistance which has prevented their taking hold in Germany. There, by an almost morbid feeling for cultural crisis, pathetic or struggle-ridden names have prevailed over such anodynes as "modernism" or "the modern style." These are derived from terms which, having lost their original historical reference, came to assume a generalized or systematic meaning: "decadence" or "secession," for instance. The Germans have at times preferred to adopt, as a designation for at least some modern artistic tendencies, the term *Neu-Romantik*. This is not without an ultimate justice, considering that, as an extreme wing of European romanticism, the German variant thereof took on the function of an avant-garde, at least potentially.

In Russia, language fears neither barbarisms nor neologisms and, from the beginning of the epoch in which avant-garde art became a primary and universally important phenomenon down to our own day (to the nationalistic turning point in the Revolution), Russian culture has sympathetically welcomed exoticism of any sort. There the original form and concept penetrated easily and quickly. But the pronounced tendency of the Russian critical spirit to translate artistic and cultural facts into religious or political myths has impeded any valid formulation of the concept. This is true even within the modernistic and aesthetic movement which developed at the end of the nineteenth century as almost the last product of the *ancien régime* and which was, in fact, destined to be destroyed by the Revolution. Precisely on this account, the one current in

Russian criticism which was obliged to give sustained and careful attention (however ill-disposed) to the concept of the avant-garde was the radical, sociological or Marxist, school. It did not, however, limit its study to the historical and social viewpoint (which would have been legitimate) but went beyond, to confront it from the viewpoint of a pragmatic sociology, partisan and political, with a mania for therapy and reform. It nearly always ended up by condemning the avant-garde, *en bloc*, with no appeal and without reservation.

This programmatic hostility is further noticeable in the fact that followers of that critical school, conscious of the fascination the avant-garde image held for radical rhetoric, tended to avoid the term, employing in its place such names as "bourgeois art," "bourgeois literature," or "bourgeois bohemianism." Only exceptionally, in the case of ideologically but not culturally orthodox minds, such as Trotsky's, did the generalized condemnation not totally abolish historical evaluation and concrete criticism (and Trotsky, for that matter, used the alternative terms mentioned above). But we shall return to the subject elsewhere, when we study the relation between the avant-garde public and the intelligentsia, when we study the typical positions of leftist criticism. These problems, furthermore, are not limited to Marxist culture.

More significant and important, because of its cultural and non-political nature, is the meager fortune of the term and concept within cultures like the American or English; there the formula is either ignored or used in unstable variants, sometimes the French "avant-garde," sometimes the English "vanguard." Lexicographical uncertainty is added to a patent sense of semantic inadequacy: this may be seen in the use of explanatory qualification, such as "the literary or artistic advance guard," or by the tendency to prefer a more analytic, less committal plural, "the advance guards." Whereas in the English-American tradition the complete expression is used always in the original French form, "l'art d'avant-garde," all the other expressions frequently appear in quotes or italicized as if to indicate their alien origin, perhaps to underline the putative exceptionality in the Anglo-Saxon cultural climate of a phenomenon

thus approximately designated in English. Anglo-American criticism often uses these terms with primary reference to French art and literature, or to its influences and reflections beyond French borders, as if avant-garde art was an international manifestation only in an indirect and mediated way; more specifically, as if it were a continental and extracontinental extension of certain aspects of the French intelligence—a real, true case of spiritual Gallicism.

Does this perhaps mean that the phenomenon called avant-garde art did not take place within Anglo-American culture? Certainly not. It means only that a less rigid classical tradition (or a tradition only intermittently so) has made the sense of exception, novelty, and surprise less acute, by natural contrast, in these cultures: that is to say, it has made less acute the sense of what would appear formally arbitrary to a cultivated Latin. It does not signify that avant-gardism is nonexistent or less prominent in England and America—quite, indeed, the contrary. Especially in certain literary tendencies, Anglo-American extremism is among the most typical and significant expressions of the contemporary avant-garde spirit. But Anglo-American avant-gardism compensates for this by being less theoretical and self-conscious, more instinctive and empirical: the writer in England or America tends, in fact, not so much logically to separate, as obscurely to confound, the problem of the avant-garde and the problem of all modern art.

The two avant-gardes

Speaking literally and linguistically rather than figuratively or ideally, Anglo-American culture is surely not wrong in treating the term "avant-garde art" as if it were a Gallicism: the formula and concept are of a not easily identifiable origin, but clearly French, indeed clearly Parisian. We shall not pretend to present the first document, or first several, in which the term is used in a way analogous, if not identical, to the modern use. That would be quite impossible anyway, precisely because it is impossible to trace an image back to its original source. Here we shall be content to cite a piece

of evidence showing that, before being applied figuratively to the art of our time, the metaphor had already been adopted by another avant-garde, the revolutionary and radical, as its own emblem. This evidence also proves that the representatives of the radical-revolutionary avant-garde, even while they extended the phrase in some measure to the sphere of art, considered it first as bound up with the vague idea of an inclusive and generalized avant-gardism.

It was a little-known Fourieriste, Gabriel-Désiré Laverdant, who, three years before the 1848 Revolution, affirmed the connection in a work entitled *De la mission de l'art et du rôle des artistes*. The passage is also interesting from other viewpoints since it stresses not only the idea of the interdependence of art and society, but also the doctrine of art as an instrument for social action and reform, a means of revolutionary propaganda and agitation. But here is the passage:

Art, the expression of society, manifests, in its highest soaring, the most advanced social tendencies: it is the forerunner and the revealer. Therefore, to know whether art worthily fulfills its proper mission as initiator, whether the artist is truly of the avant-garde, one must know where Humanity is going, know what the destiny of the human race is . . . Along with the hymn to happiness, the dolorous and despairing ode . . . To lay bare with a brutal brush all the brutalities, all the filth, which are at the base of our society.

I include the last two phrases merely to emphasize that the scope of Laverdant's passage is prophetic in another way. It is, however, the first and most important part of the citation which serves our aim: to demonstrate how the avant-garde image originally remained subordinate, even within the sphere of art, to the ideals of a radicalism which was not cultural but political. That the image and the term remained dear to the apostles of the anarchistic and libertarian revolt is proved by Bakunin's founding and briefly publishing in 1878, at Chaux de Fonds, Switzerland, a periodical of political agitation called *L'Avant-garde*.

Furthermore, it is rather rare to find the concept or term outside political literature in the 1870s, nearly impossible in the preceding

decade. As a matter of fact, one finds the phrase, "les littérateurs d'avant-garde," in the personal notebook kept by Baudelaire from 1862 to 1864, *Mon coeur mis à nu*. It comes at the end of a long series of examples meant to prove the predilection of the French for military metaphors. The very fact that Baudelaire mocks such a phrase (as the term *littérateurs* with its vaguely derogative connotation indicates) demonstrates that he considered it a pre-existent phrase. It is natural to suppose that he took it from the rhetorical repertory of journalism in his time, and two analogous phrases in the same list seem to suggest a like conclusion. They are "la presse militante" and "la littérature militante." Their presence in the same inventory is perhaps enough to reveal by whom, and in what way, the other phrase was used (which is what interests us). Clearly to Baudelaire, as to the men of the opposition, *littérateurs d'avant-garde* meant only radical writers, writers ideologically on the left; this explains the restriction of the formula to literature, even to a single literary party. It also explains the mocking reproof on the part of such a man, such a poet and artist, as Baudelaire was: not only is the metaphor mocked, but so is its implied notion.

In reality, only a few years after 1870, when the French spirit seemed to overcome, without forgetting, the national and social crisis represented by the disaster of the Prussian war, by the revolt and repression of the Commune, did the image of the avant-garde again emerge to take on, along with the first, a different, secondary meaning. Only then did it begin to designate separately the cultural-artistic avant-garde while still designating, in a wider and more distinct context, the sociopolitical avant-garde. This was made possible because for an instant the two avant-gardes appeared to march allied or united, thus renewing the romantic precedent and the tradition established in the course of the generation enclosed by the revolutions of 1830 and 1848. This generation was not only literary but political. In place of the preceding generation's conservatism or liberalism, its credo had been the democratic ideal, even the ideal of the extreme left. It is not to be forgotten that, while the *fin de siècle* literary-artistic movements were destined to take up political or

reactionary attitudes (particularly in decadence and its offshoots), the connections between the political left and the literary left were sufficiently clearly defined and important to a generation that experienced "l'année terrible" and assisted in "le débacle."

In the case of naturalism, the political and literary left seem identical. Here readers should not be surprised if we incidentally reaffirm the avant-garde character of naturalism; we shall put this and other such judgments to the test at a later, more opportune point. For now, it is enough to point out that all too often we look at the recent literary-artistic past through the eyes of the current avant-garde, itself inclined to accuse not only long outstripped traditions of being *passé* but also inclined to level that accusation at other only recently vanquished avant-gardes. That is precisely why, to the observer today, the sympathies held by many naturalistic writers for the political avant-garde are much more obvious than their affinity with the aesthetic avant-gardism of those days. Hence the need to recall that this brief coinciding of the two avant-gardes is manifest in at least two famous symbolist poets. No one doubts that Rimbaud and Verlaine belong to the avant-garde experience; it is not to be forgotten that in the course of the Commune the first chose to carry the weapons of the insurgents and the second was accused (even though perhaps mistakenly) of having communard sympathies. An even more curious and typical coinciding took place after the Commune, when many of the young French artists who had flirted with anarchy and socialism were the first of those (now forgotten and ignored) who called themselves, defiantly, "decadents," a name originally derogatory. They all belonged to that type of plebeian bohemianism then characteristic of Paris.

This alliance of political and artistic radicalism, this parallel of the two avant-gardes, survived in France down to the first of the modern literary little magazines, significantly entitled *La Revue indépendante*. This magazine, founded about 1880, was perhaps the last organ to gather fraternally, under the same banner, the rebels of politics and the rebels of art, the representatives of advanced opinion in the two spheres of social and artistic thought. Abruptly

afterward, what might be called the divorce of the two avant-gardes took place. With the appearance of other groups and of reviews otherwise animated, expressions such as "the art, or literature, of the avant-garde" came into vogue. These expressions took on the common inheritance of French language and culture, and passed over the frontiers as "exchange currency" into the international market of ideas.

Thus, what had up to then been a secondary, figurative meaning became instead the primary, in fact the only, meaning: the isolated image and the abbreviated term avant-garde became, without qualification, another synonym for the artistic avant-garde, while the political notion functioned almost solely as rhetoric and was no longer used exclusively by those faithful to the revolutionary and subversive ideal. The point was reached at which anyone who still used the phrase outside the ambience of the political left was led to qualify it with special adjectives and attributes, as if to underline that, in this case, one was dealing not with a technical term but with a generalized publicizing or propagandistic image.

This does not detract from the fact that, after the split, the relationship between the artistic and the political avant-garde was later to be at least partially re-established. Perhaps that reconciliation has more reality in appearance than in substance. However that may be, it actually manifests itself on a level far different from that of primitive parallelism, now outlived. Further, what counts most, the later connection often takes on contradictory and equivocal aspects. This equivocation will be taken into account when we study the ambiguous alliances which seem in our day to join the left, in culture and in art.

A novel concept, a novel fact

Since the term "avant-garde art" came into common usage, it is extraordinary how often it has recurred, not only in literature and journalism but also in public polemic and cultivated conversation. No less extraordinary, if only by sharp contrast, is the practical ab-

sence of exhaustive critical elaboration and even of a simple defini-
tion of the concept contained in the phrase. Just because at every
step one encounters the verbal entity (or some equivalent), one
naturally inclines to consider the so-designated phenomenon as a
permanent, or at least recurrent, factor in the history of art and letters.
However we may judge avant-garde art when we meet it, for us the
phenomenon and idea are so present and evident that we do not
stop, even momentarily, to wonder if we might be dealing with an
illusion or an appearance rather than a reality, with a myth or a
superstition rather than a concept. Even more telling, when we do
maintain that it is a reality, we never ask if the so-designated his-
torical condition is of recent or remote origin. Never mind that the
foes of avant-garde art do nothing but sigh nostalgically for the good
old days when art was traditional, academic, and classical. Never
mind that its defenders do nothing but insist on the necessity of
liquidating the art of the past, once and for all, liquidating traditions.
It is still true that both sides, paradoxically, continue the discussion
with the tacit presupposition that always (or for a very long time,
even if under different conditions and forms) there has been the
same hostile relation, the same conflict, between new art and old art.

That supposition, however, is only an equivocation, owing to a
poverty of imagination and historical culture—a poverty afflicting
even the actors and spectators of cultural revolutions, who are igno-
rant of the fact that to understand such revolutions contemporary
observation is not enough. Retrospective observation is also needed,
an intellectual reconstruction of historical structures unlike those
of the present. To this lack is added the customary confusion between
the history of taste and the history of art. The inability to distinguish
between these two disciplines is exactly what impedes us from realiz-
ing how novelty in an artistic accomplishment is something quite
different from novelty in the artist's attitude vis-à-vis his own work,
and vis-à-vis the aesthetic task imposed upon him by his own era.

Be that as it may, it is by now an undoubted fact that the term
and concept of avant-garde art reach no further back in time than
the last quarter of the past century. Terms and concepts of like con-

tent or significance are not to be found, not even potentially, further back than the culture of romanticism or—at the very most—before the preromantic epoch of crisis, ferment, and transition which preceded romanticism, when the modern critical classical tradition dissolved. This very circumstance should suffice to make us understand that we have to deal with a novelty which is not merely formal but substantial, with a phenomenon truly "of exception" in cultural history. Strange to say, the critic-artist more easily takes into account the exceptionality and novelty than does the academic critic, the dilettante more easily than the professional in the History of Ideas. It is very hard to find in historical or erudite writings a judgment like that of Massimo Bontempelli, who, with good reason, did not hesitate to define avant-garde art as "an exclusively modern discovery, born only when art began to contemplate itself from a historical viewpoint."

That word "discovery" (*trovata*) may seem bizarre; indeed, if one thinks it over, the term avant-garde seems more appropriate to describe an invention rather than a discovery. Or, if you will, the name itself is a discovery, but a discovery of a *quid* not existing before. That, besides, is characteristic of any discovery in cultural history, where objective reality coincides with the subjective consciousness of that reality. In the case at hand, this means asserting that avant-garde art was historically impossible before the elaboration of the idea itself, or of some analogous notion. Whereas the scientist who speaks of the discovery of electricity thereby implies the existence of electricity before the discovery itself (which, anyway, means only the scientific awareness of electrical phenomena), in the cultural field discovery is creation, consciousness is existence. The sole epistemological principle valid on the humanist level is the Cartesian *cogito, ergo sum*—or better, *est cogitatum, ergo est*.

This theoretical position is, among other things, most useful for dissipating such equivocations as "the romanticism of the classicists" or "the classicism of the romantics": formulas that thus show themselves for what they are, facile anachronisms. The latter phrase, just because it admits a historical dialectic in which the past functions

as thesis and the present as antithesis, suggesting the possibility of an *a posteriori* synthesis, seems only a little less false than the first, where the synthesis is *a priori*. But, in the case of avant-garde art, the hypothesis that it existed previous to the era which coined its name is an anachronism twice over: it judges the past in terms of the present *and* the future. An authentic avant-garde can arise only when the concept as we know it (or at least a potential version of it) emerges. It is evident that such a concept (or its equivalent) is present in the Western historical consciousness only in our epoch, with the most remote temporal limits being the various preludes to the romantic experience.

In the philosophy of history, no other conclusion is conceivable. It is an open truth, a postulate needing no proof. But in concrete history, such a proof is useful and necessary. This is not the place for it, however, here in the preamble to our research. It is better to take up, as soon as possible, the connection between avant-gardism and romanticism which, despite appearances to the contrary, remains a parental bond. The relation between the sole and authentic avant-garde (the modern one) and the false avant-gardes of the past is antagonistic and can be studied only at the end of our inquiry, after we have arrived at a sufficient definition of the concept of avant-garde art. That will also be the time to discuss the connection between two parallel concepts whose identity or coinciding has already been postulated: avant-garde art and modern art.

2. THE CONCEPT OF A MOVEMENT

Schools and movements

Language is our greatest historical revealer. Therefore, when we are considering what at first seems to be a uniform phenomenon, we need only an essential linguistic change, for example, the appearance of a new name, to reveal the presence of another, different, phenomenon. In the opening pages of this study it was noted that the avant-garde is a group manifestation; to what extent, and in what way, we shall see at the proper point. On the other hand, it is undeniable that in the art of the past an analogous or identical circumstance has also occurred: there have been other artistic and literary regroupings. It then seems a particularly meaningful symptom that, whereas we did and do call the old-fashioned regroupings "schools," we call the modern ones "movements." This circumstance did not escape the vigilance of T. S. Eliot who, in his essay on a specific group of seventeenth-century English poets, after asking to what extent the so-called metaphysicals formed a school, immediately added in parentheses, "in our own time we should say a 'movement.'"

One may say that all past regroupings in art and literature are called, and can only be called, schools. The various local and formal

traditions of ancient Greece are schools; schools, too, are the *neoteroi* or *poetae novi* of Alexandria and Rome; the whole of Provençal poetry is one great school, a subschool being the special tradition of "the gay science" (for example, the *trobar clus* of Arnaut Daniel and his followers); others are the *dolcestilnovisti* of Italy and the Minnesingers of Germany, *les grands rhétoriqueurs* of the medieval era and the Pléïade of the French Renaissance, the various Petrarchisms and *secentismi* of Italy and Europe. Where, in the past, we do not find schools, we find academies, such as the Italian Arcadia of the eighteenth century. Such, it seems, was the state of things up to the threshold of modern times.

The term "school" is used even more frequently in the history of painting and sculpture, of the plastic arts in general. There it acquires an even more literal and specific meaning. Indeed it is in this area, because of the relatively greater importance of techniques, training, and apprenticeship, that even today the term survives (although the most typical and recent example is only a wholly external and artificial grouping, the so-called School of Paris).

It then seems a highly significant and prominent fact that romanticism was the first cultural-artistic manifestation of prime importance which no one now would dare call a school. We also tend to deny the name to the relatively minor manifestations immediately preceding it, *Sturm und Drang*, or, immediately following, realism or naturalism. This is significant precisely because the actors and spectators of these manifestations felt them to be movements, not schools. Should one object that the term romanticism transcends the confines of literature and art and extends to all spheres of cultural and civil life, that would merely reconfirm our point. The passing beyond the limits of art, the aspiration toward what the Germans call *Weltanschauung*, is perhaps the principal characteristic by which to separate what we call movements from what we call schools.

After romanticism, few and mostly insignificant cases come to mind for which one uses the term school. First, there is the "scuola boreale," a phrase that Vincenzo Monti, leader of Italian classicism, coined to employ against romanticism, with an aim not much differ-

ent from that of Robert Buchanan when the latter, so many years later, felt called upon to define the Pre-Raphaelite Brotherhood as "the fleshly school"; the expression "the natural school" was coined by the great critic Belinsky for the particular realism of Russian narrative art in his day, which failed to crystallize into any conscious or voluntary grouping and was a tendency rather than a movement; finally, we have the "école romane" which Moréas, its founder and *condottiere*, significantly used to indicate a slight and short-lived handful of deserters from symbolism. It is suggestive that, of four examples, three reflect what is henceforth the most frequent variation: the traditional term "school" used in a critical, even polemical, way. Only the fourth example gives evidence of another, more rare, permutation: the term used as the official and deliberate name for a group of artists intent on a common program. But we must remember that Moréas' purpose was, in a certain sense, regressive. It may be that the choice of the name *école romane* (the adjective being no less important than the noun) was dictated by a more or less clear awareness of this regression. We may then conclude, without fear of contradiction, since the exceptions are only apparent, that all artistic and cultural manifestations, from romanticism on, regularly tend to define and designate themselves as movements.

True, at times there are more vast and vague cultural manifestations which we more suitably label "currents." "Current" is favored in sociological and positivistic criticism (Georg Brandes, above all, established its vogue). It seems especially to allude to vital forces, intuitive and unconscious elements, tendencies rather than groups. As a historical term used, so to speak, *a posteriori*, it underlines phenomena of cultural history which seem to share characteristics of natural history. Thus its validity is limited to generalized and unstable orientations, cultural situations more in potential than in execution, to tendencies in a fluid or raw state. Briefly, it indicates environmental factors only translatable with difficulty into terms of historical consciousness and theoretical awareness. "Movement," on the other hand, is a technical term, nowadays appropriate to art history and literary criticism, insofar as both are concrete history

and specific criticism. What counts most, "movement" is the term which not only the observers, but also the protagonists, of that history use. Finally (and the antithetical term "school" fits in here too), it is much more than a mere *flatus vocis.*

The school notion presupposes a master and a method, the criterion of tradition and the principle of authority. It does not take account of history, only of time (in terms of the possibility and necessity of handing on to posterity a system to work by, a series of technical secrets endowed with a vitality apparently immune to any change or metamorphosis: *ars longa, vita brevis*). The school, then, is pre-eminently static and classical, while the movement is essentially dynamic and romantic. Where the school presupposes disciples consecrated to a transcendent end, the followers of a movement always work in terms of an end immanent in the movement itself. The school is inconceivable outside the humanistic ideal, the idea of culture as a thesaurus. The movement, instead, conceives of culture not as increment but as creation—or, at least, as a center of activity and energy.

Although virtually all of the usual manifestations of modern art (and more specifically avant-garde art) are to be identified with the concept of a movement, some seem closer to the school concept, even if they do not take on that name. This happens every time there triumphs within modern art sociological-aesthetic myths of the type expressed in attitudes like "art for art's sake," the Parnasse or the Pre-Raphaelite Brotherhood, myths that have crystallized in certain doctrines of decadence and symbolism—more generally, of aestheticism. These myths belong to the religion, superstition, fetishism, or idolatry called the cult of art; they are exemplified in the phrases "ivory tower," *buen retiro,* and *hortus conclusus,* all aesthetic variations of *noli me tangere* or *noli tangere circulos meos.* Their typical symbols were the tower (Vyacheslav Ivanov in Russia), the *Kreis* (Stefan George in Germany), *les lundis* (Mallarmé in France), perhaps also the D'Annunzian or Pascolian *convivio* as used by Adolfo de Bosis in Italy. On the social level, what corresponds to these myths are the groups calling themselves coteries, *chapelles,* or cenacles,

desiring by such names to distinguish their aristocratic and solitary nature from the more popular and democratic ateliers, cabarets, and cafés of the bohemian avant-garde, the spirit of *la rive gauche*, of the Latin Quarter and Montparnasse, Soho or Greenwich Village. But we should not forget that the antithesis between the cenacle and the literary café is much less extreme than that which opposes them both to the salons of the artistic *ancien régime;* often these salons were nothing but dilettante and mundane variants of the school spirit, where the academic mentality united with the courtly.

The most typical cenacles were decadent by tradition and symbolist in atmosphere: they gathered in France, Russia, and Germany around the above-mentioned figures of Mallarmé, Ivanov, and George—not so much masters or heads of schools as priests of the modern religion of poetry and art. Actually, in such cases, we are dealing not so much with schools, movements, or cenacles as with sects. Classical antiquity or, better, the humanist tradition knew nothing of the sectarian spirit in poetry, of hierarchical and esoteric concepts in art, of that aesthetic initiation which is simultaneously a mystical initiation, an Eleusinian, Pythagorean, or Orphic mystery. The sect, like the school, represents a static moment; cenacles and sects are only the mystically passive face of the movement, the other side of its coin. For now, this observation suffices to anticipate (though from a different point of view) the solution we shall offer to the problem of whether symbolism and aesthetic attitudes derive from, or share in, avant-garde art. Are they movements or not?

Certainly it was symbolism which carried one of the external signs most characteristically avant-garde to the highest degree of development: periodicals of the group or movement; all of them were organs for a specific creative current and, especially, for a particular tendency of taste. The particular importance of this phenomenon justifies our treating it, briefly and specifically, in the following excursus.

In the case of symbolism itself, and movements more or less analogous rising within French culture, it will suffice to cite a bundle of random titles: *Le Symboliste* and *Le Décadent, La Revue indépendante*

and *La Revue blanche, La Wallonie* and *La Revue wagnérienne, La Plume* and *La Vogue, Taches d'encre* and *La Conque.* Such a list proves the validity of our observation and abundantly exemplifies the scope of the phenomenon observed. In Anglo-American literary terminology, such literary periodicals are called "little magazines"—justly so, since their most symptomatic characteristics are limited printings and sparse, though highly selective, circulation (even that selection is made on primarily negative grounds). In sum, their chief characteristic is the noncommercial nature of their publishing; that is their natural condition (and the no less natural reason for the failure of each of them or, at least, for their short lives).

Sometimes the goal of the little review is merely to publish proclamations and programs or a series of manifestos, announcing the foundation of a new movement, explicating and elaborating its doctrine, categorically and polemically. Or else they merely present to a friendly or hostile public an anthology of the collective work in a new tendency or by a new group of artists and writers. Precisely for that reason, we are often dealing with only more or less confessedly special numbers or special collections, which, with a good will or bad, abandon the obligation to appear regularly or periodically and content themselves with appearing as yearbooks, annuals, miscellanies, or anthologies. Sometimes particularly favorable conditions permit one of these periodicals to exercise wider or longer-lasting influence on a more varied and widely diffused public; they then become editorial institutions of the normal and permanent type, with collateral collections and complementary undertakings. This happened especially in France, and the two exemplary cases are *Mercure de France* and the *Nouvelle revue française:* one the quasi-official organ of symbolism; the other, the organ of the avant-gardes between the two wars.

Outside France, this phenomenon is less intense, if not less frequent; perhaps the only analogous cases are found in Spain and Italy before and after the First World War: the *Revista de occidente* and *La Voce,* although the function fulfilled by the latter might better be compared to Charles Péguy's editorial activity with his *Cahiers*

de la quinzaine. Not that less solid organs failed to exercise, in other places and other times, an equally potent influence, equal in depth if not in extension. Suffice it to think of Russia, before and after the Revolution, with Bryusov and *Vesy* (The Balance) and Mayakovsky's *Lev* (The Left Front); Germany, with its notable series of expressionist organs, not to mention Stefan George's *Blätter für die Kunst;* America, with *The Dial* under Marianne Moore's direction; England, with T. S. Eliot's *Criterion; 900* and *Solaria* in Italy; *Sur* in Argentina.

On this subject, we may anticipate a later discussion of the relative popularity of romantic art and literature, poles apart from the avant-garde's almost absolute lack of popularity. This opposition was presented as a hypothesis by Ortega y Gasset and, even if one disagrees, at least in part he must unquestionably admit that there is a notable difference between the typical avant-garde periodical and the characteristic nineteenth-century and romantic periodical (such as *The Edinburgh Review,* the first *Revue des deux mondes,* and the splendid Russian reviews that so greatly aided in the classic flowering of Russian literature). We can express the difference by defining the romantic, nineteenth-century periodical as essentially an organ of opinion, exercising an avant-garde function only insofar as it leads and precedes a vast corps of readers in the labyrinth of ideas and issues; but the avant-garde periodical functions as an independent and isolated military unit, completely and sharply detached from the public, quick to act, not only to explore but also to battle, conquer, and adventure on its own. From this point of view, the opposition between the avant-garde and the romantic is less acute than the opposition between it and the popular and commercial periodical of our time: instead of guiding public opinion, the latter satisfies the crowd's passions and the crowd compensates it with an immense circulation and a notable economic success. On the other hand, the triumph of mass journalism is precisely what motivates and justifies the existence of the avant-garde review, which represents a reaction, as natural as it is necessary, to the spread of culture out to (or down to) the vulgar.

It was precisely within romantic culture that there flowered,

along with the reviews of opinion, the first avant-garde reviews in the modern sense. Enough to recall *Atheneum*, which its founding Dioscuri briefly wanted to call *Schlegeleum*, although it was destined to become the organ not only of the brothers Schlegel but also of their friends Tieck, Schleiermacher, and Novalis. The virtually dual number of the rejected title and the minuscule numbers of collaborators, as well, are significant. They reveal, in fact, the characteristic limited plurality as compared to the literary singularity that had distinguished the personal reviews of Goethe and Schiller, where the individual artist sought to speak "solo" even though with the voice of all. This is only another way of saying that *Atheneum* was a review of a group, a cenacle, a movement: an avant-garde periodical.

The romantic and the avant-garde periodical both differ notably from the Enlightenment periodical, which was not universal but generalized, written for education and propaganda, to instruct and to edify; together, they demonstrate how recent is the phenomenon of a literary-art press. This newness is in itself enough to explain why that press is strictly bound to the cultural reality symbolized in the term "movement." It is evident that, because of the difference in material and social factors (not least, the tardy apparition of the technical means and the totally modern phenomenon of the mass circulation of its product), the institution called a school was never in any position to possess or produce organs similar to the reviews distinguishing romantic and postromantic culture. Nevertheless, to the factual impossibility we must add a spiritual one. A literary-art school, in the traditional sense of the word, is not inclined to propagandize. It does not so much affirm in words the uniqueness, particularity, or exceptionality of its own theoretical doctrines and practical achievements, but rather aims to prove in deeds the supreme value of the teaching it exercises or represents.

The school does not aim to discuss; it intends only to teach. In place of proclamations and programs, manifestos and reviews (in other words, activities both literally and spiritually journalistic and polemical because they are bound to the needs of their own time and group), the school prefers to create new variants of traditional poetics

and rhetoric, normative or didactic simply by nature. Thus, to take two typical examples from the extreme cases of medieval and baroque cultures, representative school writings are treatises and manuals like the *ensenhamens* of the Provençal poets or Baltasar Gracián's *Agudeza y arte de ingenio*. For the study of art and poetry of the past, the catalogues of genres are clearly important; no more and no less important are the little magazines for those who study movements in the literature and art of our time. Possibly, however, for the future literary and art historian, our little reviews will be documents more useful than the organs of opinion have been in the case of romantic culture, if only because they more faithfully bear witness to divergence and exception: they operate in closer proximity to the sources of the work, closer to the creative process and the experimental phases.

The dialectic of movements

We return to the concept of movements to study it both internally and externally, its ideological and psychological motivations as well as its practical, sociological consequences. A movement is constituted primarily to obtain a positive result, for a concrete end. The ultimate hope is naturally the success of the specific movement or, on a higher, broader level, the affirmation of the avant-garde spirit in all cultural fields. But often a movement takes shape and agitates for no other end than its own self, out of the sheer joy of dynamism, a taste for action, a sportive enthusiasm, and the emotional fascination of adventure. This is the first aspect of the avant-garde movements to be discussed here, and we shall define it as *activism* or the *activistic moment*.

Experience teaches us that the gratuitous is not the most common type, or is at least not so frequent as the movement formed in part or in whole to agitate *against* something or someone. The something may be the academy, tradition; the someone may be a master whose teaching and example, whose prestige and authority, are considered wrong or harmful. More often then not, the someone is that collective

individual called the public. However, and whenever, this spirit of hostility and opposition appears, it reveals a permanent tendency that is characteristic of the avant-garde movement. We shall call it *antagonism* or the *antagonistic moment*.

Activism and antagonism are attitudes, immanent (so to speak) in the concept of a movement, which gives us the chance to discuss them in this chapter. There are, however, two other attitudes which, though they derive from the same concept, end up by transcending it. After brief comment here, we shall discuss them in the next chapter. The taste for action for action's sake, the dynamism inherent in the very idea of movement, can in fact drive itself beyond the point of control by any convention or reservation, scruple or limit. It finds joy not merely in the inebriation of movement, but even more in the act of beating down barriers, razing obstacles, destroying whatever stands in its way. The attitude thus constituted can be defined as a kind of transcendental antagonism, and we can give it no better name than *nihilism* or the *nihilistic moment*.

Looking deeper, we ultimately see that, in the febrile anxiety to go always further, the movement and its constituent human entity can reach the point where it no longer heeds the ruins and losses of others and ignores even its own catastrophe and perdition. It even welcomes and accepts this self-ruin as an obscure or unknown sacrifice to the success of future movements. This fourth aspect or posture we may define with the name *agonism* or the *agonistic moment*.

As noted, there is a perceptible difference between the first and second moments, on the one hand, and the third and fourth on the other. In the first two, certainly the form and ultimate cause (if not the content and primary cause) can always appear as rational elements or factors, just as war and sport, the duel and the game, can appear rational in the relation of means to ends. From a different perspective, the first two moments seem to represent the avant-garde ideology in that they establish the methods and ends of action; just as a more general concept of movement and the very idea of avant-garde seem to represent their mythology. The absolute irrationality of the second two moments is clear to any viewer, from any point

of view. This does not mean that they do not remain in mystical metaphysical contact with the first two. By virtue of such irrationality, agonism is inconceivable except in the realm of pure psychology, just as nihilism is to be comprehended only sociologically. In other words, the third and fourth moments are unthinkable except in the dimension of time ar.d history. That indeed is why the two first moments, by themselves, constitute the logic of movements, whereas by adding the other two we get what might be called the *dialectic of movements.*

Activism

Of the four "moments," the activist is perhaps the least important or, in any case, the least characteristic. Kurt Hiller originally coined the term, to define a precise formal tendency within German expressionism. He did so intending to reduce the individualistic and anarchistic impulses in expressionism, to reform them in the direction of a neo-enlightenment by elevating psychological revolt to the level of practical and social reform. Later the term came instead to indicate a generalized aspect of modern civilization and culture, even to define a notion diametrically opposite to the original one: the idea of a blind, gratuitous activity, the cult of the act rather than action. The purely political use of the term means the same thing within a particular framework: the tendency of certain individuals, parties, or groups to act without heeding plans or programs, to function with any method—including terrorism and direct action—for the mere sake of doing something, or of changing the sociopolitical system in whatever way they can. Avant-garde activism undoubtedly shares in this more generalized activism, in that debased Faustianism which seems one of the most typical aspects of modern civilization (or of barbarism).

Indeed, the very metaphor of "avant-garde" points precisely to the activist moment (rather than to the antagonistic). Within the military connotations of the image, the implication is not so much of an advance against an enemy as a marching toward, a reconnoiter-

ing or exploring of, that difficult and unknown territory called no-man's land. Spearhead action, the deployment of forces, maneuvering and formation rather than mass action and open fire: these characteristics are well rendered by the titles of two expressionist reviews, *Die Aktion* and *Der Sturm*. The Russian futurists, especially Mayakovsky, often expressed this spirit vividly, not so much as war as guerrilla warfare. Mayakovsky even tried to translate the tendency into literary precepts. He spoke of a conceptual cavalry and apostrophized contemporary artists with such rhetorical exclamations as, "Painter, will you try to evoke a cavalry charge with a barbed wire of subtle lines?" In fact, Mayakovsky often compared the pretended triumph of his movement to the happy outcome of a well-handled tactical maneuver. He once wrote, "Futurism has squeezed Russia in a vise," and the phrasing reveals an undisguised and direct sense of force and violence. Italian futurist circles expressed this spirit with greater crudity and brutality, as illustrated by the title of a book of poems by G. P. Lucini, *Revolverate* (Revolver Shots). Furthermore, in their manifestos, war is often spoken of (and not only metaphorically) as the "world's purifier." Apollinaire used the latter term as a synonym for invention or new art in his antithesis between new art and the old, which he also described as an antithesis between adventure (new) and order (old).

Massimo Bontempelli emphasized the same force as a generalized attribute of the avant-garde's historical experience. *L'Avventura novecentista*, as already mentioned, is his name for the collection of personal and literary effects of the movement he directed. He further emphasized the specific factor of artistic creation with the same reference and image when, in the reissuing of his own works, he entitled the collection of his most typical twentieth-century prose, *Avventure*. The psychological concept of adventure relates even the most extreme aesthetic of avant-gardism to manifestations and tendencies more traditional and moderate: for example, to the work of André Gide and his doctrine of ethical and psychic availability.

Activism, or psychological dynamism, naturally does not exclude the cult of physical dynamism. In fact, the exaltation of sport

derives from the first; from the second, the exaltation of the automobile, train, and airplane. The exaltation of sport was favored by the Italian avant-garde, by futurism and the Novecento, but it was often equally beloved by such movements as Russian futurism where Mayakovsky at times raised it to the level of a genuine messianism: "Our God is the race, our heart the drum." The second is not so much idolatry of the machine (from which Italian futurism wanted to draw an aesthetic) as idolatry of the vehicle: "A roaring auto," said Marinetti, "is more beautiful than the Victory of Samothrace." But we shall discuss such tendencies later, as the phenomenon of *modernolatry* or modernism.

Concepts stemming from the machine aesthetic, especially the cult of the vehicle, imply the reduction of art to pure emotion or sensation. Marinetti demonstrates this with his boast of having been the first to introduce a new beauty, "the beauty of speed" (to do so, he willfully ignored the precedent of a *laude* of D'Annunzio's). The cult of speed, in another of Marinetti's manifestos, fuses the two dynamisms, physical and spiritual, into a single tendency, in which the antagonistic moment also appears. "We want to exalt aggressive action, the racing foot, the fatal leap, the smack and the punch." This kind of attitude, typical of Italian futurism, can hardly be better defined than with the words of Marinetti's own programmatic declaration: "Heroism and patsy-ism in art and life." The strange combination of these two isms is itself enough to reveal how avant-gardism, in many cases, is more interested in motion than in creation, gestures than acts. It reveals how, and why, its creation often appears as a vulgar variant of aestheticism and sometimes is reduced to nothing more than a kind of "operation" (as Piccone Stella had occasion to remark of futurism).

Not that the activist myth is always a superficial or external manifestation. As an exceptional example we need only point to the noble dream expressed by Rimbaud's *Lettre du voyant:* the dream of a poetry of the future returning, like the Greek lyric, to the pure springs of being; the dream of poetry not simply as accompaniment or comment, but as the creation of a new reality. "Poetry will no

longer give rhythm to action: *elle sera en avant.*" Here we have the truly dynamic and progressive vision of poetry, even if only as pure idea. In any case, this vision is far more exalted than the one dominating the ingenuous futurism of so much modern thought, all too inclined (as Apollinaire already noted) to confuse the idea of progress with the idea of speed.

Antagonism

With antagonism, certainly the most noticeable and showy avant-garde posture, we again take up the distinction between antagonism toward the public and antagonism toward tradition. Here we shall discuss only the first in detail, postponing the second to a later occasion, when we meet it again as the antitraditionalism (down-with-the-past) so dear to the Italian futurists. We shall proceed this way for the sake of exposition; actually, the two antagonisms are merely complementary forms of the same opposition to the historic and social order. Furthermore, in practice, such a distinction is difficult to make. The reader will often feel that antagonism to the public comes insensibly to be confused with antagonism to tradition.

For now, it is enough to say as a general introduction that both antagonisms assume attitudes that are as much individual as group-oriented. Hostility isolates, on one hand, but on the other it reunites. This principle facilitates the appearance of the sectarian spirit which afflicts avant-gardism, despite its anarchistic temperament. The spirit of the sect dominates even that anarchism which is, if only in non-ideological forms, the single political ideal that the avant-garde artist sincerely feels, despite any totalitarian sympathies, left or right. That, as will be seen, does not cancel out the aristocratic character of the avant-garde protest. Avant-garde individualism is not strictly libertarian, as its cult of "the happy few" demonstrates.

On one hand, the anarchistic state of mind presupposes the individualistic revolt of the "unique" *against* society in the largest sense. On the other, it presupposes solidarity *within* a society in

the restricted sense of that word—that is to say, solidarity within the community of rebels and libertarians. Malraux, in his *Psychologie de l'art*, acutely perceived such factors at work in the art world: "Now it seems that the artist defines himself by breaking away from what precedes him, by means of a slow and purposeful self-conquest. But each artist brings to the fraternal, isolated *clan* his own conquests, and they separate him more and more from his own particular environment." The modern artist replaces that particular environment, determined by his family and social origins, with what the French call *milieu artiste*. There, sect and movement become a caste; hence a social fact in a primarily psychological way, motivated by vocation and election, not by blood or racial inheritance or by economic and class distinctions. Precisely on this account the modern artist is declassed, in both a positive and a negative sense (the latter well rendered by the English "outcast"). In other words, the *milieu artiste* can also sink down into a bohemia. Two postures, now plebeian and now aristocratic, now "dandy" and now "bohemian," derive from these two limiting points, the widest swing of the same pendulum. Dandy and bohemian are equal and opposite manifestations of an identical state of mind and social situation. That situation we shall later describe as alienation, and we may meanwhile symbolize it in the opposing images of the ivory tower and the ghetto.

It is exactly the bohemian spirit and the psychology of the *milieu artiste* that determine and provoke all the external manifestations of avant-gardistic antagonism toward the public. Such manifestations occur in the areas of contact between society and the artist's world. The innumerable expressions of this antagonism can be reduced, almost without exception, to the lowest common denominator of nonconformism. If the avant-garde has an etiquette, it consists of perverting and wholly subverting conventional deportment, the Galateo rules, "good manners." Hence those inverted norms of conduct which are called eccentricity and exhibitionism. To give an example, at once single and multiple, we need only cite the famous yellow sash Mayakovsky would display, following (perhaps without knowing it) precedents such as Théophile Gautier's red waistcoat and

Oscar Wilde's green carnation, equal and diverse fruits of a paradoxical and extravagant taste for a kind of "anti-uniform." Eccentricity and exhibitionism are merely flashy, certainly not potent, forms of antagonism; they do not develop beyond defiance. But defiance is sometimes transformed into what political language calls provocation, and what ethical religious language calls scandal. Some of the street-strolling manifestations of Italian futurism, or of Russian futurism and imagism, were genuine and purposeful scandals; Sergei Esenin, one of imagism's condottieri, confessed as much when he defined himself in a poem as "that scandalous Russian poet."

From provocation and scandal it is an easy step to a tough-guy act, the caprices of the already-mentioned plebeian bohemia. In fact, the Italian painter Ottone Rosai called his booklet exactly that, *Confessioni di un teppista* (Confessions of a Tough Guy). "Confessions of a Street Urchin" (the Russian for "street urchin" being a variant of the English "hooligan") is what Esenin himself called one of his most important lyrics and most celebrated collections of poems. At times hooliganism takes the form of out-and-out terrorism. It makes vengeance raids and undertakes "direct action," like Fascist vigilantes *avant la lettre*, as in Ardengo Soffici's *Lemmonio Boreo*. This happened more than once, and in more than words, in the course of Italy's futurist movement, particularly hard-fisted and vulgar as it was, quick to pack punches even more solid than what the Russian futurist program (of the same name) called "a whack at public taste."

Baudelaire had already noticed a direct psychological connection between this tendency toward tough-guy terrorism and the norms of conduct defined above as eccentricity and exhibitionism. In the essay *De l'héroïsme de la vie moderne*, he declared that modern existence permitted no heroes but the dandy and the criminal, another way of asserting the equivalence, within bourgeois society, of aristocratic secession and plebeian transgression.

The contest, silent though it be, is always a two-sided conflict. When disdain substitutes for hostility, the conflict is muted to a soliloquy and, for all that it changes neither adversaries nor ideals, the party becomes the sect. For example, the position Russian fu-

turism proclaimed with such violently aggressive spirit in the above-cited manifesto changes to a disdainful pose in the programmatically self-defining subtitle used by the editors of the avant-garde *Little Review:* "Making no compromise with public taste." It may be said that disdain has recently dominated and is ever more frequent. Still, the aggressive impulse continually reappears in intermittent, spasmodic manifestations, with the insane ferocity of terroristic violence. Breton, for example, went futurism one better when he defined "a volley shot into a crowd" as the "surrealist act, par excellence."

Naturally, avant-gardist antagonism cannot always be reduced to such simple and elementary postures; nor is it always limited to the psychological or professional problems of the relationship between artist and tradition or between artist and public. At times, the sociopsychological dialectic is left behind altogether, and the antagonism is elevated to a cosmic, metaphysical antagonism: a defiance of God and the universe. Thus, for example, Rimbaud commands "le poète doit être voleur de feu." At other times, with less extreme but purer tension, it surmounts its own specific hostility to the external factors of public and tradition to establish a contest between subject and object, artist and artifact. Both artist and artifact thus come to be antithetical or contrasted, a state well expressed, in the case of poetry, by Mallarmé's line: "notre si vieil ébat avec le grimoire." But then the contest is nothing other than the wrestling of Tobias with the angel. Antagonism transcends itself in agonism and ascends to the sphere of aesthetic mysticism.

Before continuing, we ought parenthetically to add that the terminology of current criticism often reveals this antagonistic attitude. Thus the American literary criticism which calls itself New Criticism and is, basically, an avant-garde criticism, in its struggles against the commonplaces of traditional aesthetics, does not restrict itself to refuting them simply as errors but condemns them as fallacies and seals them as heresies. Further, the same critical school avails itself of an intuition or inspiration that is clearly antagonistic by nature: antagonistic not only in the negative case of polemics, but positively, in theory. Such is the case of the conceptual image used

by New Criticism to postulate that the constituent elements of a work of art are to be found in a state of reciprocal "tension."

Except for these last examples (belonging to the category of theory), I have as a rule cited cases that refer not so much to the history of ideas as to the history of social customs. But, precisely because they do so, they function as symptoms and significant symbols of a spiritual attitude; almost like gestures or signals, they reveal, beyond themselves, a psychic condition, a mentality much more widespread and important even than the avant-garde's. Thus, the relation of the attitude called provocation and hooliganism to the modern cult of political violence is clear. Such violence is not content with expressing itself through concrete action—it also requires a theoretical and ideological exaltation and longs to make itself into a myth (in Sorel's sense). The fact is, the avant-garde, like every other modern movement of a partisan or subversive character, is not unmindful of the demagogic moment: hence its tendency toward self-advertisement, propaganda, and proselytizing. From the same root stems the moral pressure it succeeds in exerting over certain groups and individuals, as will be seen when we study the relations of the avant-garde and fashion.

The proverb says, "one finds what one looks for," and nothing is easier to find than an enemy, even if you do not go far to look. In an analogous way, though in a direction opposite to that followed by political radicalism, aesthetic radicalism often expresses itself by opposing that special category of society (in both the large and the limited sense of the word) called the old generation, the generation of the fathers. Ivan Turgenev in the last century was the first to formulate, in a mythical and popular way, the father-son antithesis. In more recent times, and in another novel, Luigi Pirandello used the words *vecchi* and *giovani* to designate this conflict between generations. Turgenev formulated the conflict in terms of a social, particularly a political, situation which he himself popularized as "nihilism." Since that term is rightly applied to a particular moment in the avant-garde, the antithesis is easily adaptable to the cultural sphere, although we are not yet ready to discuss it in detail (further-

more, it is a question transcending the confines of this study and involving an analysis of the concept of generations which, according to Ortega y Gasset, represents the most important idea of our time). For the time being, our examination remains within the limits of the antithesis "father-son," the old and the young generation.

No one else has expressed that antithesis with Apollinaire's brutal frankness: "You can't lug the corpse of your father all over the place." Even though sometimes more moderately expressed, such is always the son's state of mind. Sons, from the time they become conscious of the antithesis, have constantly acted like "angry young men" (to use a fashionable term). Fathers too have recognized the same conflict, though they have sometimes spoken of it deploringly, without rancor or invective. A selection, now old, from Frédéric Amiel's *Journal* seems to prove this: "A new spirit rules and inspires the generation following me . . . One has to speak to those of one's own age: the young no longer listen. With the thinker it is now as with a lover: he is not supposed to have a single white hair . . . Contemporary civilization does not know what to make of old age . . . From that you can see that Darwinianism triumphs: it is war, and war requires that the soldier be young."

The avant-garde cult of youth merits detailed discussion. We subject it to a critical analysis that emphasizes, along with its valid sympathetic side, the farcical and ludicrous. Excessive exaltation of youth obviously leads to a regressive condition: from youthful freshness to adolescent ingenuousness, to boyish prankishness, to childishness. This *sui generis* primitivism determines a psychological regression and produces what one might call infantilism in certain aspects of avant-garde movements and art. It is easily recognizable on aesthetic as well as psychological grounds. Psychologically, it is evident in what the Italian futurists called their "modernolatry" and is a phenomenon we shall encounter again when we discuss the relation between modernity and modernism. Here it is enough to say that the avant-garde often loves certain forms and devices of modern life primarily as toys. Art itself sometimes ends up being considered a plaything, as Aldo Palazzeschi seems willingly to do in the poem-

program of his futurist period which ends with the famous line, "ma lasciatemi divertire" (but let me amuse myself).

The aesthetic of art as a game, taken more literally and frivolously than the Schillerian concept of *Spieltrieb*, characterizes those currents of avant-garde art which hope to oppose that game to the quasi-gnomic serenity of classical poetry and of so much traditional art. Precisely for this reason, Giovanni Pascoli's "aesthetic of the *fanciullino*" appears to be a modernism. From poetics and history, suffice it to cite the success of that portion of avant-garde poetry which the English call nonsense verse. G. K. Chesterton admirably defined the essence and function of the form in his essay, *A Defense of Nonsense*, where he studied Edward Lear and Lewis Carroll but also attempted to prove the universal validity of that kind of poetry made up of the capricious and the arbitrary. The basic principle of the genre is held to be the idea of evasion ("escape") or the flight toward a world where things are not horribly fixed in unalterable correctness ("appropriateness"). Chesterton's definition is enough to explain the triumph of the fable, the *Märchen*, or the old *sotie* in art-prose; the importance of the ingenuous deformation of children's drawings in the figurative arts; the frequency of the ballet and *féerie* on the stage; the animated cartoon on the screen; the child's sing-song in music. The very name *dada* seems to designate a childish fixation: Tristan Tzara claimed to have found it in a dictionary, and the lexicographers Hatzfeld and Darmesteter were later to define it as "onomatopoetic baby-talk."

We shall again take up this aspect when we speak of the humor, voluntary or involuntary, of avant-garde art. Here we shall limit ourselves merely to reporting the phenomenon under the antagonistic constant. It is, despite appearances to the contrary, only a variant of that antagonism. Certainly one cannot imagine a greater antagonism than that existing between the child's world and the grown-up's world. It is also known that language is one of the ways children express their opposition to the adult world. The avant-garde faithfully follows that example, displaying its own antagonism toward the public, toward the convictions or conventions characterizing the

public, by a polemical jargon full of picturesque violence, sparing neither person nor thing, made up more of gestures and insults than of articulate discourse. The individual in the middle, the common man who is generally hostile to new art, gets pointed out as a burgher or philistine, a pig-tailed reactionary or Boeotian dunce; his opinions on art get stamped with arrogant terms like *kitsch* or *poncif,* corresponding works and styles, with terms like *croûtes* or *chewing gum;* the conventional or commercial artist who satisfies them is comically and mockingly called *pompier.* But what best validates the parallel and infantile avant-garde antagonism is that the new generation (that of the avant-garde artist) opposes the old generation, the academy and tradition, by means of a deliberate use of an idiom all its own, a quasi-private jargon. This tendency calls to mind the theory sustained in a paradoxical essay by the youthful Nietzsche. According to his theory, metaphor—that is, the idiom of poetry—would have originated in the desire of a group of youths to distinguish themselves by a kind of secret language. Their language would be opposed to the prose idiom, since that was the means of communication in the old generation and, in the patriarchal society it dominated, the sign of authority and an instrument of power.

In other words, from this point of view, the same linguistic hermeticism, which is one of the avant-garde's most important characteristics of form and style, would be conceived of as both the cause and the effect of the antagonism between public and artist. The problem of obscurity in so much contemporary poetic language is furthermore understood by many modern critics as the necessary reaction to the flat, opaque, and prosaic nature of our public speech, where the practical end of quantitative communication spoils the quality of expressive means. According to that doctrine, the linguistic obscurity of contemporary poetry should exercise a function at once cathartic and therapeutic in respect to the degeneration afflicting common language through convention and habits. The quasi-private idiom of our lyric poetry would then have a social end, would serve as a corrective to the linguistic corruption characteristic of any mass culture. That idiom would tend continually to re-enrich and renew

the words of the *koine*, old and impoverished by use, by technical and ready-made phrases endowed with a significance no less rigid than vague. Poetic obscurity would then aim at creating a treasure trove of new meanings within the poverty of common language, a game of multiple, diverse, and opposing meanings. Poetry would then be by nature equivocal; its most authentic effect would be "ambiguity," according to William Empson's terminology. This kind of concept is the paradoxical derivation of a rather traditional linguistic rationalism. But precisely on that account it establishes an antinomy similar to the Nietzschean one, an antinomy between metaphor and common language. Such indeed is the sense and scope of the linguistic theories of I. A. Richards, Empson's teacher, for whom poetry would be a deviation from the language of science; or of the doctrines of Cleanth Brooks, who conceives the relation between language and poetry as one of paradox, a conscious reaction to the norms of usage and opinion. Be that as it may, in this realm the most typical avant-garde antinomy establishes an antagonistic relation, more general and elementary in character, between poetic language and social language. This antinomy, an extreme position, is also the dominant attitude. It was expressed with characteristic violence in a manifesto appearing in the review *transition*. There, under the title "Revolution of the Word," one reads the following declaration: "The writer expresses. He does not communicate. The plain reader be damned." This text amply proves that hostility toward the common idiom, everyman's language, is simply one of the many forms of avant-garde antagonism toward the public.

We shall re-examine this question later, when we confront the problem of obscurity. Here, aesthetic-linguistic doctrines, barely touched on, can serve to demonstrate how the avant-garde posture vis-à-vis the public is a pure and simple protest even before it becomes a theoretical dissent. German expressionism perhaps expresses this protest more intensely and extremely than any other avant-garde movement, precisely because it does so in forms not exclusively aesthetic. Protest, however, is common to all avant-garde art, as may be easily seen in the names of many of its institutions and move-

ments. In the history of modern art, for example, we meet with at least one art gallery, one literary review, one experimental theater (not to mention less important manifestations) which chooses as its ensign the meaningful epithet, "independents." An independence, this, which does not rule out its very opposite, that is to say, partisanship. The title *Partisan Review* shows this, although it originally signified something more political than aesthetic. A no less patent protest is expressed by the choice of an enemy's insult as one's own emblem: we need cite only the decadents and the *Salon des refusés.*

The attitude that flaunts its enemy's insult is often the fruit of an aristocratic disposition. The motive involved is always that which leads a king to found the Order of the Garter or to choose *honni soit qui mal y pense* as a motto. Although we have often mentioned the plebeian *bohême,* a tough-guy tendency, a demagogic nature and nearly anarchistic leanings, here we can—and ought to—say, without fear of repetition or contradiction, that the avant-garde spirit is eminently aristocratic. Bontempelli recognized this truth, though he based his judgment more on aesthetic than on psychological reasons: "The avant-garde is by nature solitary and aristocratic; it loves the initiated and the ivory tower." On the basis of such a tendency we ought to establish a similarity, identity even, between contemporary avant-gardism and positions such as those taken by Flaubert or Baudelaire: positions, in the first case, characterized by a universal antipathy for the bourgeois spirit and *opinions reçues;* in the second case, by a hatred for "la bêtise au front de taureau." Furthermore, these same attitudes were to be carried to their extreme consequences by the direct heirs and disciples of Flaubert and Baudelaire, the decadents.

What stems naturally from such psychological motivations, more than from aesthetic doctrines, is that predestined unpopularity which avant-garde followers, light-heartedly and proudly, accept. As we shall see, this unpopularity is due not only to obscurity: it also depends on more important factors, such as an attitude of hostility to the *profanum vulgus* (unlike the classical and humanist indifference to it); or again, the particular position of modern

thought in regard to the concept of "the people," a notion altogether new and our own (or, better still, a myth or invention of romantic culture). Therefore, before going on, we need to insert a long parenthesis to examine the problems of the unpopularity of avant-garde art, its relation to romanticism, and connected questions. The following chapter is that parenthesis.

3. ROMANTICISM AND THE AVANT-GARDE

Popularity and unpopularity

The problem of the popularity or unpopularity of art is not new, although in the most rigorous technical formulation it is inconceivable outside modern culture. The writer or artist of older times often complained that his work failed to receive the practical recognition or official honor it merited. By that, he meant sanction from above rather than approval from below. Thus Petrarch's famous line, *povera e nuda vai filosofia* (O philosophy, you go about naked and poor), is not a lament that the poet pretends to express. On the contrary, he attributes the judgment to the *profanum vulgus: Dice la turba al vil guadagno intesa* (So says the crowd intent on vile profit).

However that may be, in contemporary civilization the problem of the popularity of art takes on a specific, wholly new and vital, significance. It does so because special factors have intervened, such as the infinitely wider diffusion of education and the possession of at least rudimentary culture by a notable mass of individuals. To confront this question, then, we need to distinguish between diverse types and forms, different sequences of cause and effect, in which popularity or unpopularity is expressed.

Unpopularity can be merely practical and negative: dependent,

that is, on material and formal causes, the physical or spiritual inaccessibility of the work. Physical inaccessibility is a question of what we may call unpopularity by distribution or, more exactly, nondistribution. Motivated as it is by empirical causes and mere contingencies, it does not interest us here. In spiritual inaccessibility there occurs what we might call unpopularity by comprehension or, better, noncomprehension—a fact of prime importance which we shall discuss along with the problem of obscurity.

The popularity of a work, movement, or style can be immediate or mediate. The first type is characteristic only of "bestsellers"; of those publications, called "slicks" in America, which rely on the public sentimentality, or "pulps," which instead satisfy the public thirst for sensation and emotion; of comic books and papers, love stories, or hit-parade songs; of radio-television programs and variety shows; of detective novels and movies; of the *café chantant* and the music hall. In other words, immediate popularity belongs exclusively to those forms of expression which are today called, especially in England and America, popular art or culture, meaning pseudo-art or pseudo-culture, current and inferior (this use of the epithet "popular" is very different from the romantic usage). This means, primarily, popular art and culture understood as consumer goods, manufactured for a mass public by specialized commercial agencies. Paradoxically, this type of popularity often goes hand in hand with ignoring the author's name and forgetting the title; in other words, with an anonymous product and anonymous producers.

It is not exaggerating to affirm that this kind of popularity is totally unknown in the history of earlier cultures, precisely because it is inconceivable in any circumstances or conditions other than those of our epoch or, better, of certain areas in present-day Western civilization. What *has* always occurred, although today with a greater intensity than before, is a mediate popularity. This consists of a work being known not so much completely and directly as it is indirectly and in part. Practically everyone will know at least some detail, some episode or fragment, of such a work; sometimes only the title or the author's name, a character, a famous phrase or a saying

become proverbial. In older times this type of popularity was based almost exclusively on oral tradition. Today it is made possible by such instruments as radio-television and the mass press: organs in which one can perhaps see the technical perfection (or mechanical degradation) of that oral tradition. In such a degree and manner the contemporary public manifests its knowledge of masterpieces of the national or classical literature—this is a consideration which ought to resolve once and for all the old question whether or not the classics are popular. It shows that in reality the public only knows the modern classics by way of vulgarization, just as it knew older classics only by vulgarization.

This species of popularity, which I call mediate, is not totally foreign to avant-garde art itself: a circumstance due to various factors, not least to curiosity, as we shall see when we discuss avant-garde art and fashion. From all this, we see that no absolute popularity or unpopularity exists; both are relative. Only in the empirical area can one speak of the popularity or unpopularity of an aesthetic form or artistic movement. And only in that sense do we have motive or reason to affirm that, in respect to classical art, romanticism was popular, and that avant-garde art is, compared to romanticism, unpopular.

Such an assertion, along with the need to prove its degree of truth or error, suggests the need to examine the reciprocal relationship between romanticism and avant-gardism from a viewpoint which, although particular, is not arbitrary. The first movement is, in fact, recognized as initiating what may be called the popular aesthetic; the second is considered, by antonomasia, the unpopular art. "All the art of youth is unpopular," says Ortega y Gasset, "and not casually or by accident, but by virtue of an essential destiny." The citation, indeed, seems to recommend the addition to our categories of yet another classification distinguishing voluntary from involuntary unpopularity. But so as not yet to prejudice a closer examination of the justice of the charge of willfulness so often leveled against avant-garde art, it is preferable to use two categories of a different order, suggested by the same situation. We shall speak

instead of accidental unpopularity and substantive unpopularity. Even while agreeing with Ortega y Gasset in maintaining that the avant-garde's unpopularity is one of substance, we ought to sustain, on the other hand, the view that romanticism's popularity was merely an accident. (Under scrutiny, the only art form truly popular during the romantic movement was the opera, extremely conventional, stylistically.) However that may be, what we have so far said permits us here to annul (at least from this point of view) the break between romanticism and avant-gardism and will permit us later to prove that the line uniting them, chronologically and historically, is a continuous one.

Romanticism as a precedent

Many historians and critics have affirmed the continuity of the ideological and historical line between romanticism and avant-gardism. But almost always this involves rightists, often polemicists, already hostile to romanticism, who attack the avant-garde as an extreme case of what they call the "disease of romanticism." It will suffice to cite as examples the names of the Baron de Seillière, Pierre Lasserre, and Irving Babbitt. Rare indeed is the case of a scholar maintaining the continuity who is not adversely prejudiced. Mario Praz is one such, and he feels that romanticism not only survived decadence and symbolism, but remains one of the major factors in avant-garde art and culture—a most valid opinion since that survival is a fact evident to the historical vision. If Praz's view has any flaw, it errs only in overvaluing the identity of the two terms and in undervaluing the distinction. Rarer still is an avant-garde artist who, like Rimbaud in his *Lettre du voyant*, is able to take into account the parental bond between romanticism and the ideal of new art and poetry; who, even more, recognizes, in part at least, how valid still is a message of which even the romantics themselves could not have been fully aware. "Romanticism has never been properly judged. Who was there to judge it? The critics? The Romantics? they prove so clearly that the song is very seldom the work, that is, the idea

sung and understood by the singer." Yet it remains true that to affirm the existence of a continuity between romanticism and avant-gardism is, if anything, characteristic of hostile criticism. The partisan nature of the judgment thus vitiates the theoretical and critical correctness of the testimony. Avant-gardists indeed have their own good reasons for refuting the hypothesis (enough to recall their opposition to the principle of spiritual and cultural inheritance, or their favorite myth of the annihilation of all the past, precedent and tradition). Thus there has been no need of this supplementary motive in leading them to deny a truth so dear to their most tendentious adversaries. Rimbaud himself, even while paying tribute to the value of the romantic heritage, undoubtedly felt the need to deny it. In fact, he recognized for his contemporaries the right *not* to recognize that tradition, even to deny it, if only for their own raison d'être, the exigencies of their own Zeitgeist. "Besides, newcomers have a right to condemn their ancestors: *on est chez soi et on a le temps.*"

Not all protagonists, actors, and defenders, or spectators well disposed to the avant-garde, have denied this affiliation. The few who have recognized it still limit it to some one case or particular movement. Herbert Read, for example, when he dealt specifically with the relationship between romanticism and surrealism, saw in the second a logical and extreme consequence of the state of mind expressed by the first. Yet we must note, that, as one sees in the essay entitled *Surrealism and the Romantic Principle*, he does not conceive of the relationship historically, as a natural and direct heritage, but as a free return to that system of eternal aesthetic values which romanticism itself would express in an extreme, but still particular and temporary, way.

For this and other reasons, one may then doubt that Herbert Read would feel equally disposed to acknowledge the existence of a relationship between the "romantic principle" and avant-garde movements other than surrealism (especially such other tendencies as those culminating in the experiments of abstractionism and cubism). Certainly rarest of all exceptions is the case of an avant-garde artist or critic who recognizes the avant-garde's affiliation with

romanticism as a central factor. Thus the following evaluation by Massimo Bontempelli is truly exceptional: "All the so-called arts of the avant-garde characterizing the first fifteen years of the century, that is the period just before the war, were the glowing pyre on which romanticism burned its furthest advances." And even this assertion loses in emphasis and scope through its too limited chronology: it is wrong to assign so recent and definite a birth date to the avant-garde, and wrong to prophecy for it an end so near at hand. In fact, not everyone can share the opinion that we have reached the point which Bontempelli calls the overcoming of the avant-garde: avant-gardism has not yet liquidated its specific experience nor the more general one of its own inheritance and of the romantic survival.

As for the erroneous belief that modern art has completely overcome or liquidated romanticism, not only the recent avant-gardes, avant-gardes properly so called, have held it. That belief was shared by followers of art-for-art's-sake and of the Parnasse, by the decadents and symbolists, finally by the realists and naturalists: in other words, by the mystics of art and the mystics of science, sure that they had transcended romanticism solely because they had overcome psychological sentimentality or aesthetic idealism. This makes it all the more easy to understand how and why the latest avant-gardes, although they are often perceptive in tracing survivals of the romantic psyche in their immediate predecessors, the naturalists and symbolists, cannot but yield to the same illusion, namely that they freed modern culture from the romantic heritage.

Some reader may wish to object that such an assertion contradicts an initial postulate of this study: the principle that reality and consciousness are identical on the level of spiritual history. To him we may easily respond that the epistemological criterion holds only for theoretical consciousness, not for polemical consciousness. While the first is pure, the second is impure; not intellectual but practical, it is a function not of being and knowing, but of acting and doing. The programmatic antiromanticism of the avant-garde originates in this kind of polemical consciousness. The issue here is not so much a hostility to the authentic and original romanticism as an opposition

to a posthumous and outlived romanticism, something become conventional, a pathetic mode, a taste for the sensational. In a word, we are dealing with that retarded and deteriorated romanticism which the public for the avant-garde movements loves so dearly, precisely because it is so decayed and moribund, deprived of whatever is still valid and vital in the tradition from which it springs.

Among the critics giving theoretical sanction to the avant-garde's antiromanticism, Ortega y Gasset is most worthy of being heard. His sanction is noteworthy not only because he is so exceptional an interpreter, but also because his view is inspired by great serenity and speculative impartiality. He speaks from observation and meditation, certainly not from antiromantic prejudice and, still less, from hostility to the avant-garde. Hence the necessity of intently studying the Spanish philosopher's opinion on this issue and analyzing it more accurately. To say that romanticism began in the same way that modern art did is, according to Ortega, to cite a fallacious precedent: as a psychological phenomenon, romanticism was exactly opposite to the present case. Romanticism rapidly conquered the people, who had never been able to stomach the old classical art. The enemy against whom it had to fight was a select minority that remained paralyzed within the archaic forms of poetry's *ancien régime*. As may be seen, we are once again at our point of departure: the popularity or unpopularity of art.

In this statement Ortega seems to confuse the theoretical exaltation of the people (that is to say, the romantic interpretation of the concept of the people, the cult of popular art and poetry) with the actual influence of romantic art and poetry on the taste and the public of its own day. It is quite true that the old art was not acceptable, or was incomprehensible, to the people, the public in a broad sense; they could not, as Ortega says, "stomach it." But it is no less true that the new and romantic art became just as hard for them to stomach, or at least remained alien to them, and particularly the new art's populist tendencies. This is so because the neoprimitive current within romanticism, as within the avant-garde, remained and remains the most unpopular current.

There we have it: the reason why it is difficult to accept Ortega's claim that "romanticism is, par excellence, the popular style" and therefore sympathetically embraced by the masses. Obviously Ortega too easily identifies the concept of the people with that of the public, as many romantics had also done. The confusion originates from the fact that, while the public for classic art was the aristocracy, the public for modern art (for social and political rather than aesthetic reasons) was becoming and has become an advanced wing of the petty bourgeoisie.

It may be true that the only genuine enemy romanticism had to combat was the academic public, the professional culture; in other words, the intellectual elite of the *ancien régime*. It is in fact true, but precisely because the popular public neither read nor followed the first romantics and thus had neither reason nor way to display its own approval or dissent. Then the situation in which the annunciators of the romantic revolution found themselves is analogous to that of today's avant-gardists, who struggle against a contemporary variant of the same public. And yet this type of public is more cultured or educated than is commonly believed exactly because it takes for its ideals, or idols, what may be called, if not classicism, at least the traditional or the academic. For this reason also, it is still endowed with notable prestige; to combat its prestige, innovators now (as did the romantics) need to count on the support of a select, enlightened, and advanced section of opinion.

Furthermore, the cult of novelty and even of the strange, which is the basis for avant-garde art's substantive and not accidental unpopularity, was an exquisitely romantic phenomenon even before it became typically avant-garde. And if romanticism, when it attempted to impose this cult of novelty, appealed with demagogic idealism to popular judgment rather than to the taste of the cultivated public, this also was a precedent to be followed more than once by the avant-garde movements themselves, in the form of rhetorical appeals. Even admitting, as one must in justice, that romanticism maintained a relatively respectful attitude toward the public (precisely because it too often confused that public with "the

people"), still the antagonistic attitude the avant-gardes assumed toward the public does not mean they ignored or denied it. The very intention, or willingness, to *épater le bourgeois* is no more than one of many ways to square accounts with the public and is indeed perhaps the most valid acknowledgment of the presence and influence of that public. Seen in this way, romanticism and avant-gardism, instead of being reciprocal opposites, come to appear as relatives, reacting to the humanistic and classical position in parallel ways. In fact only the humanist-classical position, based on the certainty that a limited and compact public exists, bound to the same criteria of taste, makes it possible for the artist to assume a superbly indifferent posture before the general and uncultivated public, in the tradition proverbially and poetically expressed by the Horatian *odi profanum vulgus et arceo*. The disdain of the avant-garde artist is instead directed exactly toward that part of the public which claims best to represent the civilization of its epoch; this posture naturally allies him, more strictly than to the early romantics, to that group of arrogant priests in the religion of art who appeared in the third and fourth quarters of the last century.

It is true beyond doubt that, as Ortega y Gasset maintains, romanticism was "the first-born son of democracy," and this can be said even for the socially and politically reactionary currents within the movement. But to be the son (or father) of the democratic spirit does not mean always acting democratically: inaugurating the government of, and by, all the people is an affair of the minority. By the mere fact that it was a new art, romanticism was just as aristocratic as the later avant-garde. German romanticism, from a theoretical point of view the most original and ideologically the most *völkisch*, was also the most reactionary and unpopular of the various national romanticisms and, potentially at least, the most avant-gardistic. Indeed, from this viewpoint, leftist, sociological, and Marxist criticism is quite right (apart from the apocalyptic tone and the derogatory phrases like decadence and degeneration) in proclaiming that, between avant-garde art and contemporary society, there exists a precise and direct connection. Even those who refute

the criterion of judgment to which leftist criticism submits both sides of this relationship cannot deny the validity of the principle.

In the aesthetic realm, as well as in the sociological, classical, romantic, and avant-garde art are no more than minority cultures, precisely insofar as they are art. But whereas the first is content to distinguish itself from the majority culture, from the barbaric, uncultivated, and illiterate, romantic and avant-garde art cannot avoid displaying a certain interest, negative or positive as the case may be, in those masses which are now illiterate only in a relative sense. As against classical art, which flowered in an aristocratic climate, romantic art and avant-garde art are aristocracies subsisting and surviving in the democratic, or at least the demagogic, era. This fact suffices to show that the sociological differences distinguishing romantic art from avant-garde art are only differences of degree.

On the other hand, even though these differences are not substantial, they are sufficiently emphatic to prevent the categorical, literal, or absolute definition of romanticism as the first avant-garde movement. Still, one may legitimately assert that whereas the classical tradition is, by definition, one in which there exists no avant-garde force at all, romanticism is—in a certain way and up to a certain point—potential avant-gardism. If such a claim appears excessive, the hypothesis of historical continuity between romanticism and avant-gardism now seems irrefutable: there is not the shadow of a doubt that the latter would have been historically inconceivable without the romantic precedent.

Down-with-the-past

Italian futurism is also called *antipassatismo*, the down-with-the-past movement. As the first name is highly suggestive of a tendency common to all avant-gardism, so the second emphasizes a posture that is certainly not exclusive with the avant-garde. Furthermore, it was precisely in Italy that Apollinaire published his manifesto, in French, called *L'Antitradition futuriste*, and the phrase emphasizes the direct connection between the two terms. It proclaims as a specific

attribute of that movement the general tendency we have already called antagonism. Surely antitraditionalism was more polemical and programmatic in Italian futurism than in any other avant-garde movement; surely in no other country did it express itself in such clamorous demonstrations against tradition, the academy, and the temples thereof, the library and the museum. These protests culminated in Umberto Boccioni's invectives against the Italian cult of antiquity and in the famous speech Giovanni Papini delivered in the Eternal City, against the spirit of Rome. To show the participation of Russian futurism in this attitude, it is enough to recall a passage from the manifesto "A Whack at the Public Taste," where the authors postulate the need "to throw overboard the ballast of the classics from modernity's steamship." Or we have only to translate some lines from Mayakovsky: "Make bombardment echo on the museum walls . . . Why didn't they string up Pushkin?"

At any rate, even when the term "futurism" is used to designate a general tendency, its relation to antitraditionalism is not reducible to a purely semantic bond. There is, in fact, almost no avant-garde manifestation which is not a new variation on the attitude defined by Apollinaire as "antitradition." Precisely on this account, antitraditionalism transcends any specific futurism and is not to be wholly identified with futurism in general. The futurists did not invent the tendency (apart from its name); indeed it was their forerunner, and it outlived them. The repudiation of the past and tradition is a phenomenon simultaneous with the formation of the earliest avant-gardes or with the rise of the first great figures to blaze the trail for art in our time. It reveals itself in the sudden conviction that all preceding art, from classical antiquity to the eve of our day, had been nothing but a waste of time. Now, as Rimbaud says in the *Lettre du voyant* to conclude a brief résumé of the history of Western poetry from the end of Hellenism on, "le jeu moisit . . . il a duré mille ans!" Furthermore, the antitraditional posture is not monopolized exclusively by the more boisterous and extreme avant-gardes; it belongs also to the more moderate moderns, as Richard Aldington shows in his autobiography, *Life for Life's Sake.* There he tells us that

the artists and writers of "the vanguard" believed, nearly unani-mously, that all the art of the past was "dead stuff to be scrapped." This negative credo is bound, on the purely psychological level, to what we call avant-garde nihilism; on the sociological level, however, it is joined to antagonism toward the public; on the aesthetic level, to the unpopularity of modern art, its hermeticism. This again leads us to the problem of the relation of romanticism and the avant-garde: in this instance, to the question whether or not there was a romantic antitraditionalism.

Now, not only was there a romantic antitraditionalism, but indeed it was, in some places and movements, no less extreme and absolute than in the avant-garde itself. The romantics were in fact opposed to the whole classical tradition, the art of Athens and Rome, the Italian Renaissance and French classicism, eighteenth-century enlightenment and neoclassicism. To prove how much their anti-traditionalism was like the avant-garde's, we have only to juxtapose the famous alexandrine of an eighteenth-century poet, destined to become one of the banners of the romantic movement, with the verses composed by Apollinaire a century and a half later. Alongside the alexandrine, "Qui nous délivrera des Grecs et des Romains?" we put Apollinaire's "A la fin tu es las de ce monde ancien . . . Tu en a assez de vivre dans l'antiquité grecque et romaine."

Romantic antitraditionalism naturally worked within particular limitations and exceptions, as well exemplified in the predilection of so many German romantics (and many romantics in other coun-tries) for ancient Greece: the current called romantic Hellenism. And of course we should not forget that the greater romantics, the Ger-mans especially, by their new orientations of taste made possible and necessary that critical receptivity which Burckhardt so admired, that aesthetic catholicity which remains one of the great merits of historicism and forms part of our heritage.

We can then say that the romantic attitude toward the past was ambivalent: along with the revolutionary and destructive moment, there was the moment of reconstruction and restoration; along with the phase of disdain and neglect, the phase of regret and nostalgia.

The romantic writer, like the historian in Friedrich Schlegel's definition, was often a "retrospective prophet"—hence arise medievalism and orientalism, the cult of the barbaric and exotic, the elemental and primitive, all phenomena much more intense and broad than the avant-garde's aesthetic primitivism. The avant-gardes turn their attention almost exclusively to negroid sculpture and the art of savages, prehistoric graffiti and pre-Columbian Indian art; they turn, in short, toward cultures remote in space and time, almost to prehistory itself. This particular mode of rediscovering remote and forgotten traditions is not contradictory to what has already been said about avant-garde antitraditionalism, precisely because the avant-garde can evaluate archaic traditions better than official art and conservative criticism can, if only by way of polemical reaction to the erroneous interpretations and evaluations of the academy. "At the beginning of the century," says Malraux, "it was the painters who wished to be most modern, which means most committed to the future, who rummaged most furiously in the past." And in a celebrated passage of *Une Saison en enfer*, Rimbaud had already said, speaking only in his own name but revealing a tendency common to other poets, "the old stuff (*vieillerie*) of poetry had a large part in my alchemy of the world."

The second statement seems less contradictory than the first when one recalls that the normal and genuine polemic of the avant-garde concentrates its fire not so much on the remote past as on the more recent past, on the cultural world of the oldsters and oldtimers, on their fathers' and grandfathers' generations. This explains how and why the sons of our century are most relentless in their controversies over their immediate progenitors, such as the romantics who carried the standard ahead of them. But this also suggests that, despite apparent and substantial differences, avant-garde antitraditionalism does not radically diverge from the romantic variety, that, in fact, it represents basically an extreme variation of the same thing. As for the constant, it is one of the most direct and natural manifestations of the modern spirit.

Before proceeding in our study of avant-garde phenomenology,

we ought to clarify an obscure and equivocal point, of the sort lead-
ing to error. The solution of this dubious point will help us, more-
over, to comprehend the dialectic of antitraditionalism. Here is the
place to emphasize that, from the reaction of the avant-garde to
tradition, we should not deduce that any form of convention is alien
to avant-garde art. Like any artistic tradition, however antitraditional
it may be, the avant-garde also has its conventions. In the broad
sense of the word, it is itself no more than a new system of con-
ventions, despite the contrary opinion of its followers. Naturally, its
most obvious function involves its anticonventional tendency. This
means that the conventions of avant-garde art, in a conscious or
unconscious way, are directly and rigidly determined by an inverse
relation to traditional conventions. Thanks to this relation, a para-
doxical one, the conventions of avant-garde art are often as easily
deduced as those of the academy: their deviation from the norm is
so regular and normal a fact that it is transformed into a canon no
less exceptional than predictable. Disorder becomes a rule when it
is opposed in a deliberate and symmetrical manner to a pre-estab-
lished order. Rimbaud spoke for all avant-garde artists when he
said, "I ended up finding the disorder of my spirit sacred." If this
is true, it ought not to be too difficult, when all accounts are tallied,
to formulate for the avant-garde what Alfred Jarry postulated under
the clowning name of *pataphysique*, that is to say, the science deter-
mining the laws that govern the exception, not the rule.

Anticipations

The connection between the relative popularity of romanticism
and the nearly absolute unpopularity of avant-gardism, or the partial
and moderate traditionalism of the one as contrasted with the nearly
total and extreme antitraditionalism of the other: these, as already
observed, barely exhaust the long series of possible relationships
between the two movements. If we here try to establish one or
another of these other possibilities, we must do so in a way that
anticipates the later results of this inquiry. We are not yet far enough

along to resolve them definitively, but far enough to point out the program to be developed. It will do for now to allude as we go, case by case, to the aspects of the problem which can be dealt with briefly.

Popularity and unpopularity, relative traditionalism and absolute antitraditionalism, these concepts serve to emphasize a relation between historical awareness and social awareness within romanticism and the avant-garde. These two types of awareness more properly belong to the mental forms we have called the psychology and ideology of a movement. In different circumstances and from different viewpoints, we shall encounter analogous relationships when we consider the avant-garde and fashion, the avant-garde and the public. That problem can be solved only when we are able to contemplate it on a higher and more theoretical level: that is, as a function of the link between avant-gardism and modern art, modernity and modernism. We shall find it unavoidably necessary to examine the emphasis found in both romanticism and the avant-garde upon aesthetics and poetics: unavoidable, because this connection is what has most interested scholars. Indeed, in just that area we shall develop certain problems here anticipated. One of the most important aspects of avant-garde poetics is what is referred to as experimentalism; for this, one easily recognizes an immediate precedent in romantic aesthetic experimentation, the anxious search for new and virgin forms, with the aim not only of destroying the barbed wire of rules, the gilded cage of classical poetics, but also of creating a new morphology of art, a new spiritual language.

For example, critics, and not only hostile ones, have defined the evolution of contemporary art as a process of dehumanization. Here again it will suffice to recall that the defenders of classical art, in their controversies with the romantics, repeated this commonplace to the point of satiety: they, the argument runs, have chosen the study of man and the representation of the human as their proper task, while the romantics tend to negate this principle, to brutalize and barbarize, to bring about a cultural regression or involution. Elsewhere we shall discuss certain avant-garde tendencies, cerebralism and abstractionism, in terms of dehumanization; there we

shall see that cerebralism and abstractionism are phenomena not fundamentally different from tendencies which at first glance seem contradictory. They do not differ much, for example, from biologism and vitalism, which are merely extensions beyond the purely human of the romantic taste for the sentimental, pathetic, and impassioned. In them, the cult of the primordial in a naturalistic and cosmic sense takes the place of the earlier psychological primitivism.

On the plane of aesthetic metaphysics, we must examine the doctrines going under the names of the "aesthetic of the dream" and the "poetics of the supernatural," equally dear to the romantic and the avant-garde artist. There the relationship between symbolists and surrealists, on the one side, and the extreme (particularly the German) romantics, on the other, seems almost that of disciple to master. And for that matter, there is no need to go so far afield: Victor Hugo seems already to have synthesized and summed up certain surrealist and symbolist concepts when he suggestively defined the poet as "the terrified magician."

And so also in the case of the modern aesthetic of the game: the earlier and motivating doctrine of romantic irony can be easily invoked. Even in the case of forms and tendencies that may seem exclusive to the avant-garde, the mystique of purity, for example, it will easily be proved that such a thing (even considered as a simple reaction) is inconceivable except as the paradoxical, contradictory consequence of certain romantic doctrines: among many, it will suffice to mention "fusing of genres."

Finally, when we take up the problem of avant-garde criticism, whether from the systematic or the methodological point of view, we shall be able to see the historical and theoretical relations which again join that criticism to the criticism of the romantics and *their* critics, old and new. Suffice it to say that the favorable criticism is but an extension or adaptation of romantic criticism; as for the hostile, the anti-avant-garde critics are nearly always also antiromantics. We need, apropos of this, only invoke the names of such French critics as Lasserre, Seillière, and Benda; or to take the example of Irving Babbitt, who in a work significantly entitled *The New Laocoön*,

on the arts and letters of our time, makes accusations analogous to those leveled in his other, more famous, *Rousseau and Romanticism.*

4. AGONISM AND FUTURISM

Nihilism

We now return, after a long parenthesis, to the typology of avant-garde attitudes, continuing from the point at which we left it, the nihilistic moment or *nihilism*. It will perhaps be useful to say that this term is not to be taken as implicitly derogatory; it has no more of a derogatory connotation than any other term used here, though the others are generally of a more innocuous appearance. We use the term to allude in a purely descriptive way to a determinate state of mind, not to judge, even less to condemn, that state of mind. This, fundamentally, is to use the word as originally intended, since the French orientalist Burnouf coined it to translate, without any value judgment, the philosophical concept of nirvana. Turgenev, to be sure, then used the term in quite a different way and caused it to take on, inside Russia and beyond, the added meaning of terrorism or the extreme of intellectual radicalism. Nihilism is used here, without love or hate, to indicate a characteristic *forma mentis*, and nothing else.

If the essence of activism lies in acting for the sake of acting; of antagonism, acting by negative reaction; then the essence of nihilism lies in attaining nonaction by acting, lies in destructive, not con-

structive, labor. No avant-garde movement fails to display, at least to some degree, this tendency, either on this side of the activist and antagonist impulses or beyond them. Activism and antagonism are most profoundly and authentically revealed in Italian futurism, but the stimulus of nihilistic destruction appears there too. For example, that stimulus is betrayed or, better, is expressed in the title *L'Incendario* (The Firebug), which was imposed on the first edition of Palazzeschi's poems by Marinetti (the poems now seem more crepuscular than futuristic). As for Russian futurism, it is enough to point out that within that movement there briefly crystallized a current or group whose members called themselves *nichevoki*, which has the ring of "the nothing-ists." Mayakovsky later gave extreme nihilistic expression to antitraditionalism and the cult of the *tabula rasa* when he said, "I write *nihil* on anything that has been done before." English vorticism acutely displayed the same state of mind with its official, short-lived organ *Blast*, so called by the same Wyndham Lewis who no less suggestively entitled his own literary memoirs, *Blasting and Bombardiering*. But it was perhaps only in dadaism that the nihilistic tendency functioned as the primary, even solitary, psychic condition; there it took the form of an intransigent puerility, an extreme infantilism. We have already mentioned this complementary and particular aspect of nihilism and shall again; enough now to establish that there existed in the avant-garde mentality a nihilism and an infantilism which functioned reciprocally. Further, as practical psychology teaches us, the taste for destruction seems innate in the soul of a child.

Be that as it may, the nihilistic tendency in its pure state demonstrably attained its most intense and varied expression in dadaism. Fundamentally, the dadaist position began by repeating and carrying to extremes what Rimbaud, the great standard bearer of contemporary avant-gardism, had already formulated at the end of his poetic career: "Now I hate mystical effusions and stylistic quirks. *Maintenant je sais que l'art est une sottise.*" In a way both analogous and opposed to Rimbaud's negation, the nihilism of dada is not a specifically literary or aesthetic posture; it is radical and totalitarian, integral

and metaphysical. It invests not only the movement's program of action but also its very raison d'être. "Dada does not mean anything," declared Tristan Tzara, and his negative statement ought to be extended to issues even more substantial than the mere name. "There is a great destructive, negative task to be done: sweeping out, cleaning up"—so we read in yet another of the founder's manifestoes. These dadaist manifestoes announce a totally nihilistic attitude, whether the issue is art in general ("the abolition of creation") or the art of the avant-garde itself ("the abolition of the future"). The second of these analogous formulas attacks the favorite myth not only of futurism but of the whole avant-garde.

Although many ex-dadaists protested against the history of the movement that Georges Ribémont-Dessaignes wrote for the *Nouvelle revue française*, he was certainly right in saying that "the action of dada was a revolt against art, morality, and society." This again demonstrates that, in the spirit of avant-garde art, ideology and psychology are quite as important as poetics and aesthetics. Even an unprejudiced observer like André Gide judged dadaism, which its supporters had called "a demolishing operation," to be "a negating operation": demolishing and negating extended to all human values, as we see from the title of one of the movement's organs, *Le Cannibal*.

Furthermore, avant-garde nihilism was not exhausted in dadaism. Just as it had at least in part inherited the tendency from futurism, so it passed it on in turn, almost intact, to surrealism. It is not necessary to point out that the latter survives, more or less endemically and latently, in the most recent avant-garde experiences. As proof, enough to cite a little review founded a few years ago by a group of young American expatriate writers, laconically and significantly entitled *Zero*. The ability of the nihilistic tendency to transform itself into a thousand disguises does not negate, but rather affirms, its continuity and permanence; it can be metamorphosed into skeptical and cynical negations, as sometimes happened with the surrealists, who more than once used the words of their leader André Breton to proclaim "the feeling of the theatrical and joyless

uselessness of all things." Naturally, the nihilistic attitude had its immediate and spontaneous aesthetic reflections, among them the *denigrating image* (to be discussed later), a form inspired by a genuine poetic nihilism, especially when dictated by an intent that goes beyond the merely technical factors of stylistic deformation.

However, it remains true that avant-garde nihilism is predominantly psychological or social in nature, though functioning in terms of cultural problems. In other words, we are dealing with a professional psychological deformation which is a function of particular sociological phenomena. Doubtless the nihilistic posture represents the point of extreme tension reached by antagonism toward the public and tradition; doubtless its true significance is a revolt of the modern artist against the spiritual and social ambience in which he is destined to be born and to grow and to die. The motivations for this revolt appear simultaneously under the different guises of reaction and escape: reaction against the modern debasement of art in mass culture and popular art; escape into a world very remote from that of the dominant cultural reality, from vulgar and common art, by dissolving art and culture into a new and paradoxical nirvana.

Only a few rare leftist critics, those who are not insensitive to the tragic pathos of contemporary culture, have been able fully to comprehend and feel this nihilistic dialectic of avant-gardism. Such is the British Marxist, Christopher Caudwell, as may be seen in a passage from his *Studies in a Dying Culture*, which is valid despite the severely condemnatory tone and the *parti pris* of the ideology inspiring it: "Thus bourgeois art disintegrates under the tension of two forces, both arising from the same feature of bourgeois culture. On the one hand there is production for the market—vulgarisation, commercialisation. On the other there is hypostatisation of the art work as the goal of the art process, and the relation between art work and individual as paramount. This necessarily leads to a dissolution of those social values which make the art in question a social relation, and therefore ultimately results in the art work's ceasing to be an art work and becoming a mere private phantasy . . .

And, in the sphere of art it produced the increasing individualism which, seen at its best in Shakespeare, was a positive value, but pushed to its limit finally spelt the complete breakdown of art in Surrealism, Dadaism and Steinism." But of this we shall speak at greater length when we study the connection between avant-garde art and the society from which it derives and which it opposes.

Agonism

Of unlimited importance is the moment of *agonism*, no doubt representing one of the most inclusive psychological tendencies in modern culture and deserving, therefore, a more ample discussion. But here it will be treated only as a function of avant-garde art where it manifests itself in some of the most typical forms of that art. The ideal meaning behind the word *agonism* is clearly joined to the Greek *agone* and *agonia* from which it derives, although it transcends the pure etymological meaning. If agonism meant no more than *agone*, it would be only a synonym for activism and would express only the modern cult of contest, sport, and game. If agonism meant no more than *agonia*, it would allude to that tragic sense of life so intensely felt by Pascal and Kierkegaard, Nietzsche and Dostoevsky, by all those whom Leone Sestov called the "philosphers of tragedy": the sense, that is, of what the existentialist movement in our day has popularized.

But what we mean here by agonism is more pathetic than tragic, is neither Christian nor Dionysian. Derived from the modern historical pathos, it represents the deepest psychological motivation not only behind the decadent movement, but also behind the general currents culminating in that particular movement and not exhausted by it, since they were destined to outlive decadence and reach back in time to romanticism itself. In these currents (and this seems at least an apparent difference from the decadent position), the agonistic attitude is not a passive state of mind, exclusively dominated by a sense of imminent catastrophe; on the contrary, it strives to

transform the catastrophe into a miracle. By acting, and through its very failure, it tends toward a result justifying and transcending itself.

Agonism means tension: the pathos of a Laocoön struggling in his ultimate spasm to make his own suffering immortal and fecund. In short, agonism means sacrifice and consecration: an hyperbolic passion, a bow bent toward the impossible, a paradoxical and positive form of spiritual defeatism. The most typical aesthetic symbol of this state of mind is precisely that attempted and failed masterpiece of the most extreme literary avant-gardism, the *Coup de dés* thrown by Mallarmé almost as an ultimate gesture of defiance at the instant of supreme tension.

Mario Praz, or others for him, justly rendered as the "romantic agony" the translation of his study of the cult of death, flesh, and the devil, among the most extreme and symptomatic themes of modern literature. The author intended, with that title, to demonstrate once again the continuity between the romantic and the avant-garde mentalities. Nothing better demonstrates the presence of an agonistic mentality in the avant-garde aesthetic consciousness than the frequency in modern poetry of what we shall call the *hyperbolic image* (to be discussed later). That the agonistic myth had been more or less obscurely divined by the contemporary critical consciousness is shown by the frequent concept of the artist as victim-hero. The agonistic tendency not only appears within the confines of aesthetic psychology or sociology; at times it expresses itself directly even in critical terminology. Enough to recall the frequent use of the concept of tension in New Criticism, not only antagonistically, in reference to the conflict supposed to occur between opposite polarities within a work of art, but also by way of a contrast between the work and the atmosphere in which it is produced, a contrast presupposing that the creative act occurs in a state of crisis.

Obviously, in an epoch like ours, dominated by an anxiety or an anguish alien to any metaphysical or mystical redemption, agonism must above all be conceived of as a sacrifice to the Moloch of historicism. Romanticism is, to a large extent, historicism, and his-

toricism means not only an enlarging and deepening of the historical vision of the world, or the capacity for comprehending the infinite metamorphoses of the Zeitgeist, but also an idolizing of history, the history not only of the past, but of the present and future, made into a divinity. This is precisely the transcendental function, or ideal mission, of avant-garde agonism—to be studied in the following section, as *futurism*, a term used as a common noun to indicate a general tendency rather than a determinate movement. Meanwhile, it will suffice here to define the agonistic variant of futurism as a self-sacrifice not to posthumous glory, but to the glory of posterity.

But this side, or that, of the agonistic sacrifice to the future (the avant-gardes were sufficiently conscious of this to name a movement for it), we ought to say also that avant-garde artists sometimes allowed themselves to be completely seduced by an agonism which was almost gratuitous, by a sense of sacrifice and a morbid taste for present suffering that was not conceived of as self-immolation on behalf of future generations. We can give testimony for this feeling from the realm of the lyric. It occurs in the verses from Apollinaire's *Calligrames*, used to introduce this book, in which the poet asks the men of the present for pity:

> *Pitié pour nous qui combattons toujours aux frontières*
> *De l'illimité et de l'avenir*
> *Pitié pour nos erreurs pitié pour nos péchés.*

But we can also give testimony from the critical realm to support the more general truth, using a passage where Massimo Bontempelli, after declaring that "the very spirit of avant-garde movements is that of the sacrifice and consecration of the self for those who come after," then concludes with an affirmation that even an excessively restricted chronology does not invalidate: "In practice, the avant-gardes of the first fifteen years of the century have in general submitted to the fate of military avant-gardes, from whom the image is taken: men destined for the slaughter so that after them others may stop to build."

Furthermore, this immolation of the self to the art of the future

must be understood not only as an anonymous and collective sacrifice, but also as the self-immolation of the isolated creative personality. Thus the agonistic sacrifice is felt as the fatal obligation of the individual artist, not only of the movement he leads or the historic current that sweeps him along. So Rimbaud in *Lettre du voyant* speaks of the perdition that destiny assigns to anyone wishing to be a new poet:

Qu'il crève dans son bondissement par les choses inouïes et innomables: viendront d'autres horribles travailleurs; ils commenceront par les horizons où l'autre s'est affaissé.

[*Let him croak with his jumping into unheard of and unnameable things: other horrible workers will come; they'll start from the horizons where he broke down.*]

Still in the ideologies of more recent avant-gardes, the agonistic sacrifice is conceived in terms of a collective group of men born and growing up at the same moment in history: in other words, as Gertrude Stein called a generation that ironically survived itself and a world war, a lost generation. But it is important to repeat that this destiny is often accepted not only as a historic fatalism but as a psychological one as well. So the agonistic tendency itself seems to represent the masochistic impulse in the avant-garde psychosis, just as the nihilistic seems to be the sadistic.

Futurism

Exactly by virtue of this paradoxical agonism, functioning almost as a positive defeatism, followers of the avant-garde in the arts act as if they were disposed to make dung heaps of themselves for the fertilizing of conquered lands, or mountains of corpses over which a new generation may in its turn scale the besieged fortress. A real and true *course au flambeau*, agonism then transforms itself into *futurism*, as Bontempelli well understood and showed us in the preceding section. As already observed, the futurist moment belongs to all the avant-gardes and not only to the one named for

it; to generalize the term is not in the least arbitrary, even in view of Ortega y Gasset's and Arnold Toynbee's use of it as a historic and philosophically generic term to designate eternal psychological tendencies belonging to all periods and all phases of culture.

Therefore, the so-named movement was only a significant symptom of a broader and deeper state of mind. Italian futurism had the great merit of fixing and expressing it, coining that most fortunate term as its own label. Indeed, precisely because the futurist moment is more or less present in all the avant-gardes, the best definitions are not those offered by actual and official futurism, which in any case sensed only its most superficial and external aspects; the best definitions come from witnesses outside the specific movement. One of these is, again, Bontempelli who, at the end of the passage cited earlier, furnishes, perhaps unwittingly and without wanting to, the definition we seek: "In sum, the avant-gardes had the function of creating the primitive or, better, primordial condition out of which is then born the creator found at the beginning of a new series." This means that in the psychology and ideology of avant-garde art, historically considered (from the viewpoint of what Hegelians and Marxists would call the historical dialectic), the futurist manifestation represents, so to speak, a prophetic and utopian phase, the arena of agitation and preparation for the announced revolution, if not the revolution itself. So evident and natural a political parallel could not escape Leon Trotsky, who in his book of literary theory and criticism defined the historical mission of Russian futurism as follows: "Futurism was the pre-vision of all that (the imminent social and political crises, the explosions and catastrophes of history to come) within the sphere of art."

We can then sum up the tendency in question by saying that the initiators and followers of an avant-garde movement were conscious of being the precursors of the art of the future. Hence derives the characteristic impatience of the contemporary soul which Umberto Saba clearly noted in one of his little books of aphorisms, thinking perhaps not only of our century but also of the Novecento movement named after it: "The twentieth century seems to have

one desire only, to get to the twenty-first as soon as possible." To understand the historical impatience of avant-gardism we need, first of all, to examine critically the agonistic component of the concept of the *precursor*.

The idea of the precursor, as commonly used, is an *a posteriori* concept. It involves a retrospective historical awareness which identifies men and ideas of a more or less remote past as seeming to have anticipated some philosophical or religious, ethical or political, cultural or artistic revelation belonging to the present or to the less remote past. In the rare moments when avant-garde art seeks to justify itself by the authority or arbitration of history, in any one of the partial and infrequent fits of humanism or traditionalism that now and again afflict it, even it deigns to look for its own patent of nobility in the chronicles of the past and to trace for itself a family tree of more or less authentic ancestors, more or less distant precursors.

Such a regression is particularly erroneous in the case we are studying here. In fact, even if for different reasons, there seems to be justice in the polemical claims of its followers and supporters that avant-garde art is an art of exception, exceptional not only in the present but also in the whole tradition. But in any case the regression is fallacious: historically it is clearly arbitrary, a patent spiritual anachronism, to believe in the objective existence of precursors, concrete and thus identifiable, for a given historical reality. In the face of such a pretension, only two alternatives are possible: either admit that everyone, as children of history and the past, has had precursors (excepting Adam) and that these precursors are no more and no less than the whole human race; or contrariwise deny that anyone has ever had any, insofar as each of us constitutes a *unicum* and an *individuum*, each enclosing within himself an irreducible and unmistakable historical and psychic personality.

The invalidity of the precursor concept, understood retrospectively, multiplies to infinity when considered in an inverse relation, as a function of the future, an anticipatory anachronism—which is exactly what the avant-garde in general, and the futurist moment in

particular, does do. How can we reasonably and consciously consider ourselves as the roots or seeds of a plant this side of creation, not yet existing in any solid historical terrain, of whose ability to strike roots, of whose growing power, we know nothing, ignorant even of its botanical species? If by this question, purely rhetorical as it is, we intend to deny value to the precursor as a concept, we must be careful not to discredit or undervalue its significance and scope as a myth. Its mythical character constitutes the efficacy and importance of this idea-force, rich in normative powers and formative virtues, as is any metaphysical or mystical belief.

Similar powers and virtues naturally adhere even in the first and most modest conception contained in the notion of the precursor, which in its totality and integrity could only have been formulated by self-complacent modernists, those thus ignorant of, or at least alienated from, the spirit of the ancients who—and how dearly—loved the opposite notion of the epigone (when that was, naturally, void of the excessively pejorative sense now attributed to the word). But the metaphysical and mystical intensity of the precursor myth grows in geometric proportion when the initial relationship is replaced (the present–past, operating in favor of the present contemporary age and the generation to which we belong) by an inverse relationship (present–future, where, following the dictates of the agonistic spirit, the current generation and the culture of our day become a subordinate function of the culture to come).

This attitude, in itself, makes up the integrating part of what might be called the historical mythology of contemporary art, and exercises particular influence in avant-garde psychology and ideology. Precisely therefore, it works directly, as an emotional leavening, on the mentality of the artist in our time, making him assume arbitrary and paradoxical positions in the face of his own work. Thus it is seldom expressed in critical theory, but often lyrically, as a poetic confession. This type, or way, of confession recurs in the prose of manifestoes, which often are fiction and literature rather than aesthetics and poetics. It recurs even more frequently in the works of

art themselves, as in these lines from Mayakovsky, significant also because they betray the hyperbolic ideal in a wholly mechanical and quantitative way:

> *Shakespeare and Byron possessed 80,000 words in all:*
> *The future genius-poet shall in every minute*
> *Possess 80,000,000,000 words, squared.*

As such a citation shows, the author seems to conceive of his own art and that of his generation as a preparatory phase, as the study for or prelude to a future revolution in the arts. The poetry of the future is furnished with an arsenal of verbal instruments which grows in geometric proportion, in contrast to the arithmetic proportions of the technical means presently available; an arsenal of future means whose quantity can be rendered only in astronomic ciphers or by virtue of a hyperbolic image.

The sense or consciousness of belonging to an intermediate stage, to a present already distinct from the past and to a future in potentiality which will be valid only when the future is actuality, all this explains the origin of the idea of transition, that agonistic concept par excellence, favorite myth of an apocalyptic and crisis-ridden era, a myth particularly dear to the most recent avant-gardes and, despite all appearances to the contrary, bound up with the futurist attitude. That the avant-garde spirit was conscious of what this concept leads to is proved by the fact that a literary review, written in English, brought out for years in Paris the work of expatriate and cosmopolitan writers; it commends itself greatly to us for having published fragments of *Finnegans Wake* when James Joyce's extreme experiment was still "work in progress." The founder and director of this review, Eugene Jolas, chose to entitle it, paradoxically with an initial minuscule, *transition.*

The idea of transition, as a variant of avant-garde futurism, clearly reveals its special function as an antithesis to the historical myth favored by the classicals ages, as so luminously formulated by Ortega in *The Revolt of the Masses:* the myth that consists of the illusory belief of each of those classical ages that it had attained to

the "fullness of time." Each classical age felt that it represented a summit, to which the recent past was only the way up and which the imminent future would be obliged to preserve if it wished to avoid what would otherwise be a fatal and infelicitous fall back to barbarism. By virtue of an analogous historical-mythical antithesis, that between classical and romantic, the antinomy between the classical and the transitional again recalls the problem of the avant-garde's relation to romanticism, and makes it necessary to examine that relationship from a futurist viewpoint.

To a superficial observer, the romantic idea of the Zeitgeist in fact appears almost as a modern variation of the myth of the fullness of time. But that myth is static, whereas the Zeitgeist myth is dynamic. The fundamental principle of the latter is that every age attains the fullness of its own time, not by being, but by becoming, not in terms of its own self but of its relative historical mission and hence of history as an absolute. This means that for moderns the consciousness of historical culmination, or the fullness of time, is at once granted or denied to each epoch, pertaining to none or to all. In the consciousness of a classical epoch, it is not the present that brings the past to a culmination, but the past that culminates in the present, and the present is in its turn understood as a new triumph of ancient and eternal values, as a return to the principles of the true and the just, as a restoration or rebirth of those principles. But for the moderns the present is valid only by virtue of the potentialities of the future, as the matrix of the future, insofar as it is the forge of history in continual metamorphosis, seen as a permanent spiritual revolution.

Here, again, we see the romantic spirit and the avant-garde spirit in contrast, as if to demonstrate that what we call the futurism of the avant-garde could not have been born without the romantic precedent of the Zeitgeist. The two myths are complementary: the "presentism" of the Zeitgeist stands to the futurism of contemporary art as romanticism does to avant-gardism. Furthermore, it was precisely by the term "presentism" that Wyndham Lewis defined the credo of the movement he founded and named "vorticism," by which he deceived himself into believing that he had surpassed Italian and

French futurism, as the dadaists also tried to do when they postulated the "abolition of the future." It may be that in so doing dadaism and vorticism overcame the historical and concrete futurism, but certainly not the typical and ideal one, what should be defined as the agonistic interpretation of the mission of the present. In any event, the image used by Wyndham Lewis *is* agonistic and nihilistic when, in his manifesto, he describes his movement as "the new vortex," which "plunges to the heart of the present."

A passage from Jung proves that the dialectic of the Zeitgeist was not exclusive to the romantic and avant-garde cultures, but easily extends to almost all the sectors of civilization in our time and infects even the philosophical and scientific exponents. One of Jung's passages reveals a clear awareness of the absolute modernity of the conception of the present as a matrix of the future, as well as the quasi-transcendental value that the idea, or image, of transition has assumed for us: "Today is a process of transition which separates itself from yesterday in order to go toward tomorrow. He who understands it, in this way, has the right to consider himself a modern." And in another passage the same author shows that he understands the connection between the nineteenth-century myth of limitless progress and the avant-garde's future-oriented utopias. He also perceives the antagonistic, antitraditional components, nihilistic and agonistic, in the futurist attitude: "The progressivist ideal is always rather abstract, unnatural, and immoral, inasmuch as it requires faithlessness to tradition. Progress won by will power is always a spasm."

Decadence

At this point we need another parenthesis. One may legitimately doubt that what the history of modern arts and letters knows as *decadence* is really an avant-garde movement while still recognizing its general kinship with romanticism. Actually, a retrospective awareness of its precursors is characteristic of the decadent mentality, and modern "decadences" do nothing but appeal to defunct

civilizations, to predecessor and ancient decadences: Alexandrian or Byzantine Hellenism; the Latin of the late empire, or Silver Latin; the Middle Ages, those most obscure, barbaric, and gothic centuries. On the other hand, a tendency to ignore the anticipatory and prospective side of the precursor concept seems to come just as naturally to the decadent termperament. It also ignores the antihistorical and presentist aspects of the avant-garde mind: the first is ignored because of its own vision of the past as an uninterrupted decaying; the second, because of its own concept of decadence as pure Zeitgeist.

In this regard it must be observed that the decadent spirit sometimes (though not always) shows itself hostile to contemporary civilization, and this might lead one to suppose a negative attitude on the part of the decadents toward the avant-garde's futurist impatience. Théophile Gautier shows that this is not always the case when he affirms, in his essay on Baudelaire, that the decadent spirit is in harmony with the crisis of contemporary civilization. Gautier's hypothesis, as well as the implied relation between decadence and futurism, would seem to be confirmed by the confrontation and contrast between a Russian and an Italian definition. The old Russian poet Vyacheslav Ivanov, in his debate with Mikhail Gershenzon on cultural destinies ("Correspondence from Opposite Corners"), defined decadence as "the feeling, at once oppressive and exalting, of being the last of a series." Bontempelli, at the end of the passage cited earlier, believes the mission and function of the avant-garde to be the opening of a new series, or at least the preparing of its way.

These two definitions represent two extremes and as such they touch, showing that decadence and avant-gardism are related, if not identical. The implicit distinction is a secondary one, limited to recognizing that, while the futurist mentality tremulously awaits an artistic palingenesis, preparing for its coming practically and mystically, the decadent mentality resigns itself to awaiting it passively, with anguished fatality and inert anxiety. Bontempelli considers the avant-garde's aim and ideal to be the establishing of a primitive or primordial condition which makes possible a grand future renascence. But in the decadent spirit one can also perceive

a profound and disturbed nostalgia for a new primitiveness: the wait with mixed fear and hope for the coming of a new "return to barbarism." Paul Verlaine had already sensed this sentimental and dialectic contrast when he closed his sonnet "Décadence" with the vision of a mob of "huge white barbarians" at the horizon of that sky over the sinking Roman Empire.

Fundamentally there is no great difference between the decadent's dream of a new infancy (dear to old age) and the futurist's dream of a new maturity or youth, of a more virginal and stronger world. Degeneration and immaturity equally aspire to transcend the self in a subsequent flourishing; thus the generations that feel themselves decrepit, like those that feel themselves adolescent, are both lost generations, par excellence. If agonistic tendencies triumph in avant-garde futurism, a passive agonism dominates the decadent mentality, the pure and simple sense of agony. Decadence means no more than a morbid complacency in feeling oneself passé: a sentiment that also, unconsciously, inspires the burnt offerings of the avant-garde to the cultural future.

The Zeitgeist which was for the romantics only one of the many metamorphoses of the genius of history, hence a dialectic and dramatic manifestation, became for the avant-garde a tragic and heroic manifestation; for the decadents, dionysian or pathetic. Nothing is more full of pathos than determinism or nihilism; hence, nothing more full of pathos than the anarchistic fatalism of the dadaists, who fundamentally represented only a return of decadence within recent avant-gardes. Thus Von Sydow's definition of decadence as a "culture of negation" seems especially suited to the dadaists. Yet one could say the same for futurism, in which the critic Piccone Stella, writing on the occasion of Marinetti's death, believed he saw "the last clanking patrol of European decadence" (perceived by others before him, beginning with Benedetto Croce and Francesco Flora). This explains why and how the most facile and frequent motif of hostile criticism is to accuse all avant-garde art of decadence, following a prejudice that leftists love as dearly as rightists do. But this

prejudice disqualifies itself by using the myth or concept antihistorically.

This too long digression can be justified as a complementary proof of the hypothesis that historical continuity exists between the romantic and the avant-garde Zeitgeists. In effect it establishes a supplementary connection between the paradoxical historicism of the decadent's love of the past and the no less paradoxical futurism of the avant-gardist. We advise anyone who has doubts on this score to think again of the concept of transition, which we have shown to be related to futurism and which itself reveals an affinity to decadence.

5. FASHION, TASTE, AND THE PUBLIC

Fashion, avant-garde, and stereotype

We have considered antagonism toward the public and agonistic sacrifice for the future's sake as abstract psychological categories, moments of a theoretical tension; only thus can they be taken as axioms. But in historical and day-to-day reality they function in a wholly empirical and relativist way: even the avant-garde has to live and work in the present, accept compromises and adjustments, reconcile itself with the official culture of the times, and collaborate with at least some part of the public. These adjustments and compromises, reconciliations and collaborations, are also reciprocal and are rendered necessary by the intervention of a powerful factor, fashion. We shall study that factor, first in itself; then in relation to the avant-garde spirit.

The chief characteristic of fashion is to impose and suddenly to accept as a new rule or norm what was, until a minute before, an exception or whim, then to abandon it again after it has become a commonplace, everybody's "thing." Fashion's task, in brief, is to maintain a continual process of standardization: putting a rarity or novelty into general and universal use, then passing on to another rarity or novelty when the first has ceased to be such. In the sphere

of art, we may express this phenomenon by saying that fashion tends to translate a new or strange form into acceptable and imitable forms and then to submit some other form to analogous metamorphoses and conversions as soon as the first has been made diffuse and common enough to have turned into what the French call *poncif* (stencil) and what we may anglicize as "stereotype."

According to Baudelaire's clever paradox, the chief task of genius is precisely to invent a stereotype. We do not have to be reminded that genius is an exquisitely romantic concept, but the modernity of the stereotype is worth emphasizing. The tacitly enunciated task of classic art was the splendid repetition of the eternal maxims of ancient wisdom; impossible, then, for it to conceive of the commonplace pejoratively. But since the triumph of the romantic cult of originality and novelty, the aesthetic equivalent of the commonplace has come to be more and more pejoratively considered. That is exactly why the stereotype is a wholly modern concept; by virtue of that modernity there exists, despite any contrary appearances, a connection between the avant-garde and stereotypes. Clement Greenberg in fact tried to establish the existence of such a connection in a *Partisan Review* article many years ago. He juxtaposed the concepts of avant-garde and of *kitsch* (the German synonym for the French *poncif*—if *poncif* or stereotype signifies the vulgarity of a theme, *kitsch* underlines the mediocrity or banality of a particular work of art). Greenberg established the connection on a level which was not purely critical or literary. As a leftist critic he maintained that avant-garde and kitsch were the cultural fruits, one as bad as the other, of a unique social, economic, and political situation; equivalent and parallel results, in the field of art, of the same stage of evolution or, better, the same phase of decadence in bourgeois and capitalistic society. We might sum up Greenberg's position, translating it into Spengler's language, by saying that the coinciding of avant-garde and kitsch shows that we are dealing with a Civilization now unable to produce a Kultur.

The validity of Greenberg's observation resides in his recognition that the two terms, kitsch and avant-garde, are antithetic in

appearance but correlative in substance. His error lies in treating the essence of that correlation in too generic a way: he conceives of it not only in the perspective of social history but also of cultural history, not only according to sociology but also according to the ideology and artistic psychology of avant-garde art. The terms *kitsch* and *stereotype* must then be studied in a specific historical dialectic, not in a generalized sociological one. We must use the comparative method without blurring the categories or comparing essentially dissimilar things. To understand these terms and their equivalents (French *cliché*, a synonym for *poncif*; Spanish *cursi* and American *corny*, adjectives corresponding to *kitsch*, to which the French *croûte* is also linked, though the latter is exclusive to the painter's jargon), we must first of all see whether the concepts they contain represent a phenomenon new to cultural history, and whether the aesthetic consciousness feels that they are new. This means we must prove our initial postulate: the modernity of the concept of kitsch and stereotype.

As noted, precisely because it undertook to perpetuate the commonplaces of traditional contents and forms (and was understood to do so), classical art was by definition unable to premise an aesthetic category upon commonness. Classical thinking on art admits of only a single negative category: the ugly. Unlike beauty, which is conceived of as unique and absolute, classicism contemplates the ugly as multiple and relative, in infinite variety and not only verbal variety either (the imperfect, the exaggerated, the disproportioned, the grotesque, the monstrous). Still these may all be reduced to the criterion of a formal error of commission or omission, of excess or deficiency. This means that the classical aesthetic, contrary to the modern, was in no position to admit into the category of the ugly those forms that might be said to have a not-new beauty, a familiar or well-known beauty, a beauty grown old, an overrepeated or common beauty: all synonyms that could serve to define kitsch or stereotype.

Only modern art, because it expresses the avant-garde as its own extreme or supreme moment, or simply because it is the child

of the romantic aesthetic of originality and novelty, can consider as the typical—and perhaps sole—form of the ugly what we might call *ci-devant* beauty, the beauty of the *ancien régime*, ex-beauty. Classical art, through the method of imitation and the practice of repetition, tends toward the ideal of renewing, in the sense of integration and perfection. But for modern art in general, and for avant-garde in particular, the only irremediable and absolute aesthetic error is a traditional artistic creation, an art that imitates and repeats itself. From the anxious modern longing for what Remy de Gourmont chose to call, suggestively, "le beau inédit" derives that sleepless and fevered experimentation which is one of the most characteristic manifestations of the avant-garde; its assiduous labor is an eternal web of Penelope, with the weave of its forms remade every day and unmade every night. Perhaps Ezra Pound intended to suggest both the necessity and the difficulty of such an undertaking when he once defined the beauty of art as "a brief gasp between one cliché and another."

The connection between the avant-garde and fashion is therefore evident: fashion too is a Penelope's web; fashion too passes through the phase of novelty and strangeness, surprise and scandal, before abandoning the new forms when they become cliché, kitsch, stereotype. Hence the profound truth of Baudelaire's paradox, which gives to genius the task of creating stereotypes. And from that follows, by the principle of contradiction inherent in the obsessive cult of genius in modern culture, that the avant-garde is condemned to conquer, through the influence of fashion, that very popularity it once disdained—and this is the beginning of its end. In fact, this *is* the inevitable, inexorable destiny of each movement: to rise up against the newly outstripped fashion of an old avant-garde and to die when a new fashion, movement, or avant-garde appears.

Such was the destiny of naturalism, legitimate child of the romanticism it opposed precisely when the romantic mentality had become current fashion, and it in turn suddenly disappeared after its own triumph, shoved off by pseudo-idealistic and mystic-mongering tendencies. Such also was the destiny of decadence, largely founded by deserters from that same naturalism, and it never re-

covered from the blow given it with the success of decadent taste by way of worldly aestheticism and the arts of costume and interior decoration, in a current variously known as *Sezession, art nouveau,* or *stile liberty.* Cubism and futurism have now become the stereotypes of the decorative and the applied arts, in stage design and home furnishings. Architectural functionalism is in the process of becoming the cliché of the building industry. The Italian Novecento died exactly when its name became a commercial slogan, given to furniture and bric-a-brac, often bloated, bizzare, and grotesque. Surrealism began to go under precisely when certain of its proceedings acquired the sanction of sensationalism in popular and commercial art. Even the avant-garde film, exemplified in such works as Cocteau's *Le Sang d'un poète,* sees its techniques copied and deformed by the dream makers of the various Cinecittà. We can truly say that from this viewpoint the whole history of avant-garde art seems reducible to an uninterrupted series of fads. Not for nothing did one of the most beautiful reviews of French symbolism choose to call itself *La Vogue.*

Fashion, then, is an important factor in what we might call the sociology of taste, where it operates, so to speak, as a demiurge. In the particular case of modern taste, it appears simultaneously as the great justifier, modifier, and denier of avant-garde art. In the art world it also exercises its function of arbiter of the emphemeral, regulator of the old and new, sublimator of caprice. Its nature is voluble and composite. There we have the reason fashion creates no style (even if the English do call *la mode* in decoration "style" as well as "fashion")—she creates instead "the stylish." And *stylization* is exactly what the Russians called their own *liberty* or *art nouveau,* that moment of eclectic aestheticism or vulgarized decadence. Avant-garde art, because at times its own creation is no more valid or enduring than a fashion, cannot but submit to the influence of fashion. In this way, even the hostile observer, insensitive to avant-garde art, can be in the right when he, like Huizinga, claims that modern art is "much more susceptible to fashion and mechanization than science is."

This susceptibility, in fact, does not prevent the avant-garde's

task from being, at least in intention, to transcend fashion and to win for itself, beyond the centuries-old fashion that is classicism, the sanction of its own classics. Sometimes that aspiration is attained. To take an example that will not stir up protest, it is enough to cite the case of Cézanne. Now this means, granting that it cannot and should not aspire to the academy, that the avant-garde can and should aspire to the tradition: a tradition conceived of not statically but dynamically, as a value constantly evolving and being formed. A so-conceived tradition is modified by the appearance of each new masterpiece, each valid work: an antitraditional tradition, then, a marvelous combination of avant-garde ingenuity and classical temperament. So paradoxical, and so just, a tradition was formulated by T. S. Eliot. We shall discuss it again in the section on criticism.

Intelligentsia and elite

So far we have studied the fashion and avant-garde connection abstractly and generally. Now we ought to point out the practical action which fashion performs in the sphere of contemporary art and letters. The viewpoint is now the spectator's rather than the actor's: those spectators who do go to see, of course, not those who stay away. In short, we now study, always in terms of the fashion principle, the relation between the avant-garde and one part of the public, the part composed of its faithful followers and devoted supporters.

Whoever knows the habitués of the artistic and cultural manifestations in our day (visitors and frequenters of galleries, aficionados of plays and concerts of "the exceptional," readers of catalogues and pamphlets, commentators on the manifestoes and programs, bookshelf bibliophiles and browsers of uncut pages, subscribers to limited editions and those who have little magazines mailed to them) knows very well that aside from the scanty handful of those who understand, who approve or disapprove on reasonable grounds case by case, we have two other types of public. One is the group made up of those for whom the valid fashion, in poetry, painting, sculpture, architecture, or theater, is the fashion of one single movement, or

of a few movements forming a single series; for them any manifestation alien to that movement, or that series, is not avant-garde art, is not art at all. The other is the group formed by those individuals who consider the fashions of the various avant-gardes as a whole; to them, diverse movements are no more than parts and they thus accept every variation of modernism with the same undifferentiated and immoderate enthusiasm, without exception or reservation. On one hand, an indiscriminate passion for the avant-garde (like that others feel for tradition and the academy); on the other hand, an exclusive passion for a movement or a particular type of avant-garde (like that some feel for a particular tradition or academy). The same alternatives recur in that vice or social passion called snobbism, as they do in home decoration, where some stay faithful to the fashion of their youth throughout their life and some instead adopt, one after another, all the fashions of the generations following their own. Two attitudes at once analogous and diverse, but both coming from the empire of fashion.

In like manner the avant-garde goes on acquiring its public and losing it; precisely the concept of fashion enables us to comprehend by what indirect way, through a negative connection, that public is formed and what strata and materials go into its composition. Once again our customary historical parallels help. The public for art and letters was never, up to the threshold of the romantic epoch, a class but was a special elite, which could only be formed or recruited within a given class, furnished by the most intelligent and educated elements of the ruling order or dominant social group (whether or not an aristocracy in the strict sense). The idea that, in exceptional cultures or in particularly splendid epochs, the public of amateurs and connoisseurs almost wholly coincided with the entire *polis*—Athens, Florence, or Paris—is a romantic and romanticizing illusion; even in those cases the elect public was only a minority, a more or less large part of the *demos*, that is, the citizenry in political power at Athens; the members of the Arti, those artisans or the merchant order in Florence; the court or the enlightened bourgeoisie in Paris.

In these cases we are not so much dealing with a public-class as

with a public from a class (the word used in a purely descriptive way, not as a value judgment as both leftist or rightist critics do, one with a negative and the other with a positive intent). Later, revolution and democracy, in destroying the old social elite, destroyed the intellectual elite deriving from it: no social group was then in any position to express an example of itself as *arbiter elegantiarum* (otherwise known as the *cortigiano*, gentleman, or *honnête homme*) in the sphere of art and culture.

In compensation, revolution and democracy, from Rousseau onward, enormously increased from a quantitative viewpoint, multiplied almost to infinity, the public (without a qualifying adjective); later instruments and institutions, such as obligatory education and the press or ideologies such as populism and socialism, added to this increase. At the same time, as is natural, a new intellectual elite was being formed, but one formed so as to lose any direct connection with the class concept. The old-style amateur and connoisseur had belonged to the dominant class or was admitted to it precisely because he was able, even if coming from the lower orders, to understand the criteria and tastes of that class, able to share its values. But the modern aficionado of art and culture, even though for the most part stemming from the petty or middle bourgeoisie, can belong or not belong to any class whatsoever, landed aristocracy or industrial bourgeoisie, professionals or bureaucrats, and in socially advanced countries even the proletariat or farmers.

Alexander Herzen had a sharp and clear feeling for an analogous phenomenon, which reached particularly intense forms in tsarist Russia. There the aristocracy, even though within itself it generated an intellectual elite that was at times refined and cultivated, remained as a whole semicultivated, semibarbaric; there never was a real and genuine bourgeoisie. Hence there sprang up an intellectual order from the lower ranks, or created by those who were rejected by other classes: an intellectual order whose function, however, was not so much cultural as political, operating not as an elite but as a party. To designate this order, Herzen coined the term "intelligentsia," which was not transcribed in accordance with the phonetic trans-

literation of Russian orthography but was taken back to the form of the original Latin word, used in a way very new and strange.

Arnold Toynbee chose to give the term excogitated by Herzen the arbitrary meaning of an intellectual bureaucracy coming up from below in a backward country, its chief aim to make possible the modernization or technological evolution of that country, moving it toward the material and external forms of more efficient and progressive foreign cultures. This can explain, for example, the westernizing of Russia or the anglicizing of India. Toynbee fails to see that his concept of the intelligentsia does not designate a regular or general phenomenon in the hypothesized conditions: no class of this type has, for example, appeared in the westernizing process of Japan. Besides, this is not the normal meaning of the word in England and America, perhaps the only regions in Western culture where it has taken root, where in general it signifies not a class or order, but the professional category of intellectuals, in particular (what justifies our digression here) that ambience of letters and culture which furnishes not only the actors in but also the spectators of avant-garde art.

In Russia the term *intelligentsia*, without becoming a class distinction, has remained a social one; the exact translation for it would perhaps be "those who labor with the intellect," or "the cultural proletariat." In fact, in Latin countries its corresponding term is just that, "the intellectual proletariat." But these intellectuals are not so much proletarian as proletarianizing. In other words, they may become ideologically and politically bound to the mass of workers and peasants, but they are not, at bottom, an order economically bound to the interests of those masses. A member of the intelligentsia is not born but made; to become a member of the intelligentsia means proletarianizing. The radical critic Mikhailovsky, precisely because he could not determine a socioeconomic origin by which to explain the motives and personality of Dostoevsky (according to the dictates of Russian sociological criticism), was obliged to adopt the term *raznochinets,* which means not belonging to a definite order or to any social strata identifiable with the people, the bourgeoisie, or the aristocracy.

We shall later see that the term *intelligentsia* cannot describe the avant-garde public, but it doubtless can designate a certain type of public, one essentially identified as a vague, professional category. In fact, whereas in the West the term means primarily the professionals of culture, in Russia and other Slavic or Communist countries it now means just plain professionals, children and families included: not only the man of letters and the artist, teacher, and scholar, the scientist and man of the cloth, the journalist and social worker, but also the engineer and technician, the lawyer and doctor, the veterinarian and midwife, the accountant and surveyor. Added to the classification, in reference to the opposing capitalist world, is the notion that the imbalance between cultural condition and economic situation dooms the intelligentsia to serve a society which aims to make serfs of it.

It seems more just to hold to this Russian interpretation of the concept, wholly social and not at all cultural, and thus not to confuse the intelligentsia with the intellectual elite. But even more important for the present argument is to reject the idea that the public for avant-garde art is furnished by the intelligentsia as such. The avant-garde public is not socially but intellectually and psychologically determined; its reasons, true or false, are reasons of the intellect and the intelligentsia has no monopoly on that, exactly because the intelligentsia is never entirely the same thing as the intellectual elite. Arthur Koestler, in one of the essays in *The Yogi and the Commissar*, even while maintaining that it is an "'aspiration towards independent thinking' which provides the only valid group-characteristic of the intelligentsia," promptly adds: "Intelligence alone is neither a necessary nor a sufficient qualification for a member of the intelligentsia." This testimony is all the more significant considering the past and character of the witness.

If a relation between intelligentsia and avant-garde does exist, it cannot be on the level of their reciprocal ties to their own society. Doubtless there is a rapport between art and society, in our case, between the avant-garde and the bourgeoisie; precisely because of this rapport, the avant-garde's antibourgeois position becomes

merely an illusion or a pose. But it would be wrong to see the intransigence and opposition of the avant-garde to the cultural and aesthetic idols of society or the bourgeoisie as a pose or an illusion. The complex dialectic of such relations will be the particular object of study in the following chapter, where we shall look at the concept of alienation. No doubt the intelligentsia can also find itself alienated from its own society (which may be other than the bourgeoisie); but the alienation of the intelligentsia cannot be translated into a specifically cultural conflict. It can be, however, in the case of the avant-garde, whose alienation is a symptom not only of a general crisis, but also of a specific one. The latter is its true raison d'être and constitutes its very nature. Precisely therefore the avant-garde is too readily inclined to see its own particular crisis in more grandiose historical proportions, even in universal dimensions. From this derive infinite contradictions and ambiguities without number; some of these ambiguities and contradictions, or errors of proportion, we wish to correct, resolve, and explain in this chapter. In this section the particular point is to dissipate the equivocation contained in joining the concept of the avant-garde to that of the social intelligentsia, and then extending the concept of alienation (a purely cultural category) to the intelligentsia.

If it is the task of the next chapter to establish the existence of a connection between the avant-garde and its authentic public, in later chapters we shall seek to resolve a series of similar misunderstandings, such as those based on the presumed parallelism between cultural radicalism and political radicalism, on the supposed analogy between artistic and social revolution.

The intellectual elite

No group is further away from conceiving of culture in a pure and disinterested way than the intelligentsia, whereas such a concept seems proper to, and innate in, the intellectual elite. The latter, not the former, furnishes the public for avant-garde art. But the intellectual elite has in common with the intelligentsia the circum-

stance of being formed outside class distinctions. Sometimes the intelligentsia is conceived of as a class, but always as a class created on the margin of, or over, the other classes; hence the mixed feeling of sympathy and disdain, indulgence and rancor, with which radicals and conservatives look on at it from opposite sides. In reality, when an individual elevates himself to the level of the intellectual elite and to the condition of the intelligentsia, he does not enter into a new class—he simply leaves an old one. Both groups are without a uniform social base, both a species of bohemia. For this reason it is often believed that the intelligentsia is the avant-garde public, rather than the intellectual elite.

For the student of history, it is not a new fact that the intelligentsia has always been either traditional in point of taste (the Russian radicals, from Belinsky and Lenin on down, have remained ever faithful to Pushkin and the classics) or nihilistic when it comes to aesthetic speculation or literary-artistic practice (as the history of the Russian intelligentsia shows, from Pisarev to Mikhailovsky). Now this means that it has always denied, in a more or less direct and absolute way, the autonomy—even the raison d'être—of art. When the intelligentsia turns its attention, or renders homage, to a work of art, it almost always functions in terms of ideological adhesion, that is to say, it attaches itself to content. It tends, in general, to deny any creation in which the purely aesthetic principle seems to dominate, or the drive for novelty of style and form. Besides, in the actual life of the intelligentsia, as Koestler well noted, there is a process of steadily increasing detachment from the revolutionary attitude even in the social and political field; it is always passing arms and baggage into the service of the secular power, the state, which then recruits its doctrinary bureaucrats from the intelligentsia and assigns them the task of formulating, and propagandizing, the state ideology.

How, then, does that intellectual elite forming the avant-garde public come to be made up? Let it not seem an evasion of the problem if we seek to resolve it with an image, if we say that the elite comes to be formed in a way analogous to that chemical phenomenon which

Goethe used as a psychic metaphor and which was once called "elective affinity." The formation of groups friendly and hostile to avant-garde art takes place by sympathy and antipathy. This truth did not escape the vigilant attention and exquisite sensitivity of Ortega y Gasset: "It seems to me, the characteristic of new art from a social viewpoint consists of dividing the public into two classes of men: those who understand it and those who do not." The same observation had also been made by Leo Tolstoy apropos of a masterwork of romantic art: "The Ninth Symphony does not unite all mankind but only a small group, which it separates from the rest."

Tolstoy was preoccupied with the moral effects of this division. Ortega, on the other hand, thinks only of its intellectual causes. What counts is that, in the one case as in the other, we are dealing with categories of individuals, not social classes. What matters is naturally Ortega's point of view, which was also Paul Valéry's in the words he once addressed to his own master and to which he himself refers in the prose piece beginning, "I said sometimes to Mallarmé." Here is what the disciple is supposed to have said: "I said sometimes to Mallarmé: 'There are some who blame you, and some who despise you. It has become an easy thing for the reporters to amuse the people at your expense, while your friends shake their heads . . . But do you not know, do you not feel, that there is, in every city of France, a youth who would let himself be cut into pieces for your verses and for you? You are his pride, his craft, his vice. He cuts himself off from everyone by his love of, faith in, your work, hard to find, to understand and to defend.'"

This is an extraordinarily important text, especially because it graphically highlights the way in which the public for a work or an art "of exception" is formed: almost by spontaneous generation, by means of single and independent joinings of isolated individuals, a group emerges that is not easily determined geographically or socially, individuals who end up finding, in the object of their own enthusiasm, reasons for community as well as for separation. But the importance of the passage must also be seen in its recognition of the almost sacred character that the object of its cult takes on for

all the *appassionati* of avant-garde art. One may perhaps doubt that this fanatic devotion for the poetry and person of Mallarmé, shown with such immutable faith by a group of young followers, is a new fact in the history of art and letters. But this kind of devotion is newer than new.

The traditional author-reader relationship between the artist and the connoisseur or amateur, was often identical to that between hierophant and neophyte: both were equally opposed to the world of the profane and uninitiated. Then it was a static and negative relationship, based on the distinction between a rare and occult knowledge and an open and general ignorance. But the new relationship, indicated by Valéry, substitutes for the ancient distinction a dramatic and dynamic rapport of antagonistic tension, not between knowledge and ignorance but between the culture of the herd and the culture of the isolates, between those who despise and those who prize a previously unknown value. The effect of an avant-garde creation, in this case the poetic work of Mallarmé, is thus to distinguish the public along the lines of Ortega's formula, not dividing those who know from those who do not know, but those who "get it" from those who do not. And as Valéry suggests, the public that understands is not formed within a socially or intellectually privileged order, the unique repository of knowledge and taste, but away from any center, an almost unforeseeable diaspora of isolated intelligences.

We shall put off the study of this crystallization of the avant-garde's public through sympathy and antipathy until the chapter on criticism, where it also touches upon other problems, obscurity, for example. Here we shall only say that the formula of crystallization through sympathy can serve to sum up and redefine the examination of the relations between the avant-garde and its public and between the avant-garde and fashion. The principle implied by this formula suffices to put precise limits on the influence of fashion, which is never in a position to determine the original adherence, even though it does operate as the external cement for that adherence. In this cementing together lies the authentic action of fashion, whose moving spirit in any case is that snobbism which is

nothing but the fanaticism of the frivolous: no doubt the avant-garde too has its snobs and bluestockings. Fashion and the avant-garde, precisely through this fanaticism, exercise an equal pressure on their own faithful. And such fanaticism sometimes becomes a real and true spiritual terrorism, acting as the sectarian spirit does or, in the jargon of art, as the spirit of the *chapelle* and *coterie*.

Furthermore, as Lionel Trilling puts it: "The word coterie should not frighten us too much . . . the coterie can corrupt as surely, and sometimes as quickly, as the big advertising appropriation. But the smallness of the coterie does not limit the 'human' quality of the work." This means that even fashion is not wholly a negative factor. But it does have an important, if not decisive, importance in the matter of avant-garde fatigue. Cocteau's "recall to order" and the return to the fold of a Soffici or a Papini are often made possible, if not actually motivated, by the influence and intervention of a new fashion. The action and limits of fashion can be briefly summed up by saying that it has power and force enough to make the avant-garde spirit change, as well as to make it fade away, but not enough to make it flower. Thus we reaffirm that it does not touch the initial act of faith, that elective affinity which is a condition and is not conditioned. Admirers and followers of avant-garde art can come into being or cease being only when, at least potentially, they are born to it. And that, once again, shows that this circle of admirers and followers does not coincide with the intelligentsia.

The avant-garde, then, is originally a fact of individual culture: it becomes group culture, as that term was provisionally defined at the start of this examination, only insofar as it is fatally led to transform itself by self-proselytizing. That fact was acutely noted by T. S. Eliot in one of his most felicitous diagnoses, when he describes culture as being limited to the ambiance of a group, not necessarily identical with any class but a group cut off from any organic relation with society as a whole, and finally being extinguished. This is indubitably the fate inherent in every movement of the avant-garde, but the avant-garde in general seems to survive its own funeral pyre and to be reborn from its ashes, phoenix-like. The alternation of

these two phases will continue so long as the civilization of which we are a part is not overthrown, and with it its own culture, by a radical revolution.

The avant-garde and politics

The problem of the relations of avant-garde and fashion, its public, the intelligentsia, of its artistic and its cultural destiny, leads naturally to a study of the relation between the avant-garde and politics. Many critics establish this relationship in such a way that the political term is the condition, and the artistic-cultural the conditioned. There is no doubt that a certain political situation can exercise a given influence on art in general, on avant-garde art in particular. All the same, that influence is almost exclusively negative: a regime or society can easily destroy the cultural or artistic condition which it cannot, of itself, bring to life. For example, it is easy to see that the support fascism originally gave to futurism (which was almost dead as an avant-garde anyway) was hesitant, Platonic, and short-lived. Certainly that support was noticeably less than the support given the movement when it denied its own heritage and turned into an academy; infinitely less efficacious than the disfavor with which that regime had to ward off any other avant-garde movement. Nazism did not tolerate, indeed it succeeded in abolishing, what is sometimes called "Jewish art," sometimes "degenerate art" (without recalling that it was a Jew, Max Nordau, who transferred the concept from medical pathology to the sphere of art). The same thing happened in Soviet Russia, where Lenin, as against Trotsky, always showed an unreserved antipathy to extremism in art, where avant-gardism died with the suicide of Esenin and was buried with the suicide of Mayakovsky. Everyone knows how difficult were the life and work of the one Russian artist of our own day who was not part of the crowd or an epigone, the great poet Boris Pasternak.

These examples are significant in terms of the rapport between avant-gardism and the capitalist bourgeoisie; this we shall study in

the following chapter, though in practical and social terms rather than ideological or political. Here the connection to be established is, instead, that between the avant-garde and democracy. This means that the avant-garde, like any culture, can only flower in a climate where political liberty triumphs, even if it often assumes an hostile pose toward democratic and liberal society. Avant-garde art is by its nature incapable of surviving not only the persecution, but even the protection or the official patronage of a totalitarian state and a collective society, whereas the hostility of public opinion can be useful to it. Having admitted this, we must deny the hypothesis that the relation between avant-garde art (or art generally) and politics can be established *a priori*. Such a connection can only be determined *a posteriori*, from the viewpoint of the avant-garde's own political opinions and convictions. These, under a persecuting regime, are often merely a necessary and opportunistic affair; they are almost always questions of genuine sentiment in libertarian regimes, even if the sentiment frequently boils down to mere wishful thinking or caprice. Furthermore, it is in the sphere of political opinion that the avant-garde more often accepts, or submits to, a fashion instead of creating or imposing one. Precisely on this account, the hypothesis (really only an analogy or a symbol) that aesthetic radicalism and social radicalism, revolutionaries in art and revolutionaries in politics, are allied, which empirically seems valid, is theoretically and historically erroneous. This is further demonstrated, to some extent at least, by the relation between futurism and fascism, or again by the prevalence of reactionary opinions within so many avant-garde movements at the end of the last and the beginning of the present century.

At issue, if anything, is not so much an alliance as a coincidence, which furthermore could naturally have worked in an opposite ideological direction. From the start, Italian futurism was also nationalism, as was all the culture of the young generation in that epoch; the fascism of the epigones of that movement was mere opportunism. The same thing happened in the ultimate phase of Russian futurism, which at its beginning was subversive and radical in

politics, on the extreme left as the Italian movement was on the extreme right. Such coincidences and analogues of a spiritual kind also determined the communism of the surrealists. But the predominantly political phase of surrealism did not last long, as may be seen from the brief life of the review *Le Surréalisme et la révolution*. If there were among the followers of the movement some like Aragon who abandoned surrealism for communism, there were others who resolved the dissension by abandoning communism and remaining faithful to surrealism. We must not forget that Italian futurists and French surrealists embraced fascism and communism, respectively, at least partly out of love of adventure, or by attraction to the nihilistic elements contained within those political tendencies. In fact, every avant-garde movement, in one of its phases at least, aspires to realize what the dadaists called "the demolition job," an ideal of the *tabula rasa* which spilled over from the individual and artistic level to that of the collective life. *There* is the reason why the coinciding of the ideology of a given avant-garde movement and a given political party is only fleeting and contingent. Only in the case of those avant-gardes flowering in a climate of continuous agitation, as, for example, modern Mexican painting (which one might hesitate to call avant-garde without reservation), does such a coinciding seem to make itself permanent.

In other words, the identification of artistic revolution with the social revolution is now no more than purely rhetorical, an empty commonplace (as seen at the start of this essay). Sometimes it may, though ephemeral, be sincere, a sentimental illusion, as in the case of Blok proclaiming that the new art ought to express "the music of the revolution," as he himself had attempted to do in *The Twelve*. But more often we are dealing with an extremist pose or fashion, as in the case of Mayakovsky's declaring himself "on the left of the 'Left Front'" in order to oppose the group and the review so named. The equivocal survival of the myth of a parallel artistic and political revolution has also been favored by the modern concept of culture as spiritual civil war: hence Mayakovsky's postulate that the pen should be put on equal footing with the sword. Besides, from such

concepts derive all those terms, often hostile, which aim to delineate the typical psyche of the modern artist, his position and attitude of disdain: rebel and revolutionary, outcast and outlaw, bohemian and *déraciné*, expatriate and émigré, fugitive or *poète maudit*, and (why not?) beatnik. It is significant that these pseudo-definitions are used indiscriminately by rightist *and* leftist criticism. It is no less suggestive that the same pseudo-definitions come to be applied, especially in rightist work, to the intelligentsia too; here we must notice that the seriousness and sincerity of the avant-garde's political orientation is in direct proportion to a given group's personal involvement in a genuine intellectual elite. That does not mean that the orientation cannot be of merely marginal and collateral importance—hence the difficulty or impossibility of labeling as avant-garde movements those cultural currents which are purely ideological or idea-oriented (unconcerned with form), such currents as the French called *unanimisme* and *populisme.*

Actually, as the above terms demonstrate, the only omnipresent or recurring political ideology within the avant-garde is the least political or the most antipolitical of all: libertarianism and anarchism. These we see in the very beginnings of the American left-wing literary avant-garde, and in the revivals of more recent times after the disillusionment of communist or Trotskyite sympathies. The individualistic moment is never absent from avant-gardism, even though it does not destroy the group or sectarian psychology. Sometimes conscious, it produces in such cases the egocentricity and doctrinaire egotism of certain works, organs, or groups. Enough to recall the titles of reviews like *The Egoist*, the names of movements like the Russian Severyanin's egofuturism, the personalism dear to the English cenacle of poets under Henry Treece's leadership, the work called *I* by the poet who dedicated the tragedy *Vladimir Mayakovsky* to himself. Sometimes such individualism is only biographical and psychological, which explains the D'Annunzianism of Marinetti, for example, only an avant-garde caricature of D'Annunzianism properly so called. Sometimes political orthodoxy forces this sentiment to express itself in spurious forms, syncretic and mixed up,

as in the Mayakovsky poem, "To a Cut-Throat," where the poet's personal pride, his certainty that he will personally survive beyond death even into the distant future, fuses with the cult of the anonymous multitude, the future masses.

It is precisely as a function of this theoretical and practical individualism that the recent movement of existentialism shows itself to be avant-garde, even though it appeals to ancient and eternal cultural sources and demonstrates a relative indifference to revolutions in the field of form and technique. From the literary viewpoint its immediate precedent is naturalism; from the ideological viewpoint, expressionism. More mystical than the first, more philosophical than the second, existentialism reveals its avant-garde character precisely through its agonistic and nihilistic tendencies, and by its own awareness of how difficult it is for individualistic and anarchistic nostalgia to coexist or survive within the collectivism of modern life.

This difficulty derives from what we might call the untimeliness of anarchistic ideology within contemporary civilization: untimeliness, often felicitously emphasized by leftist critics, who have also best sensed the connection between "culture" and "anarchy" in our time (to transform the meaning of Matthew Arnold's terms). Perhaps this is why Christopher Caudwell defines the surrealist, that is, the avant-garde artist most preoccupied with the ego, as the "ultimate bourgeois revolutionary." After the rhetorical question, "And what is the ultimate bourgeois revolutionary in political terms?" he answers lapidarily, "an anarchist." From this untimeliness, which we shall later call *historical alienation* and which at least apparently contradicts the cult of the Zeitgeist, we may derive the conclusion that Sartre, surely a leftist in philosophy as in art, has already reached: the avant-garde unconsciously functions in a reactionary way. Analogously, and conversely, we might with equal facility deduce that the reactionary ideologists to be met often enough in certain zones of avant-gardism are nothing but anarchists, without knowing it. But the problem of the avant-garde's historical function, as much metaculturally as metapolitically, would call for a too lengthy dis-

cussion. Apropos of this, and in the limits of this essay, our only remaining task is the sufficiently modest one of resolving some of the contradictions that seem to derive from the link between culture and anarchy.

We recognize that the avant-garde more often consciously adheres to, and superficially sympathizes with, leftist ideologies; we affirm that the anarchistic ideal is congenial to avant-garde psychology. But neither one nor the other serves to deny what was said above concerning the eminently aristocratic nature of avant-gardism —a nature not, in turn, belied by its displays of the plebeian spirit. Thus the withdrawals into individual solitude or into a circle of the few elect, into the quasi-ritualist posture of aristocratic protest, are, like the gestures of plebeian, anarchistic, and terroristic revolt, equally owing to the tortured awareness of the artist's situation in modern society—a situation we shall describe later as *alienation*. In the same way, the prevalence of the anarchistic mentality does not contradict the preceding claim that the communist experiment continues to exercise a particular fascination for the avant-garde mind, even though this experiment is, par excellence, totalitarian and antilibertarian, hostile to any individual exception or idiosyncracy. Besides, as Caudwell succeeded in proving by means of an examination of the reason behind the adherence of many English poets in his generation to communism, the attraction the Church of Moscow exercises for so many artists, writers, and intellectuals is due precisely to the ambivalence of an unwittingly anarchistic mentality: on one hand, the desire to see realized, in the historical and social dimensions of the present, a destructive impulse; on the other hand, the opposite desire, by which that destruction serves future construction. In other words, this adherence is owed to the extension of antagonistic and nihilistic tendencies into the political field, these tendencies being turned against the whole of bourgeois society rather than against culture alone. In the same way, the activist impulse leads the artist, writer, and intellectual of the avant-garde to militate in a party of action and agitation, while the agonistic and futurist impulses induce him to accept the idea of sacrificing his own person,

his own movement, and his own mission to the social palingenesis of the future. In other words, avant-garde communism is the fruit of an eschatological state of mind, simultaneously messianic and apocalyptic, a thing compatible, psychologically if not ideologically, with the anarchistic spirit. The force of these impulses and the attraction of that fascination are capable of producing a morbid condition of mystical ecstasy, which prevents the avant-garde artist from realizing that he would have neither the reason nor the chance to exist in a communist society. That mystical urge prevents self-criticism and self-knowledge. Only a few of those avant-garde artists who, deluded by Moscow, embraced the Trotskyite doctrine of permanent revolution have taken into account that their new, or old, adherence to more or less orthodox socialist ideals was motivated by an obscure anarchistic sentiment, rather than by clear Marxist thinking.

Be that as it may, it remains always true that, while ideological sympathies of a fascist nature seem to negate the avant-garde spirit— or to prevent its growing and developing in any social or political ambience at all—communist sympathies can favor it, or at least not hurt it, only within a bourgeois and capitalist society. Adherence to communist ideology does not impede Picasso from freely realizing, with the enthusiastic approbation of a select public, his needs as a creator and innovator: still it is not enough to justify him as an artist in the eyes of that Soviet society to which avant-garde art is anathema, a society that forbids the showing in its own public galleries of those works by the young Picasso which are now state-owned, far-sighted acquisitions of certain collectors of the *ancien régime*. A totalitarian order opposes avant-garde art not only by official and concrete acts, for example preventing the import of foreign products of that art or the exhibition of a rare or accidental indigenous product, but also by, first of all, creating, almost unwillingly, a cultural and spiritual atmosphere which makes the flowering of that art, even when restricted to marginal and private forms, unthinkable even more than materially impossible. When Fascism and Nazism fell, no avant-garde work created in secret and silence, through the years when the spiritual life of two great European nations was suffocated

by the tyranny and oppression of those two regimes, came to light. From now on we cannot believe that other masterpieces exist, unless perhaps those once visible and misunderstood. It has been said that every manuscript is a letter in a bottle, but that only means its fate is entrusted to time and fortune. Actually, in the modern world we cannot help doubting the existence of manuscripts closed in chests, paintings hidden in attics, statues stashed away in kitchens. This negative truth, at least as far as avant-garde art is concerned, is even more absolute in the case of Soviet Russia than it was in Fascist Italy or Nazi Germany.

What characterizes a totalitarian state is, in fact, an almost natural incapacity to permit evasions, or to admit exceptions; it is not paradoxical to maintain that in Russia today, the Russia of the "thaw," artistic conformity is even more mandatory than moral conformity, perhaps even more than ideological. Aesthetic and formal transgression is certainly more arduous there, if not more hazardous, than political or ethical transgression. The reality of this state of affairs was fully proved in the exemplary case of *Doctor Zhivago*. With that novel, Boris Pasternak, who until recently, especially as a poet, was the last avant-garde artist surviving in Soviet Russia, returned to traditional literary and artistic forms, even prerevolutionary ones, to express a conscientious objection which was not that of an artist but of a man. The only country beyond the curtain where residues of aesthetic protest are still displayed is Poland, precisely because that "people's democracy," more than any other, has been constrained to accept compromises with the national and religious spirit. If avant-garde art is not yet totally dead in Poland, this is solely because there culture, at least to some extent, is affected by that pluralism which distinguishes the modern culture of the bourgeois world—a pluralism that suffices to make the new order less totalitarian and monolithic.

6. THE STATE OF ALIENATION

Art and society

Much more important than any ideological and psychological connection between avant-garde art and its various political orientations (conscious or unconscious connections, but always individual) is the natural and organic connection joining that art by a complex series of bonds to the society within which it succeeds in working, even if by opposition, and which it partly expresses even while denying it. We have in passing already alluded to one such bond, when we observed that avant-garde art can flourish only under a liberal regime. Before speaking of other forms and aspects of this relationship, we must first clear up a point that may appear obscure to the reader. The obscurity involved stems from the fact that the theoretical problems of the relation of art and society (or as Madame de Staël would have put it, of "literature" and "institutions") are obfuscated by a series of arbitrary generalizations, not very valid in any case and wholly inapplicable to the present exceptional situation, a situation, despite contrary opinion, not only rare but unique in the history of culture.

According to the most frequently encountered of these generalizations, great flowerings of art or bold and innovative aesthetic

experimentations have occurred within authoritarian societies, in the womb of civilizations regulated by universally imposed and universally accepted dogmatic principles. From this generalization it is then deduced, for example, that many of the happiest creative moments in art history coincide with the enlightened despotism of some great ruler, with the admission of the artist to the heights of court life, his elevation to the pinnacles of caste and hierarchy. According to other views, the golden ages of art and poetry have been those ingenuous epochs, archaic and primitive, when the artist is both the artisan and magus of his own tribe, when the poet hands down the historical traditions and the religious beliefs of the race or clan as myths, in song and incantation. But the truth of such assertions lies not so much in the effects they expose as in the conditions they presuppose; that is to say, the complex of circumstances which leads the artist, thus favored and honored, to obey naturally and instinctively the norms of taste and culture dominating his environment, to exercise his civic, collective function with perfect ethical and psychic integration.

This privileged condition—which might be simply defined as the absence of any doubt on the artist's part in the face of his public and his mission—is certainly not, after the cultural revolution of romanticism, the normal condition of modern art; quite the contrary situation prevails. We have already observed that, on one hand, the romantic movement, for all its popularizing, was really far less popular than commonly believed; on the other hand, it won its battle not because of the favor of the educated public and the cultured classes, but despite their hostility. Romanticism, in other words, was the first cultural movement to triumph without support from above or below. That any validity should be recognized in the views of a literary opposition party would have been impossible without the reform philosophy of men of the Enlightenment who, on the ideological level, had helped to destroy a society whose traditional principles they continued to share on a cultural level. Nor, ultimately, could this have happened without the social and political renewal brought about by the French Revolution, although not all the ro-

mantics felt themselves in harmony with these changes. In other words, the triumph of romantic culture would have been impossible had European society not also been culturally conquered (even against its will) by what was later to be called the religion of liberty. And we must repeat that in this matter it makes little or no difference that romanticism was in its origins, as in some of its longest-lasting currents, tendentiously conservative or reactionary. The legitimation of the counterrevolutionary party is the clearest sign of a regime's liberality and the liberalism of the party in power.

One might reply that the liberal conditions in which romanticism operated were more apparent than real; one might cite the case of nineteenth-century Russian literature, which flowered under a despotism. But here we have an objection and an example without much validity. First of all, tsarism left many areas of activity free from the predominantly political pressure of the autocracy, operating in this respect analogously to the more or less enlightened despotism of the eighteenth century; and as a parallel, one might say, the ideological and reformist function of nineteenth-century Russian literature was in a certain sense neo-enlightened. In the second place, because of a variety of circumstances, determined by causes and factors of diverse kinds, that literature was the least romantic of the century and thus, potentially, the least avant-garde. Nonetheless, the cultural repression under tsarism was only relative; it operated intermittently and contradictorily. How true this is may easily be seen by a contrast with the present state of affairs, which reveals how absolute and total the control of literature and art has become in Soviet Russia. It proves also how the installation of a society differing completely not only from tsarism, but also from the liberal and democratic regimes of the West, coincided with the rapid and violent disappearance of avant-garde art. The same thing happened under other dictatorial regimes, Fascist Italy, Nazi Germany, Franco Spain, but not so radically as in Soviet Russia, precisely because the Communists had broken the ties to the previous society in a more thoroughgoing way than any other regime, thus becoming much more totalitarian.

Such considerations lead to the reaffirmation that avant-garde art can exist only in the type of society that is liberal-democratic from the political point of view, bourgeois-capitalistic from the socioeconomic point of view. In recognizing this, it is easy to agree with the opinion of leftist critics, but with the difference that we can, and should, deny that the relationship must necessarily be submitted to a value judgment, whether positive or negative, historical or aesthetic. What must suffice is the recognition that the relation exists—that it is a fact about which the nonideological historian and the unprejudiced critic must be neutral. What matters more, the connection must be understood not only as a general circumstance, social and political in nature, but also as a specific circumstance, of a psychological and cultural nature.

In a democratic society, as Baudelaire noted in writing about Poe, the tyranny of opinion easily dominates in moral as in cultural matters; but such tyranny is incapable of exercising decisive sanctions and establishing absolute conformity. That society ends up by tolerating, in a limited but not too restricted sphere of action, displays of eccentricity and nonconformity, tolerating individuals and groups who transgress rather than follow the norm. In the cultural field, too, democratic society is therefore forced to admit, beyond the official and normative art, precisely that other art which has been called, as a synonym for avant-garde art, the *art of exception.* Avant-garde art then cannot help paying involuntary homage to democratic and liberal-bourgeois society in the very act of proclaiming itself antidemocratic and antibourgeois; nor does it realize that it expresses the evolutionary and progressive principle of that social order in the very act of abandoning itself to the opposite chimeras of involution and revolution. The avant-garde artist (and the romantic, for that matter) often accuses modern society of driving him to death. Antonin Artaud in his biographical essay on Van Gogh does not hesitate to call the great Dutch painter a "social suicide." (It is interesting to note that these words echo those of Alfred de Vigny in his preface to *Chatterton,* where he describes the self-inflicted death of that poet.) But such an accusation would be sense-

less if it did not presuppose that this historical and psychic type of the avant-garde artist belongs specifically to our social system: even admitting that our society condemns him to death, another society would have prevented him even from being born. Just for this reason, the relation between the artist and contemporary society has been best expressed by Mallarmé. In a press interview, where for once he was allowed to use a political metaphor, he declared that in an epoch or culture like ours the artist finds himself "on strike (*en grève*) against society." But, in order to strike, one has to be employed.

Thus we can say that it is exactly the particular tensions of our bourgeois, capitalistic, and technological society which give the avant-garde a reason for existing. By way of a relative demonstration, one might point to the fact that the break between avant-garde culture and traditional culture is less sharp in North America than in continental Europe where the social system is more closely tied to the past, to ancient institutions and traditional customs, rigid and age-old structures. And, as a parallel contrast, one might cite the uncertain and tardy apparition of the avant-garde phenomenon within the less socially and technically advanced nations of Europe, Russia, Spain, and Italy. Further, this apparition coincided with those nations' first timid attempts at modernization.

As we have already said, the complex series of ties between avant-garde art and the society it belongs to, willy-nilly, must also be studied from the special and distinct perspective of a purely cultural reality. Insofar as this perspective views the relationship in terms of historical necessity, it can only reveal it as positive, as a parent-child relationship. But on a lower level, in a less inclusive sphere (what we call culture in the strictest sense), the same relationship can become consciously, freely, and resolutely negative. In this way, in the face of society and especially official society, the avant-garde looks and works like a culture of negation.

We have only to repeat that the phrase "culture of negation" was used by Von Sydow to define the essence of European decadence; yet we can, without toning it down or making exceptions, use it to define

avant-garde art as a general phenomenon. The concept cannot involve an absolute negation of culture (which would be a contradiction in terms), except by way of a metaphor. This means instead that it suggests the radical negation of a general culture by a specific one. In other words, decadence and an avant-garde only appear when, in a given historical condition or a determinate social framework, there arises a conflict between two parallel cultures. Normally, though not always, the more general and inclusive culture can ignore the particular and exclusive one, but the latter has no choice but to assume a hostile posture before the other.

As a minority culture, the avant-garde cannot get by without combating and denying the majority culture it opposes. But often the majority culture is that mass culture which has only recently appeared in the modern world, thanks to the diffusion of techniques of instruction, information, and communication, and has reached the extreme point of development in the United States, the most typically democratic, bourgeois, and industrial society. At least theoretically, it is not that society against which the avant-garde means to react, but against the civilization it creates and represents. The specific historical reality it opposes is just this mass culture, seen as a pseudo-culture. Faithful to qualitative values, the artist facing the quantitative values of modern civilization feels himself left out and rebellious. This state of mind also has practical social consequences, but above all it provokes a particular pathos in the soul of today's artist. He knows that in other times the artist, even if he was infinitely less free, never felt himself so much a derelict, rejected and isolated. Hence his dreams of reaction and revolution, his retrospective and prophetic utopias, his equally impossible desire to inaugurate new orders or to restore ancient ones.

We have already given this sociopsychological condition, characteristic of the anarchistic culture of our time, the name *alienation;* we shall diagnose it in the following pages. Meanwhile, reversing the customary procedure, we shall give its prognosis: in brief, we can say that it is chronic and thus destined to continue. In fact, it can only end when the patient dies: that is to say, when the avant-

garde artist disappears from the historical and cultural horizon. But that, in turn, cannot happen except as a direct consequence, perhaps the immediate consequence, of a radical metamorphosis in our political and social system. One reason we shall later deny the claim of some contemporary artists and critics that the avant-garde is ending or about to end, that it has been superseded and liquidated, is a moral and sentimental refusal to believe in a near and fatal fall of our society and civilization. My aim is not the useless one of presenting more or less apocalyptic prophecies concerning the fate of a historical reality infinitely more important than the relatively circumscribed object of this inquiry. As a negative and hypothetical assertion, we could say that avant-garde art is destined to perish only if our civilization is condemned to perish, that is, if the world as we know it is destined to fall before a new order in which mass culture is the only form of admissible or possible culture, an order that inaugurates an uninterrupted series of totalitarian communities unable to allow a single intellectual minority to survive, unable even to conceive of exception as valid or possible. But if such a transformation is not imminent or unavoidable, then the art of the avant-garde is condemned or destined to endure, blessed in its liberty and cursed in its alienation.

Psychological and social alienation

The state of alienation must first of all be considered as *psychological alienation*. Marx himself, the first to use the formula he borrowed from Hegel and legal terminology, certainly saw what he called *Entfremdung* as caused by a process of social degeneration, an ineluctable crisis of a society at once unable to die or to renew itself. Nevertheless, he outlined its typology in terms of individual psychology, with quasi-ethical and religious connotations, and described its course as a process of demoralization. In short, he defined it as the feeling of uselessness and isolation of a person who realizes that he is now totally estranged from a society which has lost its sense of the human condition and its own historical mission.

It was by analogy that others later extended (or restricted) the concept of alienation to the state of modern man in general and to the modern artist in particular.

Even from the first analysis of alienation as a psychological phenomenon, we see that it is merely an agonistic state of mind. That of course does not prevent its being felt as a positive reality, with enthusiasm and exaltation. In fact, many romantic artists and other hardy pioneers in subsequent generations conceived of the condition as a source of pride, a chance to hurl a haughty defiance, titanic and promethean, against man, history, and God. Forced to live in the desert of his own surrender or on the mountain of his own solitude, the artist found compensation in that heroic doom which Baudelaire called both his curse and his blessing. Using terms suggested by Nietzsche, we might say that the artist believed himself capable of sublimating that fatal and fateful malady into an almost superhuman creative energy, which the German philosopher supposed to be the basis for all mental and spiritual health. The artist hoped to succeed in realizing his self and his work by the way of sin and transgression. He hoped to get a taste of the fruit of the tree of knowledge through disobedience and revolt. He thus seemed to become, as Rimbaud wrote, "le grand malade, le grand criminel, le grand maudit, et le suprême savant."

But the euphoria was short-lived and only revealed a morbid illusion. Later, alienation came to be felt as pathetic and tragic rather than heroic and dionysian. By virtue of that feeling, the artist was driven to turn against himself the weapons of his own antagonism and the nihilism he had previously directed against society and the outside world. Baudelaire had already foreshadowed such an attitude in his myth of the *heautontimorumenos*, the self-tormentor. Sometimes the artist ends up by considering the state of alienation as a disgraceful condemnation, a moral ghetto, and seeking to react against that oppressive feeling finds no way out but the grotesque one of self-caricature and self-mockery. Conscious of the fact that bourgeois society considers him nothing but a charlatan, he voluntarily and ostentatiously assumes the role of comic actor. From this

stems the myth of the artist as white-faced clown and mountebank, which we shall have occasion to discuss from another point of view. Alternating between the extremes of self-criticism and self-pity, the artist comes to think of himself as a victim, sometimes comic, sometimes tragic. The second state, however, seems to prevail. Thus recently in some areas of avant-garde art and criticism, influenced by anthropological and psychological theories, the artist comes to be conceived of as an *agnus dei*, an expiatory scapegoat, almost as if he were the innocent creature upon which society transfers its own sense of sin and guilt, and whose sacrificial blood redeems the sins of the whole tribe. Thus the poet-artist, having descended from the role of the elect to that of rejected—think of the themes of exile on earth, of malediction and denunciation, in famous texts by Nerval, Baudelaire, and Mallarmé—again ascends to the new role of saint or martyr. Perhaps Baudelaire did not so much intend to emphasize the satanic impulse to revolt as to affirm a quasi-religious vocation when he wrote, in *Mon coeur mis à nu*, that "l'homme de lettres est l'ennemi du monde."

Sometimes alienation is understood not only in ethical and psychological terms, as the "science of the mind" (to use Toynbee's formula), but also in strictly pathological terms. We have already mentioned Nietzsche's and Baudelaire's exaltation of malady and malediction—but that now gives way to resignation and piety, just because those states are no longer treated metaphysically, as myths or figures, but as physical and objective phenomena, literally as infirmities. This view establishes a fatally determined link between art and neurosis, obviously in consequence of Freudian doctrines and psychoanalytic theories. In fact, it extends or restricts the concept of alienation to the professional malady of the artist and writer. Thus Edmund Wilson in *The Wound and the Bow* revived the myth of Philoctetes, who was abandoned in the shame of his wound on the isle of Lemnos with only his bow to live by. With this myth Wilson suggests that the artist's vocation is linked with an innate pathological predisposition, a psychosomatic trauma, with spiritual and physical disease. Sometimes madness, the most terrible of maladies,

afflicting the brain and the intellect, is considered the artist's occupational hazard, precisely because alienation, by the fatal psychic dualism it causes, may contribute to the formation in the patient's mind of that doubling of personality known as schizophrenia. Apropos of this, it is worth observing that many psychoanalytic specialists who study alienation are naturally inclined to interpret it as mental alienation, in the psychiatric sense of the word.

Both the origin and the internal logic of the word prove how inseparable are the psychological and the sociological definitions of alienation: coined or first developed by Marx, it presupposes a larger body for the individual to belong to before he can be alienated or distanced from it. But we have already discussed what might be called the artist's *social alienation* when we spoke of the unpopularity of avant-garde art and of its relation to politics. These we shall later view in other perspectives; here it will suffice to repeat what we said about the avant-garde and its public. Again we deny that this public is identical with the sociocultural group called the intelligentsia and deny that alienation can be adequately considered in purely classical terms. Yet, for obvious reasons, the state of alienation must also be examined from the angle of the modern artist's particular economic condition and his professional ties with the society of his own time. No doubt an important aspect of the artist's social alienation takes the form of *economic alienation*.

Economic and cultural alienation

One might even claim that the creation of the alienated mentality (and the avant-garde itself, for that matter) is a phenomenon at least notably conditioned by the practical, ideological, and spiritual effects of the sudden, relatively recent, transformation of the artist's economic position. In other words, the modern writer or artist has yet to reconcile himself with the fact that bourgeois-capitalist society treats him not as a creator but, on one hand, as a parasite and consumer and, on the other, as a worker and producer. Such a society, in granting him the chance to make his living directly through the

public sale of his works, through the sale of his own time and labor, has also subjected him to the dangerous alternation of economic dependence and independence. Putting him on a par with the laborer and industrial worker, it submits him to the risks of unemployment and overproduction, thus creating what Christopher Caudwell called "the false position of the poet as a producer for the market." As a courtier or artisan the artist used to be able to count on the relative security offered by a Maecenas, by a patron who took responsibility for him. Reduced to the status of a factory worker or laborer, the modern artist is deprived of any guarantee that the fruits of his own labor can satisfy a series of needs, if not urgent at least extensive and regular enough, in the market of supply and demand.

Since bourgeois culture, with its cult of respectability and its sharp distinction between intellectual and manual labor, prefers to consider the fruits of literary-artistic activity as a service rather than a product, it naturally leads the artist to assume the function or fiction of being a self-employed professional; but in most cases he lacks the doctor's, lawyer's, and engineer's regular clientele. The bourgeois state is naturally (perhaps fortunately) little inclined to regularize and normalize the artist's labor as a kind of unproductive but necessary social service, although it does do so for the priest, judge, or teacher. Indeed, whenever there are considerable signs of such an inclination, this is to be taken as a symptom that a radical change in the social structure is being prepared or has begun. In totalitarian societies, or less liberal societies, or, at most, societies in such exceptional circumstances as a temporary dictatorship during a large-scale war, we find the fairly recent phenomenon of a bureaucracy of intellectuals, artists, and writers. Thus for equal and diverse reasons we must look askance at the rare manifestations of contemporary patronage, which cannot but act like bourgeois charity. Whereas ancient patronage functioned like individual initiative even when it had access to public funds, in our day even private patronage tends to work in a public, civic way.

Despite the dangers and difficulties of this situation, the roads to economic fortune are open to the modern artist and writer to an

extent wholly unthinkable in earlier societies. Surely it is no coincidence that our age, in which the valuable book is one written for a select public, printed in limited editions for a few buyers and readers, is also the age of bestsellers sometimes selling in millions of copies. This is to say that the epoch of avant-garde art and *littérature d'exception* is also the era of commercial and industrial art. From the awareness of this state of affairs stems the frequent and nearly always sincere refusal of the genuine artist, in our day, to yield to the temptations of material success. Besides, the same artist, even when he does let himself be tempted, can only count on chance and luck since the public he might want to address cannot be reduced to a definite entity, or to a series of classifiable strata: it is too immense in size, complex in needs, and varied in structure. Nothing is more significant than the American tendency to divide this public into the three categories of high, middle, and low brow (meaning those who raise their eyebrows much, little, or not at all when objects are presented to their view). Yet it is true that neither critic nor sociologist (operating on rational grounds and judging *a posteriori*), still less the writer or artist (acting and thinking intuitively and *a priori*), can determine even approximately the value system and requirements of taste particular to these three categories at any given moment.

We must repeat that the modern artist or writer tends to push aside the temptation of success; if he does address himself to a vague type of public, it is that one, necessarily limited in size, socially inconsistent, subject to the perpetual capricious fluctuations of fashion, which is given the ridiculous and mocking epithet "high brow." This tendency may seem a traditionalist and classicist return to the judgment of an intelligent and elect public, an appeal to the aristocracy of genius: but this is only a matter of appearance. That public does not exist as a self-sustaining social group, as an isolated and distinct entity: the very concept of high brow supposes a middle brow and a low brow, often confused with it, differing only in degree. What counts, though, is that the alleged return is a new phenomenon, precisely because it is directly determined by an extreme and in-

transigent reaction to the predominant historical attitude that immediately preceded it and operated in a contrary way.

The art of the avant-garde, as a psychological phenomenon, may appear to have come about, at least in its most recent and extreme manifestations, as a reaction brought on by the failure of a different kind of attempt in an opposite direction. During the hundred years from the last quarter of the eighteenth to the next but last quarter of the nineteenth century, many writers and, to a lesser degree, many artists conceived the ambitious dream of transforming pen, brush, fiddler's bow, or maestro's baton into the marshal's staff; they dreamed, that is, of winning by the instruments of their own labors a spiritual power, a moral prestige, and a social authority such as scepter, sword, and crosier had attained. Economic success as such was desired only as the outward sign of that triumph, crown of that victory. So Balzac dreamed, stating that his own mission was to terminate by the pen what Napoleon had begun with the sword. But the dream was shared, with greater or lesser intensity, by major artists and writers of the period, from Rousseau and Voltaire down to Dostoevsky and Tolstoy, who often conceived the ambition in terms of a religious preachment and moral conversion, rather than an armed conquest of new kingdoms in the empire of the spirit. No one represented the dream, incarnated the ambition, with the extreme audacity and supreme magnificence of Balzac himself, who conquered neither the power he longed for nor even the economic sanction of that power. Precisely for this reason, Pedro Salinas described that failed dream of the writer's power with the phrase which had served as the title of Balzac's famous novel: "lost illusions." By a profoundly meaningful coincidence, the Marxist Georg Lukács had already assigned to the same writer and the same novel the historically symbolic function recognized by Salinas, a coincidence between critics of different and diametrically opposed tendencies. Luckács, in fact, considered this masterpiece of Balzac's as the first conscious revelation by a modern artist that the artist had now descended from the level of creator to that of the producer, pure and simple, a "producer for the market," to use Caudwell's phrase.

Lukács' judgment is that in *Illusions perdues* Balzac focuses the narration not only on the destiny of Lucien de Rubempré, but also on the transformation of the work of literature into merchandise.

Even though the modern artist now knows that these were idle hopes and illusions lost forever, he has yet to forget completely this dream in which he can no longer believe. Such a psychological ambivalence, at once delusion and nostalgia, justifies the artist of our day in his paradoxical, antihistorical, and illogical lament over the scarcity or downright lack of a contemporary public; it is a lament uttered precisely when, for the first time in history, the potential public for literature and art equals the greatest part of the population. And the one who utters the lament is exactly the type of artist who, by definition, addresses a restricted or specific public, which he himself distinguishes from the limitless general audience by a voluntary act of opposition. Obviously this complaint makes sense only so far as, despite everything, including his own disdain and his poses, the modern artist vainly continues to nourish an unconfessed grief for more secure and happy times—when the creator could count on a public, not large but faithful, attentive, compact, and integral, to which he was bound by the sharing of identical presuppositions, by the same system of social, aesthetic, and ethical values. The modern artist, in other words, as an idolator of genius, has not yet wholly resigned himself (at least secretly) to having forever lost the advantages inherent in cultural situations dominated by taste rather than by genius.

Wordsworth, in the optimistic atmosphere of early romanticism, even though he recognized the difficulties of the situation, accepted it as an inevitable and natural circumstance when he claimed that now "every poet must create the taste by which he is to be enjoyed." But in the postromantic culture, this particularly arduous task for modern genius became an enormous undertaking, both useless and impossible. The pathos of this vain and titanic exertion, symbolized for many modern artists in the myths of Tantalus and Sisyphus, often leads the poet to choose as his own supreme theme the tragic problematics of his own work, the useless miracle of art and poetry. A

culture dominated by such a dichotomy between genius and taste, rather than by the subordination or coordination of one and the other, can never count on having a permanent elite, capable of accepting, appreciating, and judging works of art—this because not only the artist but the elite, too, is always in that state T. S. Eliot provocatively called the "dissociation of sensibility." In any case, the artist must be forever looking for that elite, with no certainty that he will find it, either at the beginning or the end of his road. He may spend all his life marching aimlessly through the waste land, which after all is a no-man's land. This vain pilgrimage leads him to view his own work as Mallarmé did, a game of chance, like a throw of dice on the table of fate. Where the classical artist, his eye only on the remote past and distant posterity, succeeded in achieving harmony with his own contemporaries, the avant-garde artist, so mindful of the task the Zeitgeist assigns him, ends up feeling that even his work-in-progress is a sort of posthumous opus. It was Mallarmé himself who showed a particular awareness of this situation when he declared, in a not too well-known interview, "to my mind, the case of the poet in this society which will not let him live is the case of a man who cuts himself off from the world in order to sculpt his own tomb."

Such considerations, paradoxically emphasizing what we might call contemporary artist's feeling of historical alienation, lead naturally back to the purely sociological interpretation of the concept of alienation. A cultural sociology for our own time can only be constructed from the now certain hypothesis that a plurality of diverse and contradictory intellectual strata exists. Such a plurality impedes any crystallization or fossilizing; what happens is precisely the opposite of the hierarchical and sharp stratifications of medieval society, of primitive or archaic civilizations. Our cultural-social situation is in a continual state of flux, an uninterrupted process of agitations and metamorphoses. From the political point of view, this situation produces an antithesis to what Pareto called "the circulation of the elites," which really means a circulation within the elites. What happens is a continual up and down from one to another elite,

from elite to nonelite. Thus the artist and the intellectual are naturally led to form their own group, taking up positions of distance or detachment from the traditional culture of the society to which they belong, originally at least. What we then have is a continual process of disintegration, since society and the social group react, turn and turn about, in equal and opposite ways. We may say that this reciprocally destructive relationship is, at least apparently, the sole genuine bond still joining avant-garde art to its own surroundings.

This reduction of the link between art and society to a purely negative function, which from the artist's point of view is alienation, is a new historical fact of incalculable importance and profound meaning. When critics and observers of avant-garde art praise or blame it for refusing even to serve, let alone express, contemporary society, they fail to take into account the fact that the avant-garde is not only the direct expression of a negative cultural relation, but is also the expression of the human and social condition that created this schism in the cultural order.

Sometimes the negative nature of this relationship takes the appearance of reciprocal inertia, creating the illusion that a given aesthetic experience occurs almost without contact with its surroundings. In this case, social alienation takes the form of isolation from history, isolation in time. To designate this kind of manifestation or, more exactly, to place it on the map of the battlefield of modern culture, Christopher Caudwell coined the concept of the "poetic pocket," using a metaphor drawn from the art of war. He sees quite a few examples of the phenomenon in the art of the past and recognizes it in those aesthetic formations that seemed to develop by a purely inner logic, along lines for which one can find no analogues or parallels in contemporary social and political life. But examples of this type are met, with an altogether greater frequency, in modern art, especially in groups focusing on aesthetics, groups we have partially distinguished from movements by labeling them sects. The Marxist Caudwell knew better than we that no human activity, even the most free or gratuitous, can operate in a vacuum, completely ignoring the historical realities of its time; that is why the

term "poetic pocket" indicates an apparent rather than a real situation. But the term is useful and suggestive when applied intelligently to the subject we are examining, exactly because it neatly emphasizes, even to the brink of the extreme and absurd, the state of opposition in which avant-garde finds itself in respect to its surroundings.

The fanatic defenders of the absolute value of aesthetic isolation are most disposed to accuse contemporary society of failing in its alleged duty of giving practical aid and moral support to the aesthetic activities of "exception." Forgetting that these activities are often characterized by their social inertia, they seem not to realize that society can respond to inertia only by an analogous inaction. But what is important to repeat is that avant-garde art is wrong in blaming its isolation on the single type of society in which that isolation has become necessary and possible. Indifference is the natural product of tolerance; in any case, hot-house flowers cannot complain that they are not treated like flowers of the field. Together with the earlier metaphor of poetic pockets, the image of hot-house flowers can serve to set a seal on the truth previously pointed out: the alienation of contemporary art from its society, and vice-versa, displays itself not only in psychological and sociological forms, economic and practical ones, but also in cultural and aesthetic guises (the latter fundamentally of greater emphasis and significance). No doubt we have already amply treated the more obvious aspects of this specific sign of alienation, but we have yet to extend our analysis to purely formal values, even less to that more intimate aesthetic criterion called style. In brief, the category of alienation must now be considered as *stylistic alienation.*

Stylistic and aesthetic alienation

It was Malraux who observed that the origins of modern art coincided with the artist's repudiation of bourgeois culture. In contemporary aesthetic ideology the bourgeoisie, he observed, is in opposition and "it is not to the proletariat or the aristocracy that it is opposed, but to the artist." This antinomy between the bourgeois

and the artistic spirit, which—like any antinomy—implies a relation of interdependence between the contrasted terms, became par excellence the theme of Thomas Mann's work, where it is reduced from social controversy, public and external conflict, to psychic crisis and a private question. And if sometimes the drama sinks to comedy, describing the artist as a burgher and ironically evoking the equivocations thus created, at other times it raises itself toward tragedy: the writer, describing the burgher as artist, represents him as victimized by the alter ego he carries within himself and creating a work that is the artistic nemesis of bourgeois culture.

If, on the sociological plane, the problem of the relation between the artistic and the bourgeois spirit ends up despite everything by resolving itself in a synthesis, on the historical plane it remains unresolved, an antithesis. According to that second perspective, which is cultural and underlines the separation as well as the reciprocity of the two opposed terms, it must be asserted as an absolute principle that the genuine art of a bourgeois society can only be antibourgeois. It is more important to observe that this principle works not only in the sphere of content, but also in that of form. Modern art, that is, opposes the stylistic theory and practice that dominate the society and civilization to which that very art belongs; its chief function is to react against bourgeois taste. If we say taste rather than style it is because, to quote Malraux again, "there are styles in the bourgeois period but there is no one bourgeois style." What counts is not the denial that a bourgeois style exists but the only apparently contradictory claim that multiple styles coexist within the culture of that social class. The postulate here of interest is that stylistic pluralism is one of the most notable characteristics of the contemporary artistic situation or, if you will, of bourgeois culture.

It is exactly by way of a reaction against the pluralism of bourgeois taste that avant-garde art chooses the path of stylistic dissent. According to Malraux, modern painting ventured into the field of deformation and abstraction precisely to escape from that "imaginary museum" or "museum without walls" in which it had found itself since the invention, perfection, and diffusion of photographic re-

production; this made even the most archaic and arcane artistic creation, of every school and style, of every time and country, accessible and familiar to even the most sedentary artist and the most provincial public. *Art d'exception*, in this case painting, would then originate as an act of protest against the cosmopolitanism and universality of contemporary taste. These are, furthermore, positive external consequences of such an ambiguous and complex phenomenon as the aesthetic pluralism of our culture.

If that pluralism is preserved by negative factors, such as eclectic tolerance and skeptical indifference, it also make its first appearance only because of a series of conflicts and crises. The first was naturally the division, once and for all, of avant-garde culture from what had traditionally been popular art and culture. Only the waning of romantic populism made possible an awareness of the break, and the break itself was later felt as an irremediable one, just at a time when contemporary scientific sociology was establishing an all too sharp distinction between humanist culture and anthropological culture. Today purely ethnic cultures are almost completely disappearing from Western soil; this is only one of the many nemeses of a democratic, technological, and industrial civilization like ours. Many artists in our time who are, so to speak, less extremely and typically futuristic have realized that the very nature of our civilization leads to the loss or annihilation of more deeply rooted traditional values, of the less self-conscious and more spontaneous traditions. These artists have deluded themselves into believing they could remedy the process and have postulated unrealizable restorations or prophesied impossible palingeneses.

The first of these illusions seduced a man of the right like T. S. Eliot, who dreamed of the advent of a new medievalism, a hierarchical society, a stratified culture. The second illusion was cherished by Herbert Read, a man of the left, who recommended the reconstruction within a progressive society of a people's culture and an artisan's art. Unfortunately, by means of specialization and technology, modern society has broken all the links between artisan and artist, destroyed all the forms of folklore and ethnic culture; it has even

transformed the very concept of "the people," now a synonym for the quite different concept of "the masses." Thus Read's program no less than Eliot's nostalgia is easily shown for what it is—utopia by hindsight. In reality only one modern poet has effectively reached the springs of national folklore, and that was García Lorca, who belonged to a still static and crystallized society. Despite the similarity in situations, modern Irish poets, from Yeats on, have not been in a position to achieve results as felicitous as Lorca's, because they have been forced to use as their poetic instrument the language of a culture as modern as English.

In the figurative arts, the ethnic element at present functions only on the inferior level of the applied arts, such as decoration. Modern painting and sculpture, as abstractionism itself proves, have felt the influence of the rigid geometry of machines rather than the ingenuous arabesques of popular art. If anything, recent art, despite its modernism, has more readily let itself be seduced by exotic and arcane styles, preferring to follow archeological lessons rather than ethnic examples. Combinations of popular and modern styles are very rare in the art of our time, exactly because it flourishes in a state of stylistic pluralism, tends toward purity in each particular style. It hates eclectic forms and syncretic styles (except for decadence, a special case). This principle holds for the great "chameleons" of our time, such as Picasso and Stravinsky who, even though they pass with enormous facility from one to another stylistic phase, preserve a unique style in each work.

But the more important conflict is not between avant-garde art and ethnic culture, but between avant-garde art and mass culture. The latter, absolutely different from culture in an anthropological sense, is nevertheless still called popular art and popular culture. It is popular not in the romantic sense of culture and art created by the people, but empirically and practically, as culture and art produced for the masses. Looked at in this way, it is the most genuine form assumed by bourgeois culture in highly technical and industrialized countries. In those countries, furthermore, the concept of "the people" has no other function than to distinguish

the rank of manual laborers from the vast class that acts like, and is called, the petty bourgeoisie. By a fatal paradox it seems that in societies where the proletariat has been "bourgeoisified," a proletarianizing of culture is immediately produced. In other words, the second phenomenon does not occur by itself and happens only in capitalist societies. In point of fact, the mass culture dominant in Communist Russia is imposed from above; it is not the natural effect of what the public orders, following the economic law of supply and demand, but an artificial political product, following the authoritarian formula of "the social mandate." In other words, what has happened in the Soviet Union is not so much the proletarianizing as the bureaucràtizing of culture; it makes the artist a functionary rather than a producer. The immediate result of this peculiar metamorphosis is the destruction of the alienated art of the avant-garde. And from our point of view, this new fact suffices to prove that Trotsky was right when, at the end of the first stages of the communist experiment, he denied that a proletarian art or culture should or could subsist in a regime subjected to the dictatorship of the proletariat.

The sole genuine form of proletarian art and culture is that fabricated (indeed "prefabricated") on the lowest intellectual level by the bourgeoisie itself. With respect to literature, Christopher Caudwell, in one of the most suggestive passages in *Illusion and Reality*, noted that "the authentic proletarian literature of every day consists of the thrillers, the love-stories, the cowboy stories, the popular movies, jazz and the yellow press." The art of the avant-garde, essentially, opposes this mass culture and this proletarian art, the only possible types of popular art and culture in a society like ours. This is a fact not contradicted by what we have several times claimed: the task of avant-gardism is to struggle against articulate public opinion, against traditional and academic culture, against the bourgeois intelligentsia. The original and tragic position of avant-garde art, in fact, is marked by the necessity that forces it to do battle on two fronts: to struggle against two contradictory types of artistic (pseudo-artistic) production. We can designate

that warring pair with Edmund Wilson's title for one collection of his essays, "classics and commercials." Bourgeois culture is certainly unable to distinguish the values of the first from the nonvalues of the second, just as the critics in that culture are unable to determine the criteria of taste distinguishing the various strata of the contemporary public. But the avant-garde instinctively opposes the one as well as the other. It thus functions no less genuinely and primarily than in its protest against the culture of the dominating class; this struggle, too, becomes the reaction against the byproducts of that culture, against the art and culture of the masses, as defined by Caudwell.

The double-front reaction against bourgeois taste and proletarian taste can definitively resolve the only apparently paradoxical claim that avant-garde psychology is as much dominated by an aristocratic, or antiproletarian, tendency as by an anarchistic, or antibourgeois, tendency. Sociologically as well as aesthetically, the two tendencies are consistent; the parallel oppositions to bourgeois taste and proletarian taste converge in a single opposition to the criterion that identifies and unites them. This criterion may be defined as the identical, or analogous, cult of the cliché. Here we are again, with the reappearance on a much higher level of the relationship already established between avant-garde and stereotypes: an interdependence, precisely because it is determined by an equal and mutual resistance, by the symmetrical parallelism of automatic contrast. Now, as already said, the stereotype is only the modern form of the ugly, and the criterion of the beautiful is as undefinable as it is unique; on the other hand, the categories of the ugly (even considered as a particular series of historical variants) are infinite and may be defined in innumerable ways. That can serve to affirm once more, even *ad absurdum*, the principle of a complex and irreducible pluralism in contemporary aesthetic matters.

This affirmation, of great importance for the sociology of taste, loses all meaning and value on the plane of artistic creation. There, if anything, it has only a negative function. A period having many styles has none; that is true even in a case where the multiplicity

can be reduced to a more simple dualistic relationship. Neglecting for a moment the essential antithesis of modern art (between the avant-garde style and all the other styles contrary to it) and limiting ourselves temporarily to a partial and provisional antithesis, we can easily recognize that where there is no bourgeois style there cannot be any proletarian style either. In other words, proletariat and bourgeoisie, insofar as they are mass cultures, take their styles where they find them—from cultures and societies different from theirs. In short, the absence of a style of its own is not exclusive to capitalism or socialism, but happens in any democratic society, whether it is liberal or not; in any "quantitative" civilization, which is technical and industrial.

Precisely by being styleless, this type of civilization prefers an eclectic style, where what is technical ability in an aesthetic sense joins with technical ability in a practical sense. Such a style takes shape by the synthesis (better, by the syncretic fusion) of traditional academic and realistic forms, regulated by the wholly modern taste for photographic reproductions. The artist in our time, precisely because he knows how to imitate effortlessly all techniques, ancient or modern, scientific or artistic—precisely because he has in his grasp all the ways to carry out to perfection the effects of *trompe l'oeil*—refuses to accept as his own style what has now become a purely mechanical production, what is thus a true negation of style. This refusal, however, becomes an act or gesture impossible for an artist working in a technological civilization or a mass culture that is also a totalitarian society, as the case of Soviet Russia amply demonstrates. There the formula "socialist realism" is not only ideological dogma determining the content of a work of art, but also a stylistic canon for the arts of design as well as words, to the point where any divergence from the official style is considered not only aesthetic heresy but political deviation and is even condemned with the quasi-technical term of "formalism." But the refusal to serve an obligatory style, a mass taste, a manner sanctioned by the active or passive consensus of the public, remains a decision not only possible but necessary within a still bourgeois society, a so-

ciety, that is, which must admit the existence of minorities and individual eccentrics. This tolerance is naturally only a purely negative reality and as such provokes, in turn, the artist's intolerance. Jean-Paul Sarte went so far as to claim that, thanks precisely to what he calls the unification of the public (more exact would be the confusion of the public), a phenomenon due to the diffusion of mass culture from the lowest social strata to the highest, the modern writer has no choice but to assume an attitude of absolute intransigence in the face of the indistinct multitude of his readers, an undifferentiated antagonism. The passage in question ends with the just recognition of how historically exceptional this negative relationship is: "To tell the truth, the drastic blurring of levels in the public since 1848 has caused the author initially to write against all readers . . . this fundamental conflict between the writer and the public is an unprecedented phenomenon in the history of literature."

Georg Lukács in the preface to *Studies in European Realism* affirms that such a schism does exist, and he acutely defines its essence in almost identical words, although developing the idea along broader lines. The Hungarian critic in fact pushes the beginning of this phenomenon back to the French Revolution and romanticism, using, once again, the figure and work of Balzac as a symbol for the decisive moment in that crisis: "From the French Revolution on, social evolution has proceeded in one direction, which makes for an inevitable conflict between the aspirations of men of letters and their contemporary public. In this entire period the writer could achieve greatness only insofar as he reacted against the everyday currents. Since Balzac, the resistance of everyday life to the basic trends of literature and art has grown constantly stronger." Sartre's judgment and Lukács' confirmation lead us to conclude that in the course of the last century, and perhaps for the last century and a half, the state of alienation has steadily grown from the exception to the rule for the modern artist and writer. This conclusion once again shows that the principle or norm of bourgeois art is to be antibourgeois. Sartre expressed this general truth from the particular view of the writer when he declared: "The bourgeois writer and the alienated writer

work on the same level." Now this means that the artist is in a continual state of social protest, but it does not signify that he becomes, politically, a revolutionary. Analogously, the modern artist, even when driven to embrace a reactionary ideal (sometimes for purely aesthetic reasons), does not thereby necessarily become a conservative. We must never forget that, in fact, his social protest shows itself principally on the level of form, and thus alienation from society also becomes *alienation from tradition*. In contrast to the classical artist, who had recourse to tradition as a stable and recurrent series of public epiphanies, the modern artist works in chaos and shadow, and is overcome by a feeling that language and style are in continual apocalypse.

Avant-garde art seems destined to oscillate perpetually among the various forms of alienation—psychological and social, economic and historical, aesthetic and stylistic. There is no doubt that all these forms are summed up in one other, namely in *ethical alienation*. Certainly this was what Sartre had in mind in the passage quoted above. It expressed itself, even before existentialism, in that art and literature of revolt which has occupied so large a part of modern thought and culture since romanticism, and which in the case of avant-gardism, strictly defined, showed itself with maximum intensity in German expressionism. To investigate this revolt would lead us too far afield; our task here is to study the avant-garde and alienation as historical norms and mental forms. Let me here say only that the ethical alienation of avant-garde art appears precisely in the paradox that, even when it refuses to yield to the siren song of aestheticism and denies the temptation of self-idolatry, it is nevertheless condemned to a liberty which is servitude: it must all too often serve the negative and destructive principle of art for art's sake.

Nothing better demonstrates this truth than the wretched state in which the religious art of the West has been for more than two centuries, but particularly in our time. A modern artist with genuine faith and sincere religious inspiration is absolutely unable to adopt as the means to express his sense of the divine that traditional plastic language, forged in time immemorial, or adapted, for sacred art. It

has now become wholly impossible for a contemporary painter or sculptor to bring his own contribution to that figurative interpretation of Christian doctrine or legend which served, especially in the medieval period, as the Scripture of the ignorant or—as has been said—the Bible of the poor. In the history of modern painting, Georges Rouault appears as the creator gifted with the most simple, profound, and truest faith. Yet, since he wanted to be an artist as well as a believer, he had to express his own religious traditionalism by the divergent path of artistic antitraditionalism, through a deformation not only of the images but even the icons, motivated by formal exigencies quite alien to those in gothic and primitive distortion. The paradox of Rouault, and of other modern artists like him, consists in the conjunction of aesthetic dissent and ethical-mystical consent. The exceptional novelty of such a paradox can be even more sharply emphasized by observing that in different cultures the contrary paradox would have been, if not impossible, very infrequent: the union of moral-theological disbelief with aesthetic and stylistic conformity. Certain scholars have recently advanced the hypothesis that Giotto was an "epicurean," one of those who, Dante said, "make the soul as mortal as the body." If this hypothesis were true, it would be obvious that for Giotto, as for any artist grown up in analogous social and spiritual conditions, it would not even be conceivable, despite his own heresies or contrary beliefs and opinions, that he should take the path of protest—as inconceivable to deny the theoretical content as to renounce the formal tradition of his own culture.

7. TECHNOLOGY AND THE AVANT-GARDE

Experimentalism

A whole series of relations has thus far been established: activism, or the spirit of adventure; agonism, or the spirit of sacrifice; futurism, or the present subordinated to the future; unpopularity and fashion, or the continual oscillation of old and new; finally, alienation as seen especially in its cultural, aesthetic, and stylistic connections. From these derives a further category, which may be summed up by saying that one of the primary characteristics of avant-garde art is, technically and formally, *experimentalism*. It is in fact evident that in each of the above categories there inheres a single stimulus sufficient to lead the avant-garde artist to experiment. But we hardly need say that, in the majority of cases in which the experimental comes into play, a variety of stimuli and a complex of multiple motivations determine its activity.

The experimental factor in avant-gardism is obvious to anyone having even a summary knowledge of the course of contemporary art. To use only examples offered by the word-arts, suffice it to say that for three quarters of a century the history of European poetry and literature has not only been a series of movements such as naturalism and decadence, symbolism and futurism, dadaism and

surrealism; it has also been a sequence of creations, adoptions, and liquidations of technical forms like free verse and unrestricted verse, the prose poem and experiments in the free association of words, polyphonic prose and the interior monologue. The experimental nature of the avant-garde is furthermore programmatically stated in many of the labels coined for new formal tendencies and technical researches, especially in the plastic arts. Few movements in painting have neglected to indicate by way of their names what the meaning or direction of their work was, as certainly was the case of those painters who accepted the epithet of *fauves*. If there have been larger movements, like futurism and surrealism, which manifested their figurative ideals in special programs, defined in more or less specific formulas, like plastic dynamism or metaphysical painting, the history of painting and sculpture of our time abounds in aesthetic movements or currents with names that are themselves a manifesto or program. The most significant case in this respect is impressionism, all the more so because of the supreme importance of the movement so named. Perhaps it is just because of this implicit or confessed characteristic of serious formal commitment that impressionism, for all its placidly serene inspiration and the quiet integrity of its work, must be considered a genuinely avant-garde movement, perhaps the first coherent, organic, and consciously avant-garde movement in the history of modern art. Further, that was the opinion of witnesses at the time, almost all hostile and foremost among them the public and the contemporary academics; and such is also the opinion of witnesses of today, almost all favorable. One of the latter, Massimo Bontempelli, is certainly not altogether off the mark when he says that in a certain sense all the avant-gardes derive from impressionism, even though at times we have derivation by opposition, as in the case of expressionism.

The name *cubism* is of similar significance and scope, and from its experimentations come also those tendencies given the generalized label of *abstract art*; in the same way, from the particular researches of impressionistic painting came divisionism and pointillism. Regarding the architectural avant-garde (about which I shall say

something later), we find only designations that underline the experimental—for example, functionalism or rational architecture. The same may be said of the musical avant-garde, which expresses its tendencies in exclusively technical names, such as atonalism or twelve-tone music, microtonal music or electronic music.

The experimental aspect of avant-garde art is manifested not only in depth, within the limits of a given art form, but also in breadth, in the attempts to enlarge the frontiers of that form or to invade other territories, to the advantage of one or both of the arts. Everyone knows to what extremes symbolism carried the doctrine, already present in romanticism, of the possibility of the cross-translation of sensations: synesthesia, called by Baudelaire "correspondence." Suffice it to cite some of Mallarmé's experiments or a document like "Voyelles," the famous (or infamous) sonnet in which Rimbaud assigned a different chromatic value to each of the vowels, bringing things to the point at which the three letters *e, i,* and *o,* as François Coppée's mocking epigram put it, "forment le drapeau tricolore."

Such inquiries had also been preceded by Wagner's experiment with music drama, aspiring, as it did, to a syncretism of the arts. In practice almost all the experiments of this kind were reducible to what was called *Tonfarbe* or *audition colorée;* they aimed at establishing purely phonetic-chromatic relations or at subordinating poetry to music, as did Wagner and the decadents, subordinating the words to the *chanson.* On this account, precisely, there are very many works in modern lyric poetry indicating, in their titles at least, the aspiration to melodic modes, reaching toward "the condition of music." Take, as random examples, Léon Paul Fargue's *Gammes* and Umberto Saba's *Preludio e fughe.* The contrary procedure is analogous: in Claude Debussy, musical description and colorism seem to be leading the music to the condition of poetry or painting.

But later experimentalism wished to or, better, dreamed it could go far beyond that; fundamentally we here have wishful thinking, intentions, programs, pure and simple. Starting from the theory of *typographical emphasis,* dear to Mallarmé in his later phase and to

the futurists, which gave a page of poetry the guise of a poster or a musical score, Apollinaire added to it what he called *visible lyricism:* a graphic-figurative correspondence between the manuscript or printed poem and the sense or imagery of that poem. He was thus repeating, unwittingly, Hellenistic experiments but taking seriously what had in other times been considered a game. In Apollinaire's footsteps, although remaining on the purely theoretical level, Reverdy went so far as to postulate a *plastic lyricism*. And Léon Paul Fargue proclaimed: "To us, ideographic symbols, shaped writing, tasted words, the New Mexico!" To the illusion that the arts were interchangeable and mutually correspondent, there was often united a childish belief that a transformation which was not formal and organic, but external and mechanical, could have a final and absolute value, rather than a merely instrumental and relative one. As an extreme example of such a belief, suffice it to cite the so-called comma poems of the young Philippine-American poet José Garcia Villa, in which the space between each word is occupied by that punctuation mark: a purely arbitrary graphic novelty in which the poet claimed to see a literary equivalent of . . . Seurat's pointillistic paintings!

Avant-garde experimentalism must be observed in its more common and current manifestations, not only in such extreme and absurd extravagances. The former must then be contrasted, on one hand, with the superficial and discrete experiments of the conventional artist and, on the other hand, with that will to style which distinguishes some of the most eminent artists of our period. From the second contrast it will become clear that avant-garde experimentalism is not always a desperate and sleepless search for individual expression (as in Joyce's case) or, even less, for perfect and ideal form (as in Flaubert's). In each of these two writers one has to do with an extreme, modern version of the classical *apprentissage* or mastery. And the fervent, life-long patience with which Flaubert and Joyce (it was Pound who first compared them) sought the ideal of a material that always and everywhere becomes form only through the miracle of style really does seem classical, at least in its reasons

and aims, despite all its heroic or dionysian tension. From this point of view we might even say that an experimentalism aiming solely at novelty can end up sterile and false. Thus the same Valéry, who defined genius in a famous verse as a "long impatience," recognized elsewhere in his writings that "the ideal of the new is contrary to the requirements of form."

What we said about Flaubert and Joyce can perhaps be repeated for Picasso and Stravinsky. They, like many of the greatest avant-garde artists, do not limit their experiments to the avant-garde itself, but in their anxious search for a new and modern classicism often work with the taste, style, and even the mannerisms of neo- and pseudo-classical forms. The experimentalism of such artists is a kind of aesthetic Faustianism, a search for Eldorado and the fountain of youth, for the philosopher's stone in the sphere of artistic creation. Fundamentally, the least important avant-gardism is that which limits itself to transmitting the material of art or renewing its language, even if such is the most frequent and typical. In certain arts, especially music (think of Schoenberg and his followers), avant-gardism seems to exhaust itself almost completely in technical-stylistic metamorphoses. If in the best cases the experiment does become an authentic experience (in the most profound sense of the word), all too often, in the more literal-minded and narrow avant-gardes, it remains merely an experiment.

Experimentalism so conceived is at once a stepping stone to something else and is gratuitous; if one looks closely it is, when not harmful, useless or extraneous to art itself. But socially it is a very interesting fact, since it tends not so much to form the artist as to transform the public, that is, to educate it. From such a point of view, the whole avant-garde functions like the theatrical variation of it which is appropriately called *experimental theater*—a theater that in fact aspires to educate the author and actor of tomorrow through the process of educating the spectator of today. Avant-garde theater, chiefly aiming to educate the spectator, thus shifts from private to public experimentation. There are those who believe that the primary end of avant-garde literature lies precisely in thus being not a display

case or salesroom but a free, or at least an open, laboratory. The publisher James Laughlin expressed this view, in the preface to his third anthology of "exceptional" writers (1938), when he declared that his own publishing house, New Directions, intended "to print the best work *of a certain kind*—the best *experimental* writing" and was "not a salesroom but a testing ground . . . a laboratory for the reader as well as the writer." This conception is one of the splendid commonplaces of avant-gardism, as shown by the fact that Eugene Jolas attributed the same function to the famous journal he edited. In the introduction to an anthology of the then defunct *transition* he retrospectively defined that review, using nearly identical words, as "a proving ground of the new literature, a laboratory for poetic experiment."

"Laboratory" and "proving ground"—these are phrases suggested by the scientific and industrial technology of our time, and it would perhaps be wrong to regard them as metaphors, pure and simple. They reveal above all a concept of artistic practice which differs radically from the classical, traditional, and academic one. The laboratory and the proving ground doubtless serve to train the artist: that is, they aim toward his perfection as an artist; this is profoundly different from the goal of a school, which is the perfection of the school itself. The laboratory and proving ground serve, in the second place (perhaps it is really the first place), an even higher aim: the technical and scientific progress of art itself. It is indeed precisely the use of such images which suggest the ideal of the avant-garde artist as an obscure artisan who consecrates his own life and work to the future triumph of art. The images, in brief, help us to recognize both the kinship between experimentalism and the activist, agonistic, and futurist tendencies and the relations that bind avant-garde culture to modern praxis.

Experimentalism so conceived basically results in the contradiction or negation of the purely aesthetic end of the work of art. And although the avant-garde cannot renounce the experimental moment, which it indeed glorifies to an extreme, it has often felt a need to confess the paradox and to resolve the equivocation. Perhaps it was an awareness of such an ambiguity which dictated as a subtitle of

transition, "an international quarterly for creative experiment." In nobly aspiring to an impossible synthesis (creation *and* experimentation), the coiners of this phrase perhaps wished to assert the coincidence in aesthetic-psychic time of the moment of experimentation and the moment of creation. In reality, experiment precedes creation; creation annuls and absorbs experimentation within itself. Experiment fuses into creation, not creation into experiment. The negated alternative, even though it is considered by many avant-garde theoreticians as the ideal situation, is an inadmissible hypothesis. Creation resolves experiment, or transcends it: the experimentation that is not, as such, annulled tends to remain not only *ante-* but *anti-*creation.

Scientificism

We have already stated, and examples like rational architecture further suggest, that the avant-garde's experimental nature is not essentially or exclusively a matter of art; this circumstance separates it from the formalistic searches of traditional art and from many modern currents as well. What Pareto called the "instinct for combinations" in fact leads the modern artist to go beyond art forms and to experiment with factors extraneous to art itself. The experimentalism of some avant-gardes, especially some of the more recent —surrealism, for example—is largely a matter of content, that is, psychological. The issue is not so much experiment in the technical or stylistic realm as experiment in the *terra incognita* of the unconscious, the unexplored areas of the soul. In this regard, suffice it to cite the influence of psychiatry and the doctrines of some of Freud's rivals on the subject matter of art, especially important in surrealist poetry but also in painting. Sometimes, as in futurism, what occurs is nothing but vulgar experimentalism, formless and imitative, which works with the raw material of art, introducing mechanical ingredients (the cuebars or noisemakers in Russolo's futurist theater) or really foreign bodies (the more ingenuous collages, false moustaches or real eyeglasses on statues or portraits).

Such excesses once again reveal the eccentricity and infantilism

we have already defined—but here they play games with technical elements. Now, the cult of technique is certainly not exclusively modern; it may even seem characteristically classical. But what often triumphs in avant-garde art is not so much technique as "technicism," the latter defined as the reduction of even the nontechnical to the category of technique. "Technicism" means that the technical genius invades spiritual realms where technique has no raison d'être. As such it belongs not only to avant-garde art, but to all modern culture or pseudo-culture. It is not against the technical or the machine that the spirit justly revolts; it is against this reduction of nonmaterial values to the brute categories of the mechanical and technical.

Such a consideration resolves the problem of the links between contemporary culture in general, avant-garde art in particular, and science (or, better, applied science, popularly confused with science-without-adjectives). We must elsewhere speak of the relation to science in terms of theory, from a different and higher viewpoint. The avant-garde thinker or artist is, at any rate, particularly susceptible to the scientific myth, as a few examples can easily show. The prestige of the myth is aptly reflected in Rimbaud's aesthetic formula, "the alchemy of the word," as it is in the formula, dear to Ortega y Gasset, "the algebra of the word." The titles of numberless works of our day are scientific metaphors: Corrado Govoni's *Poesie elettriche;* Blaise Cendrars' *Poésies élastiques;* Max Jacob's *Cornet à dés, Cornet à piston, Laboratoire central;* Tristan Tzara's *Coeur à gaz;* André Breton's *Vases communicants;* the *Camps magnétiques* of Breton and Philippe Soupalt; or the pseudo-mathematical formula with which Ardengo Soffici baptized one of his first books, *Bif & zf + 18* (the Florentine printers read it as "Bizzeffe" so as to be able to pronounce it). The avant-garde predilection for arithmetical titles, inspired by a bizarre numerology, is analogous: the *150,000,000* of Vladimir Mayakovsky (here, however, the number refers to the future population of Soviet Russia); or the cipher *291,391* which Picabia chose as a title for a surrealist periodical. Perhaps these are *bizarrerie;* we must not forget, however, that in some cases the mania they seem to express did try to make itself a method and system, giving birth, for example, to the folly René Ghil called *scientific poetry.*

These and other examples show that the mechanical-scientific myth is one of the most significant ideological components of our civilization and culture. It is neatly caricatured by the Russian Evgeni Zamyatin in his utopian novel *We*, when he imagines a distant posterity considering the timetable or general directory of the railroad as the unequaled and supreme masterpiece bequeathed them by this century. Zamyatin's irony gains in eloquence when one remembers that he was an engineer by profession and lived in that revolutionary Russia where, at the time the book was written, constructivism flourished. This poetic movement, in purposeful harmony with so-called socialist edification, tried to inaugurate a technical-structural functionalism in the word-arts. On the other hand, the irony of the American customs office was involuntary when it refused to consider Brancusi's functional Bird in Flight as a work of art, but taxed it with the import duty for manufactured metals.

Avant-garde scientificism remains a significant phenomenon even when one realizes that only a purely allegorical and emblematic use of the expression "scientific" is involved. Besides, this symbolic use is made possible by a view of the world that reduces all powers and faculties, even spiritual ones, to the lowest common denominator of the scientific concept of energy. This means that avant-garde scientificism is the particular expression not only of the cult of technique, but also of that general dynamism which is one of the idols of modern culture and was elaborated into a cosmic myth by romantic philosophers. And perhaps it was as an unconscious reminiscence of the metaphysical-scientific mythology of the German romantics that Jean Cocteau defined poetry as an "electricity," a definition dictated by the idea of a double dynamism, physiological and physical.

Sometimes avant-garde scientificism is the naive and simple cult of the miracle, prodigy, and portent. Many moderns look at science almost with the eyes of savages or children, and reduce it to magic. Evident enough are the connections between Massimo Bontempelli's aesthetic doctrine, so-called *magic realism*, and his sympathy for modern life, the city and the machine. Children treat

machines as monstrous toys; thus the modern artist breaks the machine-toys of art to see what makes them go. Precisely on this account avant-garde experimentalism sometimes takes on the character of a gratuitous act, producing strange discoveries by the game of chance. Following the primitive's example, the modern man or artist sometimes seems to consider the machine not only as a source of energy but also as the fount of life, an end rather than a means, and thus treats the machine itself as more valuable than anything it produces.

Humorism

This machine cult, along with similar cults, maintains an ambiguous and equivocal relation between art and science at the heart of modern culture. The artist who momentarily lets himself be seduced by the quasi-magic scientific Faustianism of modern genius becomes abruptly conscious of how easily in a society like ours science gets fatally vulgarized and thereby, distantly but directly, produces much of the ugliness of contemporary existence, above all, the mass culture that the avant-garde opposes. The naiveté of modern man can only be relative—hence the alternating phases of enthusiasm and irony with which he faces modern civilization. The irony shows itself in mocking and grotesque forms and stems from a tension that seems perfectly to fit Bergson's definition of the comic as a contrast between free human vitality and the automatic rigidity of the machine. But often avant-garde irony is called forth by a sense of how empty are the miracles that science seems to promise. In such cases the irony can become pathetic and tragic, focusing not only on the way the machine fails man, but also on the way man fails the machine. Thus avant-garde art can be transformed into a criticism of modern life and a protest against man-the-machine. Such was certainly one of the aims of German expressionism; in fact, Lothar Schreier defined it as "the spiritual movement of an epoch which put inner experience above external life." Another expressionist, Hermann Bahr, formulated the crisis that expres-

sionism intended both to embody and to resolve as follows: "Reduced to a pure means, man has become the tool of his own work, which has been senseless since it began to serve nothing but the machine. And that robbed man of his soul. Now he wants it back. That's what is at stake." From this point of view the expressionists, perhaps better than other avant-garde artists, understood the impasse in our culture which Alfred North Whitehead so lucidly formulated in his *Science in the Modern World*: "In regard to the aesthetic needs of civilised society the reactions of science have so far been unfortunate. Its materialistic basis has directed attention to *things* as opposed to *values* . . . It may be that civilisation will never recover from the bad climate which enveloped the introduction of machinery."

Expressionism, despite its lucid consciousness of the problem, was too exacerbated and paroxysmal to resolve it or even to put it in suitable terms. The consciously or unconsciously humorous formulation of the problem seems much more easy and felicitous, although gratuitous and minor. One of the peculiar or dominant forms of antiscientific humorism is *black humor* or, to use an epithet dear to André Breton, *black bile*. Breton preferred to define this species with the arbitrary term of *umor* (without the initial "h") to underline how new or rare it was, and to separate it from the innocent British humor. This pathetic, grotesque, and absurd type of humorism favored by certain avant-garde currents has an obvious kinship with romantic irony and also with the *spleen* of Baudelaire and the decadents.

A humorism with these ingredients works, above all, on the formal mechanism of modern life which it serves to annihilate or exhaust, following the usual paradox of comedy. Its chief weapons are verbal and formal: hence, to choose examples limited to French avant-garde poetry after the First World War, we have the sympathy for *coq-à-l'âne*, word play, that phonetic caricature which Valéry recognized in Fargue's lyric poetry, and the adoption on a less innocent or more mature level of what the English call *nonsense verse*. Thus, at times that humorism chose art itself as the butt of its jokes,

which explains its inclination to parody and caricature. And this even happens in the less reflective art form of music: for example, in certain of Prokofiev's pastiches and those mocking compositions that Eric Satie produced under titles like *Sonatina burocratica* and *Pieces in the Form of a Pear*.

If parody's typical expedient is inversion, caricature's is perversion; in any case, it is a short step from one to the other. The tendency to fantastic perversion is often visible in the cult of bizarre titles, sometimes signifying nothing, as with the surrealist reviews *Bifur* and *Disc Vert*, sometimes hiding the original meaning in arbitrary or recondite variations, as in the case of the Florentine review *Lacerba*. The series of abstrusely grotesque titles is endless: many of André Breton's, *La Poisson soluble* and *Le Revolver aux cheveux blancs;* Salmon's *Manuscript trouvé dans un chapeau;* Mayakovsky's *Cloud in Trousers,* and so on and on. Even before surrealism proper, Apollinaire wrote what he called a "surrealist drama," *Les Mamelles de Tiresias.* Mayakovsky later composed a drama suggestively titled *Mystery-Buffooned,* which remains one of the most bizarre works in the avant-garde theater, along with Marinetti's *Re Baldoria* and, first and foremost of all, Alfred Jarry's *Ubu Roi,* with its famous reiteration of a slightly varied phonetic equivalent of what we call "a four-letter word" and the French, the "mot de Cambronne."

A special form of avant-garde humorism is surely the attitude called *fumisterie,* after Laforgue's *Pierrot fumiste.* That attitude is of course present even in more conventional poetic currents, such as *poesia crepuscolare* and *fantaisiste.* Fumism is merely a species of infantile cerebralism and is obviously related to another attitude, *funambulism.* The Parnassian Banville was probably following in the footsteps of Baudelaire's well-known prose poem, picturing the artist as acrobat, when he invented the myth of the wirewalking artist in the first of his *Odes funambulesques.* The myth caught on quickly and later was melded into variants of the white-face clown and the fall guy. Certainly it inspired Picasso's harlequins, dictated the fifth of Rilke's *Duino Elegies,* and finally created the Chaplin-Charlot legend. Palazzeschi had already summed up these same motifs in one of his infantile and buffooning pieces of art prose,

which assigned to the artist the task of being "the *saltimbanque* of his own soul." The motif was destined to become popular, so much so that two writers as traditional as Thomas Mann and Leonid Andreyev made it into the type of the artist-actor or buffoon, "he who gets slapped." But the two principal variants remain the most meaningful: the allegory of artist-acrobat suggests the tendency to dehumanize the human and to mechanize the vital; the allegory of the artist-Pagliaccio emphasizes his destined humiliation and alienation.

Nominalistic proof

It now only remains for us to consider avant-garde criticism, aesthetics, and historical position in reference to modern art as a whole. We have arrived at the place to stop and sum up what has been said so far; as at the beginning of our inquiry, I shall use the verbal concepts of avant-garde and movement as an organizing device. These verbal concepts are simple postulates from which a complete series of corollaries was deduced, and we shall now use them, by the same semantic method, to demonstrate the concrete reality of the tendencies thus far described abstractly.

From the quantitative and qualitative point of view (from statistical frequency and the degree of theoretical-practical influence), the first and most important category of terms is the one underlining the moment of antagonism, without necessarily distinguishing between antagonism to the public and antagonism to tradition. Sufficient as examples would be the Independents, the *fauves*, and the Secessionists; or, with a different emphasis, decadence and futurism. These are all names which also allude to alienation in its social-economic, cultural-stylistic, and historical-ethical variants. Anti-traditionalism and modernolatry are not so much secondary names as the categorical imperatives of the futurist movement, which possessed in its name the most successful and suggestive formula thought up by the avant-garde—a paradox, though a meaningful one, inasmuch as the movement was one of the lowliest and most vulgar manifestations of avant-garde culture.

This category is followed by the one naming the tendency or moment of agonism: the Russian acmeism (from the Greek *acme*); verticalism, postulated by some of the *transition* collaborators; Hispano-American ultraism; Yugoslav zenithism; the movement organized by the English poet Henry Treece under the banner of the Apocalypse. Beyond all these programmatic names, the agonistic tendency appears clearly in the name of a movement in the plastic arts which briefly flowered in Russia after World War One, self-identified as suprematism.

The class of names underlining the moment of activism has few or no examples, and the general term "movement" already expresses it sufficiently. We might perhaps put vorticism in this class, but that name seems instead to vibrate with an overtone revealing the presence of nihilism.

So far, we have only cited the names of better-known organs and groups. But numerous and frequent are the names of movements which lasted only a day or which boiled down to pure and simple wishful thinking, mere names or programs. Still, it is worth while mentioning them because they are symptomatic, however pretentious and ephemeral they may have been. In an excellent textbook aimed at students of modern French literature in American universities, a compilation of poems and critical writings made by the late Régis Michaud, the author gave a long outline of French avant-garde movements, which rose and fell in a single instant, presumably in the wake of Marinetti's Franco-Italian futurism. I am cheerfully willing to confess that I have seldom heard a single one of these innumerable names spoken, with the one exception of the last on the list, Jules Romain's unanimism. Leaving that one out, here are all the names on Michaud's list: Paroxysme, Synthétisme, Intégralisme, Impulsionisme, Sincérisme, Intensisme, Simultanéisme, Dynamisme. A rapid examination of these merely verbal entities shows the presence of the activist myth in dynamism and impulsionism; while paroxysmism emphasizes agonism and nihilism. Synthesism and integralism seem intended to point to particular aesthetic tendencies, such as syncretism and abstract art. We might

perhaps recognize in simultaneism a variant of historical futurism, or futurism in general, while the labels of intensism and sincerism seem to allude to particular contents or attitudes of a primarily psychological nature.

There are in avant-garde history numerous and ambitious names of a general and synthetic nature, such as naturalism, expressionism, and surrealism, in which the intention is to elevate the term—almost always aesthetic in origin—to a universal concept and philosophical category. But even more frequent are composite names, created by artificial combinations instead of any genuine synthesis, mingling words or notions which are not homogeneous because they belong to differing art forms or differing spiritual categories. Examples in Germany are *die neue Sachlichkeit* (the new objectivity); in Russia, cubofuturism and egofuturism. For obvious reasons, names indicating an experimental tendency in any pure state are rare in literature, although frequent enough in the other arts. Painting counts here with such names as impressionism, divisionism, and pointillism, but the only two literary examples are fundamentally the same: Russian imaginism and Anglo-American imagism. However, there is no lack of names revealing the cult of technique, even in the less empirical arts, such as the already mentioned and long-dead Soviet constructivism. A characteristic sign of the importance that the still living romantic myth of the Zeitgeist has for the avant-garde spirit is the name of the Italian movement and review using the historical term "Novecento."

To take up, once again, a distinction formulated at the start of this inquiry, we might perhaps say that, quantitatively, the program names are inferior to the manifesto names. This again indicates that, within avant-garde ideology, psychological and sociological factors prevail over aesthetic factors and over the predilection for publicity-minded and propagandistic positions. From this point of view one can also understand why the stroke of genius which is "futurism" succeeded so well. The one name that succeeded in anything like a comparable way was "cubism," and it is technical and aesthetic in content. Another successful formula was "surrealism," which aimed

at a meaning no less universal than did symbolism, perhaps even more so. The avant-garde also created a rather successful name in the two senseless syllables *da-da:* fair enough, precisely because dadaism expressed, with the greatest possible intensity, the nihilistic impulse. Certainly it is not an exceptional or fortuitous circumstance that these four names are historically and symbolically the most important, just as the four designated movements were not only the showiest but also the most successful of all. In the dialectic of the more recent avant-garde, each of these four movements in fact represents a particular phase or aspect. Dada represents the ethical willfulness of, and for, them all; surrealism, the logical willfulness; futurism, their historical will; cubism, their aesthetic will. According to the terms of Bergsonian philosophy (typical of the avant-garde, in Benda's opinion), the first and second movements symbolize the phase of the *élan vital*, while the remaining two allegorize the category of *durée*. But altogether they suggest, almost without meaning to, the most important variations and the most significant attitudes of the modern state of alienation.

Thus the dialectic of movements is transformed into a system of almost metaphysical relations. Such a system, even though it is only an effect or product, is transmuted in turn to a cause, and then exercises on the culture generating it an influence both formative and deforming. It becomes a dogma and a mystique, transforming avant-garde praxis into principle and doctrine. That dogma and mystique invade even the field of philosophy, conquering the historical and critical disciplines, dominating even the theory and historiography of art and literature. Briefly, those beliefs that initially tend to work as psychic stimuli in the creative area are transformed into theoretical formulas and operate in the critical area as well. These values, which seem destined to remain the object, become the subject, or at least the criterion, of judgment. By way of a small example, suffice it to cite the case of the Russian critical school called *formalism*, which was bound both directly and indirectly to the Russian variants of two important European movements, symbolism and futurism. That school formulated, among other things, a theory

of genres in which the particular variations of a given genre were conceived of as determined by the need to deny the canon and to surpass the norm—in other words, to stand the structure of traditional genres on its head. It is evident that such a doctrine was the direct effect of the transformation of a literary myth into a critical dogma; the consequence of the reduction of certain psychological tendencies of the avant-garde, such as antagonism, nihilism, and agonism, to historiographical norms and abstract principles. One must beware of such a danger; no one knows that better than this author, who has all too often let himself be tempted by the fascination of the game. It is only in the area of rhetoric that the very idea of the avant-garde can come to be treated as a hypostasis.

8. AVANT-GARDE CRITICISM

Prerequisites

We have studied the relation of avant-garde art to its two publics: the indifferent and hostile, traditional and academic one, and that public, as much more limited as it is more enthusiastic, of its followers and supporters. We have delineated the theoretical and concrete relations existing between the avant-garde and cultural-political ideologies. We have emphasized the bonds uniting avant-garde experimentalism with the instruments and manifestations of modern praxis, that is to say, with the machine, technology, and applied or industrial science. We have clarified the complex relations binding avant-garde art to the historical reality of its period, to the society it both expresses and rejects. We have, in sum, studied a series of perspectives external to the sphere of art and even of culture, strictly defined. Now it is time to examine the points of contact between the new art and criticism; that is to say, between the avant-garde creation and its reflexive awareness of what it has done.

Unfortunately, avant-garde criticism, instead of working autonomously alongside avant-garde art, has too often let itself be determined, in both the negative and the positive way, by the avant-garde spirit. That spirit has historically conditioned criticism in a more

decisive manner than has avant-garde art, if not by necessity, then by contingency. Critical judgment, in other words, instead of tending toward a conscious reconstruction of the ambiance of the works or toward an intelligent interpretation thereof, has preferred to develop the subordinate task of controversy and polemic, of propaganda for or against. The effect of this tendency is almost always that the historical-critical judgment of the generic phenomenon of avant-gardism, or of its specific products, has failed or missed the mark. For this reason we cannot talk about avant-garde criticism without formulating a theory for it or outlining a criticism of that criticism. In brief, we cannot say what it really *is* without saying what it *ought to be*, at least theoretically.

It is obvious that the task of avant-garde criticism is to understand the avant-garde before judging it. But what does it mean to understand avant-garde art? First, it means to grasp its validity: to justify or at least provisionally accept the fact that it does exist, to consider it a necessary condition, if not a destination at least a starting point. And once again Ortega has found the proper point: "In art, as in morality . . . one must admit the imperative of the work imposed by the period." The public for avant-garde art, that is to say, the intellectual elite sustaining it, is by definition a group of people who consider it the sole artistic program possible in our time. The error of that public or elite consists in confusing, within the object it is judging, intentions with results, which ought to be separated. But that does not negate its purpose, which is to keep faith in the postulate that avant-garde art is necessary. The existence of such a public, elect and restricted, along with the existence of the more vast and amorphous public it opposes, is furthermore both the cause and the effect of the contemporary situation of art. The principle already established by Ortega holds firm: avant-garde art provokes within its cultural-social ambiance the formation of two classes of individuals, those who succeed in understanding it and those who are congenitally unfit to grasp it.

If we concede that the task of an elect public is not to formulate

a permanently valid critical judgment, but to welcome sympatheti-
cally a given revolution in taste, the necessary and sufficient con-
dition for membership in the intellectual elite would then be an
intuition of the historical mission of avant-garde art (more important
than any evaluation of its specific contributions or even any under-
standing of the aesthetic meaning of its message). Also, in the prac-
tical area, we must recognize that one need not understand each of
the individual or collective manifestations in which that art unfolds
in space and time. Taking the terms rigorously, it is not necessary
to comprehend even *one* of those manifestations in its entirety or
perfection. One may ignore futurism or cubism, surrealism or da-
daism, even while comprehending the sense and function of avant-
garde art as a whole. What counts is to grasp some of the aspirations,
tendencies, and works of the avant-garde experience as it progresses
and to square it off in a vision of the whole.

It must not in fact be forgotten that admirers by hindsight
abound—for example, those who love and understand only impres-
sionism and reduce avant-garde painting to the epigones of that
movement. They do so precisely because time has now made familiar
and customary all which in the work of the early impressionists
initially seemed to deviate from the rule and to violate the norm.
Analogous here is the fallaciousness of those artists whom advanced
literary opinion has designated by the felicitously ironic French
formula, *pompiers de gauche* (leftist firemen). But it still remains true
that the paradoxical hypothesis of a certain incomprehension of
particular movements, accompanied by a comprehension of avant-
gardism in general, is, for all its improbability, at least theoretically
admissible. At any rate, such a hypothesis should be kept in mind
if only to avoid the dangerous and equivocal doctrine which claims
that special initiations, beyond the pure and simple initiation of
principle, are indispensable to the understanding of avant-garde art.
This initiation into the general principle coincides with a particular
forma mentis, an intuition that is also a sort of calling, and this quality
or faculty is fundamentally the only indispensable requisite.

The Problem of obscurity

The distinction between a primary, fundamental, and absolute initiation and the ulterior ones, supplementary and relative, is extraordinarily important and by itself negates the erroneous opinion that the later ones, however useful they may be, are necessary. Hostile critics claim that avant-garde art can be comprehended only by means of a series of multiple initiations, but they claim this only as a way to condemn it *a priori,* for these critics start from the assumption that any art of the initiated has only a negative value. That is the meaning of the charge of incomprehensibility and obscurity which critics constantly hurl at all avant-garde art. Many avant-garde followers in their turn make this charge into an easy boast and an empty glory, calling the obscurity and incomprehensibility by more prestigious names, such as ineffability, hermeticism, or "the demon of analogy." In this respect, too, they proudly accept the challenge of their adversaries, taking on the insult of others as their own slogan, as they had already done with other originally derogatory formulas or labels, such as cubism (from Matisse's "trop de cubes"), decadence, or *salon des refusés.*

However that may be, the obscurity and incomprehensibility of modern art is not only an easily stated fact but also a difficult charge to answer. What is problematic is certainly not the conventional and willful obscurity which the avant-garde shows off to distinguish itself as a group. As Thorstein Veblen says, "Except where it is adopted as a necessary means of secret communication, the use of a special slang in any employment is probably to be accepted as evidence that the occupation in question is substantially make-believe." What is worth taking into account is spontaneous and authentic obscurity, a characteristic phenomenon of the most genuinely modern art. It does not exclusively derive from the antagonistic genius or the experimental cult. For this reason the hermeticism that distinguishes so much contemporary art is considered by many people as a substantial, rather than accidental, fact. Such is Ortega's opinion, and someone as different as T. S. Eliot agrees

when, for example, he declares, "it appears likely that poets in our civilization, as it exists at present, must be *difficult.*"

Despite such authoritative affirmations, it is still possible to admit that the peculiar "difficulty" of avant-garde art is not an absolutely distinctive characteristic. Hermeticism is certainly not its primary element, and even less is it exclusive to avant-garde art. It was the universal act of writing, not the specific one of composing in his own modern manner, that Mallarmé defined as "putting black on white." If obscurity is one of many pre-existent tendencies which the avant-garde revived and made its own, we must say that in this case the process was perhaps less intense, less profound, and less new than usual. At least, here we do not seem to be dealing with a radical metamorphosis.

Many avant-garde artists and critics, in any case, have defended or justified their own occultism by proving the presence and frequency of obscurity even within the bosom of traditional art, even in the most celebrated and lucid classical works; by so doing they have succeeded in establishing extremely valid precedents. With equal facility they have established precedents reaching back even further, back to archaic or primitive art. This is polemically a less efficacious argument, or a less felicitous parallel, insofar as it is based on an antithesis less obvious than that between avant-gardism and official academic tradition. It is in fact based on a dubiously hypothetical continuity between original, spontaneous primitivism and the neoprimitivism which is one of the many masks of modern art (not one of its many faces).

Be that as it may, these artists and critics are right in asserting that obscurity and hermeticism are not new things in the history of art. Furthermore, we might go so far as to say that a certain type of hermeticism is more intimately connected to some of the cultivated or courtly forms of traditional art than it is to modern art as a whole. This kind of hermeticism is certainly more appropriate to schools than to movements: think of Provençal poetry and the Minnesingers, of the *trobar clus* of Arnaut Daniel and even Dante's *dolce stil nuovo*, of Petrarchism and *secentismo*, of the English metaphysicals and

Spanish *culteranismo*. Nor should we on the other hand forget that an obscurity of this type had already appeared in certain orphic and mystical tendencies of the romantic lyric even before it appeared in the bosom of avant-garde art, properly so called. We must finally note that even within avant-garde art proper, obscurity is more intensely exploited by those circles or special groups called cenacles or sects, particularly in certain *chapelles* of decadence and symbolism.

Besides, all that has only relative importance: what counts and is to be emphasized is the fact that despite everything the obscurity of avant-garde art is not resolved solely by recourse to exegesis. This, never absolutely necessary for a well-disposed or prepared reader, cannot be enough when the reader-spectator is incapable of overcoming his innate antipathy. Without denying the efficacy of education and familiarity, the obscurity of modern art will remain an insurmountable obstacle for those who consciously refuse to give at least a provisional assent; but for those who can assent even if only in principle, the most arduous asperities will be surmountable, the works most resisting understanding made accessible. The interpretation of avant-garde art is then essentially not a problem of exegesis but of psychology, since it is only after being made possible by factors of calling and attitude that interpretation is made easy by education and familiarity. To a contemporary reader—he need not be particularly forewarned so long as he is not congenitally hostile— Rimbaud's poetry, which elicited such resistance from the public of its own day, can be clear enough without excessive exertions; indeed, it even seems much less difficult, owing to the vulgarization of its forms and motifs, than does the poetry of Pindar or Petrarch, of John Donne or Maurice Scève. But whereas the problems offered in interpreting these old masters can only be solved by the necessary philological preparation, making possible a historical *reconstruction* of the conditions in which the works were created, the generic and specific problem continually offered by contemporary art cannot be resolved except through a mental *construction*, based on the intuitive awareness of the historicity of artistic experience in our day. This postulates the capacity not so much to judge as to feel the

process of history which is passing from potentiality into act—considering it not as a monument or document, but as drama and action, as work in process.

If such is the principal task for avant-garde criticism, we must then, without further ado, condemn that type of modern criticism which prides itself on being more recondite and occult than the creation itself. Nothing could be more paradoxical than what was called in Italy, all too justly, hermetic criticism, precisely because it was not intended to reveal but to veil even more darkly the mysteries of the poetry also called hermetic. Criticism of this kind tends to overvalue obscurity and to consider it a particular merit and attraction of the work, above all because it gives occasion or pretext for the interpreter's virtuosity. From that derives the Byzantinism of contemporary literary journalism, the apparition within our culture of real and true mandarins of criticism. The phenomenon is doubtless sickly, because, while art can be aristocratic, mysterious, and ambiguous, criticism ought always to exercise a democratic function, that is to say, an educative and clarifying function. If the classical critic addresses himself principally to the artificer, the avant-garde critic all too often addresses himself to a few critics in his own sect, thus betraying another tradition of modern criticism—which, following a noble romantic and nineteenth-century tradition, is to address itself to the public and to illuminate both the work of art and the spirit that contemplates it.

Judgment and prejudgment

In a sense we might say that all one need do to understand avant-garde art is to understand its starting point. This does not, of course, mean that it is useless or irrelevant to know where it is going, any more than it means that it is easy to put its achievements to the test of evaluation, as all aesthetic criticism must do. What it does mean is that neither understanding it nor the initial act of faith in it requires any special hermeneutics, except what is needed to understand any work of art, any literary text. We must repeat that, to judge

avant-garde art, exegesis is only an accessory expedient; but to interpret "culture," erudite art of the classical sort, it is a necessity. Still, interpreting means evaluating, and evaluating avant-garde art turns out to be an arduous task even for those who look at it from within—a desperate undertaking to those who look on from the outside. Hence one inevitably concludes that it must be accepted with patience and indulgence, not with the disdain it usually receives from its first judges, the recurring lamentation of the common reader, viewer, or listener when he is set in front of a poem by Mallarmé, a painting of Picasso, or a composition by Schoenberg: the lament, that is, of "I don't get it." This holds true, naturally, even when the lament has the ring of a sincere confession instead of an oblique accusation.

The humility and candor which mark such confessions are almost always missing in the declamations of the official representatives of hostile criticism. What these critics show themselves particularly incapable of doing is contemplating the avant-garde with a historian's serene gaze. And that is all the more strange since their favorite argument is to claim the authority of history. When they compare modern creations with the great masterworks of the past, they are not discriminating, they are being discriminatory. Hence their ears are deaf to an appeal as noble, eloquent, and moving as Apollinaire's:

> *Vous dont la bouche est faite á l'image de Dieu*
> *Bouche qui est l'ordre même*
> *Soyez indulgents quand vous nous comparez*
> *A ceux qui furent la perfection de l'ordre*
> *Nous qui quêtons partout l'aventure.*

So we can say that hostile critics often, indeed always, have eyes and see not, ears and hear not. However, *they* are the very ones who accuse avant-garde artists of having eyes to see with and ears to hear with, but of using them in a way that is aesthetically, psychologically, and physiologically abnormal. An exemplary formulation of this type of criticism is the quadruple *bon mot* that the American

teacher-poet William Ellery Leonard tossed at the poor imagists (which may be found in Glenn Hughes's study of imagism)—certainly felicitous as rhetoric and as a polemical shot:

1. *The Imagists can't see straight.*
2. *The Imagists can't feel straight.*
3. *The Imagists can't think straight.*
4. *The Imagists can't talk straight.*

A judgment reached in this way is exemplary or symptomatic of all hostile criticism; the ease with which these four phrases can be turned into a series of critical categories, polemical and negative, proves it. These categories we shall study later; now suffice it to say that the four lines anticipate what we shall have to call the pathological prejudice, which condemns modern art en bloc by way of the concept of *degeneration*. We may also add, even at this point, that each of the lines calls up a concrete and particular preconception. To say "they can't see straight" relates to the critical prejudice which condemns what we shall call *iconoclasm* in art; "they can't feel straight" alludes to the process already defined as *dehumanization;* not thinking straight refers to the inclination toward the cerebral and irrational; not speaking straight, to obscurity of style and hermetic expression. The complex of references is enough to show how such a judgment typifies not only the ignorant but also the learned public, the academic and traditional intelligentsia.

Without going into the justice of the claims in any particular case (whether the charges fit the group of poets at whom they are directed), we certainly can say that even in the area of criticism the majority of avant-garde artists show themselves easily one up on their adversaries when it comes to thinking and speaking straight. This is not saying much, since few are the hostile critics who try to attack avant-gardism directly as art without an adjective, a "rightness" of attack that would make up even for wrong premises. The majority in fact prefer to attack it from the viewpoint of its extra-aesthetic peccadillos, the avant-gardists' violations of the book of social etiquette or the moral code. Many attack it for denying those cultural

ideals it never intended or pretended to serve. We shall talk more about these opinions at the end of this chapter, discussing those two equally adverse but opposing critical schools, the left and the right.

Let us observe here only that the evaluations offered by these two types of criticism are from the outside, just as that offered by pure and simple aesthetic traditionalism is an evaluation from below. In one as in the other case the judgment cannot be carried out, because it is actually the same, or at least an analogous, prejudgment in two contrasting variations. But the only possible judgment comes from within, even though that alone is not enough, and the truly worthy judgment starts from within but goes beyond. This judgment transcends its favoring prejudice, however useful or necessary, and makes itself, so to speak, a postjudgment. In other words, the judgment of the critic on modern art must begin as a contemporary judgment and end as a posthumous one. Great criticism starts with the Zeitgeist but tends to anticipate posterity.

We must not in fact forget that, as the bourgeois is afraid of being *épaté* and so denounces modern art en bloc, the aficionado often fears to be taken for a bourgeois if he expresses doubts or even justifiable reservations about this or that work, this or that movement. Now, if opinions dictated by alien or external perspectives are not realized in judgment, what remains too intimately bound up with the experience-as-it-happens rarely rises to the level of critical vision and remains on the level of sentimental adherence, solidarity, and sympathy. A genuine judgment is possible only when the judge, after forming within himself the historic awareness of what the Zeitgeist demands, lifts his own gaze above the object and contemplates it under the species of the universal.

The universal we are talking about is naturally an aesthetic universal: the universal of form, not content. But it is therefore worthwhile noting, by the way, that avant-garde art does not seem to aspire to any other universal, aspires so little that Ortega even affirms its nontranscendence as a principle. Malraux proclaimed the same truth when he entitled the third part of his magnum opus with

the meaningful phrase, "the twilight of the absolute." In an earlier part he had already declared that modern painting, from the moment it became itself, ceased to "feel itself preoccupied by what had been called the sublime or the transcendent." Enough in this regard to observe that there is nothing of the metaphysical in modern art, not even in so-called metaphysical painting. This parenthesis is to be taken as a forewarning: when the reader in fact finds formulas like the *metaphysisic of the metaphor* and the *mystique of purity* in the following sections, he should instantly realize that metaphysics and mystique refer to the poetics and aesthetics of avant-garde art, not to any philosophy of being or any view of the world.

The most just and true criticism is no less alien to the metaphysical and to the transcendent than avant-garde art itself is. Yet it should always bring the object it studies in the abstract universal of aesthetics into the concrete universal of art history. That task is as necessary as it is arduous. In fact, it is precisely because of its aggressive historicism that such criticism rarely succeeds in taking a serenely contemplative position before its object. The antagonistic impulse innate in avant-gardism in fact extends even to avant-garde criticism, which is often militant in the literal sense and often yields to the temptation of putting culture in the role of the accused. Thus putting culture on trial was recognized by Malraux as a dominant tendency in the art and philosophy of our time. Besides, hostile criticism resists even more feebly when faced by the same temptation, although for different reasons; both end by subordinating their own judgment to the terms of a tradition extraneous to the object being judged. Just criticism ought to function in the opposite way. Instead of pretending to introduce the canons of a now static and dead tradition into the world of avant-garde art, it ought to transfer the latter into the idea and experience of a dynamic and living tradition. Tradition itself ought to be conceived not as a museum but as an atelier, as a continuous process of formation, a constant creation of new values, a crucible of new experiences. We have already alluded to the exemplary definition of this ideal given by T. S. Eliot and to the similar conception expressed by a poet of an earlier and more in-

genuous avant-garde, Apollinaire, in his felicitous verses: "Je juge cette longue querelle de la tradition et de l'invention/De l'Ordre de l'Aventure."

Only by an idea of tradition worked out in this way can the critic of the avant-garde rid his own mind of unfavorable prejudices and even of favorable ones; only thus can he avoid the equivocations of *pro* along with the misunderstandings of *contra*. This is what we meant when we spoke of a posthumous judgment: the necessity of thus overcoming the incubi of superstition as well as the gimmicks of fashion. Also, after having accused adverse criticism of so many sins and errors, we are obliged to admit the faults and failings of the other side. The latter we shall justifiably discuss at greater length if only because, despite any fault or error, it basically coincides with the most valid literary currents of our time. Its greatest defect must be seen precisely in its almost obsessive fear of not rendering new art the justice due it—a fear that sometimes paralyzes its judgment and leads this criticism to commit an injustice, however noble, against itself.

Exceptions to this rule are rarely found in the best criticism of modern art, but the *Fleurs de Tarbes* of Jean Paulhan is such an example. With sage discretion, he invites the masters of abstract painting to a less literal conception of their ideal of geometric purity. Another example is that essay of George Orwell's which reveals Salvador Dali for what he is, a painter joining an antiquated and frigid figurative academicism with a willful and extravagant content. That subject matter, and not in Dali alone, sometimes seems an agglomeration of the most heterogeneous materials, produced according to Lautréamont's recipe, which called for "the fortuitous encounter of a sewing machine and an umbrella on a dissecting table." Nothing serves better than this recipe to explain, even more than surrealist poetry itself, which indeed recognized in Lautréamont its supreme master, the painting of that movement. Surrealist painting is essentially literary and psychological rather than plastic and figurative, ready to trust its effects not to the severe language of style and form, but to the quasi-morbid shock of fortuitous en-

counters, where the jostling of mutually repugnant objects aims to symbolize the absurd complexity of the psyche.

It is obvious that, in the positions taken by Paulhan and Orwell, there is already a valid and explicit critique of the most important figurative tendencies of the contemporary avant-garde. The first in fact reminds the cubists and abstractionists that, although the geometric moment may be necessary, it is never sufficient. It ought to act not as the end of art but as a restraint; *decoration,* to use Bernard Berenson's terminology, is realized only as a function of *illustration.* And Orwell tells the surrealist painters that the marvelous is valuable only insofar as it transcends the bric-a-brac of mechanical invention, willful fusions, accidental or planned combinations. Such a teaching could serve as a warning or memento to artists and critics to heed the favorite theoretical distinction of the German romantics or of Coleridge and De Sanctis: the distinction between imagination and fantasy. It does not matter much if the latter reversed the verbal terms of the antithesis, because both groups understand the antithesis in the same way: an opposition between the conscious images of art and the unconscious ones of the psyche.

Surrealist painting is wrong when it seeks to justify itself by invoking such extraordinary precedents as Hieronymus Bosch, whose fantastic world is based on an abstruse but always systematic allegory. Modern art is certainly duty-bound to refute allegory, but does not thereby have the right to substitute for it thematic contaminations and strictly arbitrary iconographies which are motivated by the mere taste for scandal and surprise. There seems but little value in an art which fools itself into believing that it can attain to a new creative vision by taking as its subject the figuration of mental chimeras or an actual iconography of the impossible. The same doubts apply perhaps to more conventional abstractionism, to a painting and sculpture that tend exclusively toward self-contemplation as if they are themselves a mirror of absolute forms.

These errors are not only practical but theoretical; it is not just avant-garde art which is to blame for them, but its criticism as well. Fundamentally, modern art, much more than traditional art, works

in terms of a theoretical vision. When Valéry described the classicist as "a writer who writes with a critic at his elbow," he was not aware that he had perhaps better defined the modern or romantic writer. That critic who writes, thinks, and moves at the side of our artists is overly inclined to consider as an absolute, rather than a relative, value every new program and every new current of taste—in short, every aesthetic daydream, even a merely experimental or stylistic one, provided it shows signs of firming up in a current or movement. The old-fashioned critic, on the contrary, did not even take too seriously the concept—better, the phenomenon—called the school. In each school which one after another presented itself to his attention, the traditional critic in fact saw only minor variants, almost always insignificant, of what was for him the one valid, absolute, and eternal school, whose theory and practice consisted of the example and the teaching of the classics. When he met a practice or doctrine which repudiated that teaching or ignored that example, he refused it any merit and would not even call it a school.

In substance, the classical critic always looked at the work, even if he often contemplated it only from the outside and examined it only superficially. Intellectualized, yes, but only in the sense of the commonplace—and hence alien to any complex aesthetic problematics. That criticism always functioned as poetics, classical poetics, "normative" above all in the sense of normal and normalizing. In short, it was instinctively indifferent to any novelty and experiment, respectful of the rule of habit even more than of authority's canon. New historical and critical problems, which kept on being posed, one after another, over the passage of time and the flow of generations, changed that poetics according to a certain and continuous rhythm, but almost imperceptibly; the critic had only a vague notion of these changes and little clear awareness of them. The intellect viewed the world of art with a gaze so detached as to seem retrospective.

Our period, following upon romanticism, is instead and par excellence the age of multiple and mutable poetics, contradictory and polemical, dynamic and progressive. To use again epithets else-

where defined, these poetics are nihilistic, antagonistic, futuristic, and agonistic. Although this circumstance, on one hand, has led to a skeptical disbelief in a poetics that claims to be unique or eternal, on the other hand it has paradoxically inclined to attribute excessive value to every experiment or movement taking place in the fleeting but vital relativity of time, in what we might call the historical sense of duration, to repeat Bergson's formula. When translated into cultural terms, this was nothing but the Zeitgeist of the romantics. Modern critical sensibility, then, is history-minded in the face of the contemporary experience of art, but not in the relative sense of the historical critic because it tends to treat that experience as an epiphany or an absolute revelation. The avant-garde itself is only the artistic equivalent of a transcendental historicism.

It is precisely in terms of the bonds joining it to a particular historical and critical consciousness that avant-gardism is a phenomenon without precedent in the cultural tradition of the Western world. Theoretically, any work of art whatsoever, in any time, is avant-gardistic in its way, since it creates values not previously existent; from another point of view, no work of art is avant-gardistic in an absolute sense precisely because it is substantially based on already existing values. These two principles, not contradictory, are a truth ignored in avant-garde ideology and in the practice of its criticism. We must once again repeat that the latter is polemical and partisan, a criticism by the group or the movement. Therefore it paradoxically resembles the criticism of its adversaries, at least in part. It resembles that academic criticism which, in studying traditional art, is exclusively bound to considerations of school and historic style. Both seem incapable of realizing that to say classical style or baroque style, romantic poetry or abstract art, is equivalent to saying a style, a poetry, or an art created, case by case, according to theoretical presuppositions, historical circumstances, and situations of taste, each of which is summarily defined or suggested by its respective epithet or label. Now these presuppositions, circumstances, and situations condition art, but do not determine it. The labels or epithets must then be applied to the cultural ambiance, not

to the artistic creation. Authentic critical investigation starts from these presuppositions, circumstances, and situations, but only to annul or transcend them in the final evaluation of the concrete work of art. They are data, not essences. Avant-garde criticism so fixes its attention on the starting point that it neglects, too often, to consider the point of arrival. As for the hostile criticism, it stays put or moves off in the opposite direction. The common error of both is to turn too much attention to aesthetic ideals that are both equal to and opposite to those of the work which is the subject of their examination; they ignore, in different ways and for different purposes, the individuality of the real and the uniqueness of the concrete.

This long digression is justified because the errors it condemns are very common and recurrent in literary criticism, where it is even more difficult to find exceptional interpreters who are capable of seeing the true face of art beneath the mask of avant-garde mannerism. Because it is absolutely indispensable to distinguish the spurious from the genuine avant-gardism which results in art, or at least contains the seed of some future classicism, we must ultimately deny the validity of the position taken by Ortega: according to him, new art would remain a primary and absolutely important phenomenon even if it were to prove itself unable to generate a single masterpiece. If that affirmation contains any truth at all, it is the implicit recognition that the contemporary artist, independently of the results of his own efforts, cannot resign himself to retreat or even to move against the current, but must always accept the historical task of his own time, which is to work in the present for the future. But the disposition to consider as an end in itself an artistic experience which is only an experiment or an intention is more characteristic of the fanatic cultivator of avant-gardism, more so than of the true critic of the avant-garde, who cannot basically consider it anything but a means.

We must not forget that poetics is one thing and art is another. "L'oeuvre est si peu la chanson," warns Rimbaud, while Malraux reminds us that artists put into their theories what they would *like* to do, but do what they *can* do. In the note accompanying his transla-

tion of Poe's comment on "The Raven," Baudelaire even allows himself to smile at the expense of his idol and goes so far as to say: "Behold a poet who pretends that his poetry was composed according to his own poetics." Critical judgment should not stop *ante litteram*, but ought to go to the text itself and confront the concrete work of art. Now this does not prevent the recognition of validity in even the most limited and differing ends: for example, and in the case at hand, it does not prevent us from treating avant-gardism as a cultural fact. However, this does not mean that we may remain indifferent to the quantity, and above all the quality, of the works of art which the avant-garde has produced and produces within the cycle of its own existence. No discourse on art, even if inspired by nonaesthetic considerations, can ignore the intimate and ultimate need for value judgments.

Criticism, right and left

We had more to say about prejudgment than about judgment in the preceding examination of avant-garde criticism. We shall have to do the same in studying the critical tendencies known as the leftist and the rightist. The doctrines upon which both base their criticism of the avant-garde phenomenon are equally reducible to the concept of degeneration—a favorite concept in the triumphant positivism at the end of the last century, based on biological premises and already applied to certain forms of modern art, in particular by Max Nordau and Cesare Lombroso. This biologism, translated to the myth of race, was, as already noted, at the center of the theoretical accusations and practical condemnation of every form of avant-garde art by Hitler and his followers who, in fact, branded it all with the seal of degenerate art.

As we shall see in what follows, the concept of degeneration was destined to influence the critical terminology of many of the most recent interpreters of avant-garde art, even those not hostile to it. However, almost all have preferred to use Nordau's formula in other than literal variations, mostly metaphorical. At any rate it remains

true that the formula led to the modern aesthetic pathology, the psychosociological diagnosis according to which any cultural manifestation of "exception" comes to be seen as a crisis or a symptom of disease. In Nordau's case and that of some other contemporary critics, who are often unaware of how much they owe to him and his teacher Lombroso, the issue is one of genuine aesthetic pathology, which considers health as the normal state, disease as the abnormal —even if the abnormality, in a not very scientific way, comes in turn to be judged as if it were a sin or an ethical transgression. But in modern culture, alongside Nordau's tradition, there has little by little developed an aesthetic pathology which is, so to speak, positive. That is, it considers the disease as the source of, or motive for, creation because it believes that philosophic or artistic genius resides naturally in a sick body or even in a sick mind. The mystical and religious elements which re-enter into such a hypothesis are obvious, as already noted in the chapter on alienation. The example of Dostoevsky, who projected his own epilepsy into the creatures of his own fantasy, renewed among the moderns the ancient belief in prophetic or sacred malady. Perhaps it was on an analogous base that Nietzsche founded one of his most suggestive and dangerous doctrines, that the call to culture itself is the fruit of a diseased state.

Modern depth psychology, from Freud on, is not limited to looking at the elements of a work of art only as psychic symbols, as symptoms of a spiritual disease. With the idea of sublimation, it has produced a modern equivalent to the ancient Aristotelian concept of catharsis, according to which art not only serves the public end of purgation, but also functions as private therapy for the individual artist. These conceptions, as already seen, have led many psychologists, and many contemporary artists as well, to consider as fated and necessary the presumed conjunction of *art and neurosis*. Such a position must doubtless be seen as a pathological variant of the agonistic moment. Certainly the openly masochistic tendencies of the modern soul have contributed to its formation.

Hostile criticism regards the supposed connection between art and neurosis with an almost sadistic pleasure and, without discre-

tion or mercy, abandons itself to its favorite argument, which is the claim that degeneration is the dominant characteristic of culture in our time. It interprets and develops this concept in all possible forms: psychological degeneration (Seillière); moral and political degeneration (Massis); social and religious degeneration (Berdayev); philosophical degeneration (Benda); historical and cultural degeneration (Huizinga). Sometimes it combines them all and adds more, mostly social and political. Generally these are only rationalizations of the antipathy or disgust which many of these critics feel in viewing modern life and society.

Such antipathy and disgust derive from nationalistic and conservative nostalgia, as in the case of Lasserre, or from reactionary and authoritarian wishful thinking, as in the case of Irving Babbitt. These critics and others of the same temper in fact tend to consider aesthetic degeneration as the sign or effect of modern man's ethical or material corruption. In sum, rightist criticism is almost by definition the criticism which deduces the corollary of cultural and aesthetic traditionalism from the postulate of civil and political traditionalism. All the enemies of the new times fall within this group of critics, those who condemn the times en bloc with the charge of decadence and repudiate not only forms of art and culture but also the most lively forces of our period, such as democracy and socialism, technology and science. In brief, the task of rightist criticism concludes with a universal condemnation of modern civilization, and its daily and current action addresses itself, through continual polemical tension, against what these critics consider the disease of the century—that is to say, liberal ideology. In so doing they seem unaware that they are in agreement with their extreme adversaries, the leftist critics, who condemn the same civilization from the same perspective though from the opposite side.

Leftist criticism also makes a prop and a lever of the concept of degeneration, although it understands the concept almost strictly in social and political ways, in terms of economics and class consciousness. Hence it sees in avant-garde art the expression, on the cultural level, of that advanced state of decay and crisis which the

bourgeois class and the capitalist system are held to have reached. Such a condition, according to the ideology on which this criticism depends, cannot be cured by the medicine of reform, but only by the surgical intervention of revolution. In other words, leftist criticism just as much as the rightist condemns avant-garde art in the name of a present that both denounce—no matter if one rejects it in the name of the past and the other in the name of the future. From this stems the charge of ethical and civic irresponsibility which is directed at the modern artist from two sides: a senseless accusation precisely because the modern artist operates in a sphere other than that of praxis and, at any rate, works not at the center but at the margin of the society of which he is a part. Even so, despite this, there are critics who have considered Joyce, Proust, and other "bad teachers" no less to blame for our evils than are our statesmen and our ruling classes.

Leftist critics have not in fact shrunk from such *ad hominem* arguments, even though Marxism teaches them to minimize individual contributions and responsibility in the face of collective or mass forces. But the vice or sin of polemical personalism, which takes the form of a real calumny of the intelligence, is much more characteristic of reactionary criticism—above all in the counter-revolutionary and antiromantic polemic favored by the literary wing of the French right.

The connections between leftist and rightist criticism can be summed up by saying that both contemplate avant-garde art by way of an analogous anachronism; but while one looks at it through a reactionary and retrospective nostalgia, the other looks at it through an anticipatory and utopian dream. Perhaps it is because the left and the avant-garde share the futurist aspiration, although in a quite different spirit, that leftist criticism remains always more acceptable than the rightist, even in its negations of avant-garde art. This consideration leads us to look again at the already stated judgment on the tendency to equate aesthetic radicalism with political radicalism (a tendency already questioned on theoretical grounds in this essay). Even while denying in principle the parallel of the

two avant-gardes, we cannot in practice deny the evident fact that the revolutionary ideology has generally enjoyed greater prestige among avant-garde artists than has the reactionary ideology, and has inclined the political sympathies of those artists toward the ideals and parties of the left. For the same reason, the criticism inspired by leftist ideologies, when it does not wholly neglect aesthetic factors and abandon itself to prescriptive propaganda, sometimes succeeds in achieving, with its most liberal literary patrols (at least outside Russia), a notable intelligence concerning the avant-garde phenomenon.

In general, for those able to recognize the arbitrary postulates and the errors of principle, certain leftist interpretations, and more rarely the rightist (naturally more rarely since they involve cultural and psychological distaste), remain useful and suggestive. In some concrete cases they attain a notable validity. Rightist criticism, even while it is a typical product of conservative thinking, of social and religious reaction or of that rationalism and positivism so frequent in French culture, can succeed in throwing light on those aspects of the avant-garde mentality which we have called antagonism, nihilism, and agonism: the mystical and emotional aspects of the avant-garde mentality rather than the ethical and rational. Such is the involuntary result of Julien Benda's criticism. He is a philosopher who belongs ideologically to the moderate left, but who acts in theory like a man of the right and has for almost half a century only repeated the accusations of conservative and traditionalist criticism against modern French art, literature, and culture.

Leftist criticism, sociologically and politically, is generally the typical product of the intelligentsia, and that suffices to define its scope and limits. Its merits, for those able to profit from them, almost always consist of finding valid correspondences between psychology and ideology, between a cultural condition and a sociological condition. For this reason, these critics for example, do not let themselves be deceived by the pretended antibourgeois spirit of the avant-garde; leftist criticism is always able to place that spirit in direct relation to the structure of the society from which the avant-

garde derives. Among the representatives of leftist criticism, it is worth citing Leon Trotsky, a professional revolutionary who in his only book of literary criticism, *Literature and Revolution*, shows himself to have been an acute observer of certain aspects and figures of the Russian and European avant-garde. The value of his judgments is not weakened by the fact that, speaking of Russian literature in the years immediately before and after the revolution, he all too easily reduced the avant-garde experiences of that period to a single denominator: futurism. In addition, he overemphasized origins and merely classicist aspects: "Futurism carries within itself the fruits of its own social origin, the bourgeois *bohême*, in its new phase of development . . . When the war and revolution were beginning, futurism was still *bohêmien*, which is the normal condition of any literary school in urban, capitalist centers." But in compensation Trotsky very clearly perceived the theoretical and practical weaknesses in the concept of proletarian art, literature, and culture; he even perceived the speciousness of the pretended kinship between the intelligentsia and the avant-garde, which he viewed as a false or ambiguous relationship, created at least partly by the opposition.

One of the rare leftist critics who, had he lived, would perhaps have achieved a vision as acute and clear as Trotsky's was Christopher Caudwell (though, in the writings he left, he showed less literary sensibility); unfortunately Caudwell never directly faced the particular problem of the avant-garde. Neither has the most notable figure in contemporary Marxist criticism, Georg Lukács. This Hungarian critic, of German and Russian background, has preferred to study such classics as Tolstoy and Goethe, or more general aesthetic problems such as the realistic narrative; almost all his work, with its genuinely aesthetic and sociological spirit, has revivified the dead letter of ideology. Even in this case, however, we must say that Lukács treats the avant-garde only in passing and too readily reduces it to the lowest common denominator of German expressionism or to the highest common denominator of the decadent movement. He is in fact inclined to attribute an exclusively negative value to the concept of the avant-garde. The only form of

modern art which seems to him to anticipate the future, or to be, as he himself would put it, progressive, remains the surviving—and sometimes the outlived—realistic tradition, always the primary object of his inquiries. Lukács himself assigns the task of judging the seeds of the future in today's art not to contemporary criticism but to future history. "The great historical mission of the literary avant-garde consists in grasping and prefiguring these underground tendencies (social and political in nature). And only evolution can decide whether or not a given writer is really avant-garde by demonstrating that he has individualized and prefigured, with exactitude and lasting efficacy, the fundamental qualities, evolutionary tendencies, and social functions of particularized human types. After what we have already said, it should not be necessary to reaffirm that such an avant-garde could only belong to the most significant realists."

Surely there is an element of truth in the claim that the avant-gardistic quality of a given work of art (even in purely aesthetic terms) can only be fully perceived by some future consciousness. We might say that no ambitious critic can make do without yielding to the appeal of the futurist utopia. But it is neither fair nor precise to limit the progressiveness of art to a single type of content (Marxist sociology) and to a single style (realistic narrative). On the other hand, a too literal handing over of judgment to the sanction of future history deprives the critic's function of any meaning and denies the raison d'être of militant criticism, which is to work as a judgment immanent in the work-in-progress. Fortunately these objections to Lukács' work are only theoretical because in practice he does not surrender his own right and duty of judging the art of the present.

For all their merits, it is still true that Caudwell, Lukács, and the other leftist critics, though not always without aesthetic sensibility, have clarified the conditions rather than the essence of art in our day. Indeed, as a general conclusion, we can even say that the leftist critics, quite as much as the rightist, have penetratingly viewed only the extraaesthetic problems of avant-garde art. Their essential

error resides not so much in being indifferent to aesthetic values as in being unable to grasp the strictly cultural presuppositions of avant-gardism. Instead of trying to grasp these presuppositions, they have abandoned themselves to practical-moralistic prejudices or to sociopolitical preconceptions; thus they lose what was most vivid and valid in their psychosociological interpretation of the cultural fact itself. In both cases, left and right, the more serious error remains an incapacity to recognize that their respective postulates or principles, for all that they are contradictory, issue from the same historic roots, of which the avant-garde is only one of many fruits.

Perhaps it is here necessary to repeat that an opposite but analogous error is often committed by the purely aesthetic critics of the avant-garde, whether they are for it or against it. That error, already frequently touched on, only apparently contradicts that committed by ideological critics, left or right. The ideological critics in fact maintain that critical judgment is fulfilled in a polemical inquiry into the *general* presuppositions of the avant-garde. The aesthetic critics of the avant-garde, instead, believe that critical judgment is fulfilled in apologetic or polemical inquiry into its *specific* presuppositions. To the sociological historicism of moral and political critics they oppose—better, they juxtapose—a cultural and aesthetic historicism. In other words, they subordinate the evaluation of the concrete work of art to abstract determinations of a technical and formalistic nature. If the ideological group of critics seems not to realize that art is a problem of style and form, the second group often shows itself incapable of distinguishing between the singular and plural of these two formulas: between styles and forms of a tradition and the style and the form of an author or a work. One cannot understand the art of Braque without taking cubism into account; but that is not enough either. Those who go on in this way make a mistake analogous to the ideological critic's, for they confuse the individual artist with the landscape of a historical culture. To reverse the proverb, they don't see the trees for the woods.

9. *AESTHETICS AND POETICS*

Dehumanization

Now we shall consider the aesthetics and poetics of avant-garde art in terms of certain critical and theoretical prejudices that are not so much to be avoided as to be used with care. This will furnish, among other things, a supplement to the critical methodology outlined in the preceding chapter. Furthermore, the prejudices involved are only aesthetic variations of principles already formulated in our examination of the ideology and mythology of the avant-garde.

According to the first of these prejudices, the avant-garde represents and expresses the *dehumanization of art*. Although Ortega y Gasset was one of the few thinkers to develop that concept other than superficially, and perhaps the only one to give a positive value to the process at the heart of the concept, the principle itself is current coin in avant-garde criticism, common in hostile criticism. Enough to cite a passage by Huizinga where the principle, formulated in nearly identical words, is first restricted to a given movement ("futurism is synonymous with the end of man as the supreme theme of art") and then extended to all modern art, defined by the

Dutch historian as being in its whole complex a single "process of disintegration and dehumanization."

Sometimes Ortega himself seems to consider the principle and formula as most fairly or naturally applicable to the figurative arts, in particular the cubist and abstractionist tendencies. He in fact declares that "the plastic arts have revealed an actual recoiling from the forms of life and living beings." That declaration is important because it contains, implicitly, the hypothesis of an aspiration toward a figurative theory of quasi-inorganic or crystallized subject matter. Naturally there is a shadow of truth in it; what we have to see is whether the "recoiling from the forms of life and living beings" is related only to geometric abstraction, to the mathematical figures of cubism and its derivatives, or to the plastic dynamism and machine aesthetic of the futurists as well.

What we may ask, more generally and importantly, is whether the dehumanization is as decisive and exclusive a factor as Ortega claims. And, if so, is it a speculative factor, a way of seeing the world, or is it merely expressive and stylistic? The following section will take up this series of questions. For now we may briefly answer the first one partially, by saying that in avant-garde figuration there is not only abstractionism and mechanism, but also a new or special way of representing what is human, organic, and living. However, that representation is, as we are wont to say, deformed or deforming. In short, the principle of dehumanization comes to take on much more valid and precise meaning insofar as it is at least partially synonymous with the vaster and less approximate stylistic concept of *deformation*.

The principle of deformation is nothing new in the history of art. Avant-garde art certainly rediscovered it in primitive or archaic art. Thus, for example, avant-garde sculpture has attentively studied Etruscan and Egyptian statuary, as well as statues from pre-Columbian America, pre-Classical Greece, and Negro Africa. And we might perhaps say that what Ortega calls dehumanization is nothing other than neoprimitivist deformation, or a conscious replication of the

authentic and ingenuous deformation of all that barbaric and exotic art.

Along with primitive deformation, one frequently meets in art history the ritual and allegorical deformation proper to every religious and liturgical art—the Byzantine, for example. The distortion of effigies and the human body sometimes functions as the "objective correlative" of the sense of the unspeakable and transcendent proper to the mystical vision, as in the case of El Greco who was, furthermore, as a youth in contact with the Byzantine tradition on his native island of Crete. Then the paradoxical task of such a distortion is a transfiguring figuration. In some exceptional cases the deformation appears as an involuntary deviation from the norm, the direct and unconscious expression of the ingenuous, as in the case of the *douanier* Rousseau or other modern primitives.

Vulgar prejudice has it that deformation, primitive as well as avant-garde, is the result not of a particular vision or an expressive maneuver, but of faulty execution. Even admitting that some peripheral style or other derives at least partially from what Bernard Berenson called the "originality of incompetence"—that is, from the executing hand's involuntary transgression, unable as it is to reproduce perfectly the exemplary model the mind intends to reproduce—it always remains a maxim, as Malraux maintains, that "a clumsy style does not exist." Berenson himself affirms that the internal logic of a style does not admit of chance divergences and deviations: "Nothing is so tyrannically exclusive and levelling as a firmly established reigning style! No faith is more intolerant."

If primitive deformation is now universally considered a spontaneous phenomenon, many people come to think of avant-garde deformation as a consciously willed arbitrariness (no one dares attribute it to a lack of ability in the artists who practice it, such virtuosi as Braque and Rouault, Matisse and Picasso). Here it is worth citing Arnold Toynbee's opinion at length. Though less hostile to aesthetic modernism than Berenson, the English historian prefers to see in modernism not a natural process of decay or corrup-

tion, but the conscious betrayal of a noble, centuries-old tradition. He goes so far as to reduce stylistic deformation and avant-gardism in general to the level of a spiritual or ethical transgression:

The prevailing tendency to abandon our Western artistic traditions is no involuntary capitulation to a paralytic stroke of technical incompetence; it is the deliberate abandonment of a style of art which is losing its appeal to the rising generation because this generation is ceasing to cultivate its aesthetic sensibilities on the traditional Western lines. We have wilfully cast out of our souls the great masters who have been the familiar spirits of our forefathers; and, while we have been wrapt in self-complacent admiration of the spiritual vacuum which we have discovered how to make, a Tropical African spirit of music and dancing has made an unholy alliance with a pseudo-Byzantine spirit of painting and bas-relief, and has entered in to dwell in a house that it has found empty and swept and garnished. The decline which betrays itself in this revolutionary change in aesthetic taste is not technical but is spiritual. In repudiating our own native Western tradition of art and thereby reducing our aesthetic faculties to a state of inanition and sterility in which they seize upon the exotic and primitive art of Dahomey and Benin as though this were manna in the wilderness, we are confessing before all men that we have forfeited our spiritual birthright. Our abandonment of our traditional artistic technique is manifesting the consequence of some kind of spiritual breakdown in our Western Civilization; and the cause of this breakdown evidently cannot be found in a phenomenon which is one of the subsequent symptoms. (A Study of History, *IV, 52*)

Toynbee seems unable to recognize that the phenomenon he condemns, even if in some degree voluntary and conscious, is both a natural and a spontaneous process, precisely because it is historically necessary and determined. He is right in opposing deformation and avant-gardism to the classical Western stylistic tradition, wrong in equating all modern art with the taste for the barbaric and exotic. But his greatest error is the inability to realize that the reaction of modernism to tradition is one more bond, *sui generis*, to that very tradition. Avant-garde deformation, for all that the artists who practice it define it as antitraditional and anticonventional, also

becomes a tradition and a stylistic convention, as has often enough been realized. For example, Jean Paulhan in *Fleurs de Tarbes* and Harry Levin in his essay on the aesthetic concept of convention have both made this point. In this way, deformation fulfills not only a contrasting, but also a balancing, function in the face of the surviving conventions, academic and realistic, of traditional art. The deformation is determined by a stylistic drive, which inaugurates a new order as it denies the ancient order. The motivation for this denial is very simple: modern civilization has achieved a representational technique so perfect that the artist can easily become a pedagogical monstrosity, that is to say, a disciple more virtuoso than his own teachers. The extensiveness of the artist's information and the efficacy of devices could easily put the modern artist in a position to acquire, if he wants it, a mimetic handiness that artists in other times have attained only thanks to long apprenticeship, by means of hard, day-in-day-out exertion.

The classical principle of vanquished difficulty has thus lost any meaning for the art of our period. There is no doubt that pictorial realism, especially in the genres of portrait and landscape, has been destroyed by the invention of the camera. But we must also take into account that many of our painters could, if they thought it useful or necessary, rival photography. But that is exactly what the modern artist refuses to do; he has once and for all renounced a now useless competition, a victory that would no longer be real. Instead he has chosen to go the opposite way: his aim now is not what was once called imitation; it is deformative representation or, indeed, just that abstract art which polemically gets labeled nonrepresentational. And if the artist does it this way, he has his good reasons. Some of the reasons are exactly what Rimbaud exposed in "Alchimie du verbe" as the exhaustion of the old, familiar, and facile and the anxious desire for the new, strange, and difficult: "For a long time I've prided myself on possessing all possible landscapes and I've thought the fame of modern poetry and painting laughable."

Much of that fame continues to live on and to follow an opposite practice, which is to imitate academic and eclectic classicism. This

practice is now called *mannerism;* and the artists who continue to do it, *epigones.* Besides, it is also by virtue of those survivals and continuations that the contemporary period is perhaps the only one, in all the history of art, to be characterized by a complex stylistic pluralism rather than by the simple hegemony of a unique and superior style. Add an ulterior complication: in our civilization the mannerism of epigones is forever being transformed from stylistic convention to technological and practical convention. In fact, it becomes the style and language of commercial, popular, and industrial art—in short, of mass culture. We noted already in the chapter on alienation how the fluid ambiguity of the initial situation hardens ever more firmly into the terms of a single antithesis, how aesthetic pluralism is now giving way to a real and true dualism. That dualism does not remain a purely aesthetic and stylistic fact but grows into a psychological and sociological fact, creating a state of mutual opposition between the individual and groups attracted by both of the contrasted terms. Avant-gardism and deformation thus become the *bêtes noires* of the mass public, which makes them the object of its own rancor and the pretext for its own revenge. What must be emphasized, however, is that the motivations for this mutual hatred and disdain cannot be reduced to the lowest common denominator of a mutual accusation of incompetence. For as Malraux says, "there is doubtless ignorance in the feeling of repulsion of the masses confronting modern art, but there is also wrath for what it obscurely feels as a betrayal."

We might say, using a religious simile, that the masses react to modern art as idolatry does to iconoclasm. The simile is more than a metaphorical parallel: accustomed as it is to the adulatory and servile imitation of the real, the public of modern art rebels when it becomes aware of what Ortega calls "a strange iconoclastic sentiment" within modern art. In so doing, that public is sensing another of the realities seen by Ortega: iconoclastic sentiment is perhaps the primary and direct cause of the deforming and abstract stylistic tendencies. Still, not even avant-garde iconoclasm is a purely artistic fact, although Ortega does seem inclined to attribute aesthetic mo-

tives even to religious iconoclasm. It would be, if anything, fairer to attribute psychic motives even to aesthetic iconoclasm. The taste for arabesque and the grotesque is not only a matter of taste. The same principle holds for avant-garde iconoclasm, which rarely limits itself to formal and aesthetic suggestions of the deformed and deforming vision (as in Modigliani) but transcends the sphere of art to affirm, even in creation's ambit, real impulses of agonism and nihilism.

Therefore, at least in extreme cases, the iconoclasm of modern art is a polemical act, a rhetorical gesture, a practical and voluntary fact, more than creative or artistic. Hence the frequency of blaspheming manifestations, vandalistic or scandalistic, in emulation of the anonymous disfigurers of effigies, simulacra, and public images. Certainly it was a sacrilegious impulse that led Marcel Duchamp to exhibit a chamberpot in a show of art works, and on another occasion to apply a pair of male moustaches to a reproduction of Leonardo's *La Gioconda*. But this does not mean that the iconoclastic attitude can always be reduced to a vulgar gesture of protest or a brutal act of vandalism. Its more profound root is sometimes the quasi-religious aspiration toward an absolute emotional and mental freedom, the desire to reacquire an ingenuousness and innocence of vision which modern man seems forever to have lost, the anxious will to discover the eternal laws of ideal or perfect form. There is no doubt that it was an aspiration or will of this type which led Picabia to display, as if it were a painting, an empty frame, hung in midair; this led to Kandinsky's famous revelation, when he became convinced that his true work of art, creative and not imitative, was what had appeared for the first time to his eyes when he beheld one of his own traditional canvases put, by chance, back to. Such examples demonstrate that iconoclasm can come to be seen as the negative moment of a tendency elsewhere to be discussed as the *mystique of purity*.

Certainly the aspiration of some currents in modern art to represent internal and external experience impersonally is not to be attributed to iconoclastic and dehumanizing deformation (as Ortega

claims). Ortega in fact declares, and means it as praise, that "the personal, because it is the most human of human, is what young art most avoids." Perhaps he does not realize that the negative tendency is only the consequence of an idealistic striving toward a paradoxical and improbable classicism. It was certainly in the sense of such a striving, and in the wake of a current that began with Gautier, Baudelaire, and Flaubert, that T. S. Eliot postulated his impersonalizing poetics—meant, though, in a less literal and abstract way than Ortega's. This impersonalism seems a significant symptom of the will of some of the most important modern artists to repudiate the more obvious and popular tendencies of nineteenth-century art, such as lyrical subjectivism and the cult of sentiment. Precisely, therefore, the poetics of impersonality shows itself to be antiromantic—but we have here an antiromanticism more relative than absolute, aimed especially at bourgeois realism and late-romantic pathos. Eliot's impersonalism is certainly not dehumanization; the same holds true for another and minor tendency of contemporary art, characteristic above all of literature. This we might call the *transhumanizing tendency*. There is in fact a multitude of modern poets and writers, from Walt Whitman on, who work as though they wished to obey the command of Nietzsche: man is a thing we must transcend. It is perhaps this spiritual megalomania, this will to transcend the human condition and the very limits of the real, that Ortega partly had in mind when he coined the concept of the *superreal* or *superrealism* (the model for the name was surrealism, but it is joined by close analogy with the Nietzschean formula of the superman).

This state of mind typically expressed itself in hyperbole, meant not only as a striving toward a transcendental poetic ideal (as in Mallarmé) but also as an attempt to surpass the limits of man and nature. To the *hyperbolic image* was assigned the task of expressing and even realizing that attempt; it was a favorite device especially of futurism and imaginism, unanimism and populism, as well as some currents in Soviet Russia's proletarian poetry (for example, cosmism). That type of image very clearly reveals the agonistic state

of mind which dictates it, as Trotsky observed with such acumen: "The hyperbolic image reflects, up to a point, the fury of our times."

Ortega paid less attention to the superrealistic or hyperbolic tendency than to the tendency for which he coined the name *infra-realism*. He was all the more inclined to do so, since he could bring the latter into a clearer and more direct relationship to his two favorite principles, iconoclasm and dehumanization. The hypothesis was that, in some of its currents, modern art tends to lower reality to the level of the raw, unformed, subhuman, and vile. Starting from this formula of infrarealism, Ortega then uncovered, with his usual perception, another of the characteristics most typical of avant-garde poetry, the taste for what he called the *denigrating image*. It is denigrating precisely because it has the intent or effect of calumniating the object to which it is applied. Ortega perhaps neglected to emphasize the particular novelty of this type of image: it works not only satirically but lyrically. Modern poetry uses the derogatory or pejorative image not only as a vehicle for caricature and grotesque representation, but also as an instrument to disfigure, or transfigure, the object so as to produce a radical metamorphosis. This function of the denigrating image suffices in itself to show how and why avant-garde art, even more than romantic art, felt the classical idea of comedy (and its old satirical and buffooning variants) as alien to itself. As seen earlier, the very humor of the avant-garde is not so much a free creation of the *vis comica* as a secretion of bile, a case of black humor, an attack of spleen or hypochondria.

Cerebralism and voluntarism

Just as dehumanization and iconoclasm are joined, so are two other prejudices which often become real accusations, favorite arguments of the avant-garde's adversaries. The prejudices in question are that the avant-garde is voluntaristic and cerebral. To begin immediately with the second, it must be admitted that within avant-garde art there does exist a *sui generis* intellectualism, which has nothing to do with traditional or classicizing intellectualism and which is

called by the felicitous, though pejorative, term *cerebrality* or *cerebralism* (as if one wished to emphasize that it is not the natural fruit of pure reason but the quasi-mechanical product of the organs of thought). Now it is exactly this kind of intellectualism which the adversaries of modern art blame for its aesthetic errors, sometimes generally, sometimes in specific cases. The ultra-rationalist Julien Benda attributes to it, for example, the particular demerit of having generated an artistic error parallel and contrary to that biological vitalism, stemming from Bergson, against which Benda battled his whole life long: "It is well known that there exists a phenomenon diametrically opposite: that of synthetic painting (Cubism), of abstraction *à outrance*, which wants to reduce the representation of things to a few elementary forms, pure creations of the spirit. It is a case of another romanticism, the romanticism of reason."

Unlike Benda, Ortega takes into account that such cerebralism or intellectualism does not work exclusively in the field of the figurative arts. In the essay *Sobre el punto de vista en las artes* he reconstructs the successive phases of painting's historical evolution, asserting that, first, things are painted; then sensations; and finally (that is, in contemporary cubist, abstract art) ideas. However, in his better known and more important *Deshumanización del arte* he suggests that this development pertains to all the arts, even literature and poetry, where the ultimate phase, that of ideas, is represented by such currents as Pirandellism and surrealism. It was indeed exactly in reference to these currents and to analogous developments in the field of contemporary literature that Ortega put into reciprocal relationship dehumanization, abstractionism, and superrealism: "If we propose deliberately to realize ideas, we have dehumanized, de-realized, them."

This shows that not only those opposed to the avant-garde, like Benda, but those who support it, like Ortega, often tend to isolate and excessively to schematize the moment of intellectual abstraction in their view of modern art. So doing, they fail in the task of putting this moment in relation to its opposite, or to more general tendencies that are capable of reconciling under a single principle all the terms

of the contrast. Now this unifying principle does exist: it consists of the scientific spirit that we have discussed in another context. On that occasion we underlined the materialistic and practical aspect of the scientific spirit; now we must instead emphasize the theoretical and speculative. Although Apollinaire admitted and even defended the existence of a multiple variety of cubist experiences—some empirical, some metaphysical—Bernard Berenson, a critic hostile to all modern art, saw in abstraction an unconscious return to Platonism, even though he affirmed that the Platonic ideal of an abstract beauty was better realized in our machines than in our works of arts:

> *I am tempted at this point to ask whether Plato in the* Philebus *could possibly have thought of line in movement when he says that by beauty of form he means straight lines and circles and the plain and solid figures which are shaped by turning lathes and rulers and measures of angles. He affirms that these are not only relatively beautiful like ordinary things but eternally and absolutely beautiful. It is to be feared that Plato had in mind exactly what "abstract" and "non-objective" painters are producing now. But if he returned to us at present he would find his wish fulfilled not so much by the "abstract" and "non-objective" paintings that are momentarily the fashion, as by our machinery and our weapons. Their dialectic, their realization, their geometrical perfection would surpass anything he could have imagined or conceived.* (Aesthetics and History, p. 83)

Naturally there are observers who do not isolate the abstract moment, but instead correlate it with other tendencies by opposition; they treat the avant-garde dialectic as if it were a series of contraries. And there are critics who attempt to set up an antithetical dualism between the two currents we are discussing. The art critic J. P. Hodin seems to do so in his essay on expressionism, which balances the abstract current (he calls it the rational and scientific), culminating in cubism, over against the expressionist current, culminating in the ism so named. He develops his argument from an initial declaration: "When we come to consider the modern schools from the point of view of style, we can say that they fall into two main

groups. In one, there is a conscious setting up of formal laws, whose function in our time is 'scientific.'" Even though he starts from an apparent enthusiasm for abstract art, Hodin seems to deduce from its principles something which would then lead to a dehumanization of art (the phrase he uses is like Ortega's but with negative intent). But a different solution, more positive in nature, has become possible (still in Hodin's view) through contemporary aesthetic psychology, which "has defined the problem as being one of abstraction and empathy (*Einfühlung*)." Hodin then resolves that opposition by affirming one of the contrasted terms and negating the other. For him abstraction would only be an evasion of the real world, whereas empathy, insofar as it is the beginning of artistic creation, based "on the magic significance of the subject," would succeed in taking possession of that subject "by a process of mystic identification (Lévy-Bruhl)." He concludes that "empathy is the method of Expressionism." Even while continuing to express a marked preference for the expressionist solution, Hodin tempers the preceding negation and ends up by considering it a necessary and possible alternative. "Expressionist art and rational art, in the broadest sense of the two terms, are currents in which the moderns' will to form will be manifested."

But it is in a footnote that Hodin fully reveals the antithetic dualism indicated above: "Two essentially different styles, different in technique and in tradition, in the artist's approach to his object and his psychological incentives, characterize modern art. Such a phenomenon has hitherto not been known. It is the expression of our rootlessness." That such a dualism is superable in intention, and perhaps in fact, is certainly shown by the apparition of a movement choosing to adopt the composite label of *abstract expressionism*. But since the real schism is not within avant-garde art itself, but in that which marks it off and cuts it off from the world outside it, it seems that we can respond to Hodin's question only by denying its validity. At any rate, we can reply with other arguments: first, show how easy, and in some cases how fair, it would be to shift to the opposite banner many of the movements he assigns to one or the

other category; then, by the generality of a principle common to both, resolve the apparently irreducible characteristics of each of the contrary tendencies. We shall give the called-for demonstration indirectly by outlining regroupings different from Hodin's; above all we hope to avoid the partisan error of reducing a vast series of artistic phenomena to the lowest common denominator of a movement like expressionism, which however important and significant, still remained a partial if not peripheral phenomenon. As for the attempt to unify the two tendencies under a single principle, this is, in effect, the theme of this section.

We may begin a critical analysis of Hodin's assertions by hypothesizing a different dialectical relationship, and go on to advance the theory that avant-garde art expresses the scientific point of view by way of two alternatives, rather than by the single path of abstract rationalism. No one denies the presence and potency of the latter, which, while it reflects the moment of praxis and technique in futurism and its derivatives, also symbolizes the theoretical and contemplative moment in the scientific thought of cubism and abstract art. We might even say, contrary to Hodin, that the more important of these two moments is certainly the second, the speculative, which tends to lead avant-garde art toward the most absolute formalism, which is, paradoxically, iconoclastic and dehumanizing. Only a cultural ambiance dominated by a no longer anthropomorphic science—even an antihumanistic science—could render possible the composition of a treatise like that of the French abstractionist Fernand Léger, significantly entitled *Du corps humain consideré comme sujet*. All we have to do is to contrast the patent aim of that title with the Renaissance treatise of Luca Pacioli, *De divina proportione*, where the search for the mathematical laws of the human body's harmony is a search for a pre-established harmony, spiritual and metaphysical in nature, and we comprehend at once the nonmystical, nihilistic character of modern abstractionism.

As is well known, however, modern science is not just technique and theory; it is also empirical—observation and introspection beyond mere experiment and speculation; a sense not only of spirit

and matter, but also of life; in other words, not only mathematics and physics, but also psychology and biology. Precisely the influence of these disciplines leads the avant-garde from the Einsteinian category of space and physical time, where the absolute itself becomes relative, to the Bergsonian categories of *élan vital* and *durée*, where the relative once again becomes humanly absolute. But fundamentally it is only on the plane where these two diverse philosophical and scientific lines cross that what Benda calls the two romanticisms of the contemporary period can be reconciled, the romanticism of reason and the romanticism of passion. Both are fundamentally a neoromanticism of science, in which the cubist principle of mental abstraction and the futurist principle of mechanical automatism accord with the surrealist and expressionist principles of psychological automatism and psychic empathy.

Obviously this series of interconnections brings us back again to the question or prejudice of cerebralism. That has now resolved itself; better, it is resolved by the recognition of how legitimate are the psychological curiosities and vitalistic interests of so many modern artists. Formal, stylistic, structural, and syntactic cerebralism is only the direct consequence of a subject-content made up of psychic experiences that have never been so rich and complex as in the case of modern consciousness and culture. Many of the enemies of avant-garde art are not so much protesting against its aesthetic and formalistic cerebralism as against its content, revealed by depth psychology: that is what they believe they are denying by defining it as obscene or immoral, crude or formless. They condemn the subject-content as raw and lowly matter gathered by the artist with an automatic inertia; with this charge of passivity they believe they show that the avant-garde is not observing one of its favorite principles, spontaneity. On the other hand, the same critics repudiate abstract formalism with the opposite pretext, as if it were only an absurd caprice, a senseless whim of the will. That opinion derives from the second and opposite prejudgment, the charge of willfulness (a prejudgment not limited to the adversaries of the avant-garde). It is, in fact, implicit in Ortega's thought, as we see from the phrase already cited in another context ("if we *deliberately* set out to realize ideas"). The Spanish critic draws

from this deliberateness a motive for explicit praise, as when he glorifies Mallarmé for having been "the first man of the last century who *willed* himself to be a poet." The adversaries of avant-gardism, however, develop the charge of willfulness in ambiguous and complex formulations, which they articulate in severe reproofs and solemn rebukes. This posture is fundamentally contradictory for the intelligentsia of the right, who, by virtue of their own aesthetic and ethical rigor, ought to look with more sympathy at the volitional factor in a work of art.

From a neutral point of view, remote from praise and blame alike, we recognize that there is a basis of truth in the assertion of an excessive intervention of willfulness in some avant-garde manifestations. It must be noted that many of the spectators and actors of the avant-garde have tacitly or indirectly admitted as much. If we merely look at the title *Why Abstract?* which the American painter Hilaire Hiler chose for his pamphlet on theory, we see at once that the question is not problematic but rhetorical; the answer implies an affirmation that one *can* make art abstract and, indeed, that one *must* do so. But even the fact that artists admit the charge is not enough to resolve the complex question of avant-garde voluntarism; the question can hardly be asked without a prior definition of the concept of the will as interpreted by modern culture.

It is easily seen that within modern culture a romantic and Schopenhauerian concept is in the process of displacing the classical, Christian, Stoic, and humanistic concept of the will. In this newer concept the will is no longer a human faculty, but instead a vital energy and cosmic force; not a restraint or inhibition, but an impulse or instinct. The hypothesis of will power as a conscious, rational, and autonomous faculty has thus yielded to the opposite hypothesis of an unconscious, irrational, and automatic will. If we reduce these two different concepts to the modest sphere of artistic practice, and if we readopt terminology we have used throughout this inquiry, we might say that as the first and more ancient notion of volition determines the concept and institution of the school, so the second conditions the idea and phenomenon of the movement.

The prejudgment of avant-garde art in terms of its willfulness

thus comes to lose virtually all point precisely because those who use the notion negatively belong to the camp dominated by the ancient interpretation of volition, while the accused conversely belong to the camp in which the modern notion has triumphed. In the case of the first we must again note that we face a strange contradiction: these defenders of tradition use for polemical condemnation an element considered as a positive factor in every classical and conservative culture. As for the others, supporters of the avant-garde, using the volitional prejudgment in a favorable way, one must certainly recognize that they tend not so much to contradict themselves as to confound the two notions of volition. This confusion leads to combining, syncretically if not eclectically, the hypotheses of autonomy and automatism. Nothing better proves this confusion, whether spontaneous or deliberate, than the recipe for composing a dadaist poem offered in one of the most curious and paradoxical proclamations of Tristan Tzara: "Take one newspaper. Take one pair of scissors. Choose from that newspaper an article of the length desired for the poem you intend to write. Cut out the article. Next cut out with care each of the words forming that article. Next put them in a bag. Mix gently. Take out one by one each excision in the order they fall from the bag. Copy carefully. The poem will resemble you. *Voilà*, there you are, an infinitely original poet of a seductive sensibility, even if still not understood by the vulgar." And to show that prior even to the compilation of that recipe, or independently of it, poetic attempts dictated by the same method were already being used, all we have to do is cite Palazzeschi's "Passeggiata," which consists only of a series of bottle labels, or Aragon's "Serenade," which boils down to the transcription, in a succession of versicles, of the letters of the French alphabet.

Encountering work composed in such a way, the suspicion of adverse observers (sometimes shared by some unprejudiced ones), that it is all a question of mystification and imbroglio, is undoubtedly legitimate. On the other hand, one has the duty to recognize that mystification and imbroglio (which can also be the direct result of a taste for scandal, or more generally of antagonism for the public)

are practices not only admitted by the avant-garde itself, but even highly praised by it. Precisely on this account, the artist-mystifier cannot be accused of insincerity or dishonesty. Avant-garde mystification is in fact not only a practical act; it is also gratuitous. It derives, even if indirectly, from the aesthetic of the joke and the poetics of the game.

The cited recipe and poems, the observation about the motives for mystification, all suffice to exemplify or suggest the fusion of determinism and free will, automatism and caprice, basic to the modern concept of volition. True, the recipe and the examples are extreme and polemical cases operating in the direction or dimension of eccentricity. That does not diminish their interest or their significance: in such an inquiry as ours, even poses and daydreams have an importance because they reveal the avant-garde mentality (though they do not justify its products). Besides, the distinction pointed out has no sense or validity in the face of results. In the area of aesthetics we certainly cannot talk of an automatic art or of a voluntaristic one either. These terms have reference only to intentions or, beyond intentions, to fallacies or failings. Before real art, automatism and voluntarism cannot function except as negative terms. Only in an examination of avant-garde art as a cultural fact can they serve as descriptive terms and, as such, be neutral.

For those accepting it in the most obvious and traditional sense, it is evident that the prejudgment in terms of voluntarism turns out to be most particularly applicable to abstract figuration, to cubism and metaphysical painting. Then it remains for us to examine, in a perspective appropriate to our inquiry, what function the principle of automatism exercises within the movements that proclaim or postulate it. The principle is doubtless one of the constituents of surrealist poetics. As a doctrine, it derives not only from psychoanalysis and other theories of the unconscious, but also from the Bergsonian concept of involuntary memory—a concept which Proust applied to the novelist's creation and one which, of itself, reveals the paradox of the modern view of volition. In the poetics of surrealism, the principle of automatism was translated into a stylistic

procedure; its theoreticians called it *automatic writing*, and André Breton himself defined it and designated it as "a true photograph of thought." To understand what "thought" means in this phrase, it will suffice to recall another formula, *spoken thought*, which Breton considered the chief object of art and defined, in its turn, as "pure psychic automatism." That definition is enough to show that avant-garde irrationalism conceives of thought only as a mechanical association of ideas. So much so that Breton describes "spoken thought" as if it were an automatic and inarticulate mental activity, as we may see in his famous precept: "Put your trust in the inexhaustible character of the murmur."

As for the phrase *stream of consciousness*, invented by William James for scientific aims and then adopted by all the British and American critics of Joyce, just as in the case of *monologue intérieur* coined by Valéry Larbaud to define the narrative method of such French writers as Proust and Dujardin, we are here dealing with phrases affirming the existence, in the poetics of the modern novel, of tendencies identical to those designated by theoreticians of surrealist poetry as automatic writing and spoken thought. No doubt, then, that both terms, automatic writing and stream of consciousness, both spoken thought and interior monologue, even when limited to technique and method, are little more than simple metaphors. Art can be called automatic only if the adjective is understood as a synonym for spontaneous, when the work is considered the product at once of nature and of intelligence: the act of representing the unconscious can only be a conscious act. But we must also repeat, in this regard, that the object of our research is precisely avant-gardism as ideology and as an aesthetic myth. Only from this point of view can such a concept as automatism have sense and validity.

It is evident that a wholly psychic concept of thinking is a typically modern phenomenon. It stems equally, in fact, from romanticism and psychoanalysis. To anyone who would object to the juxtaposition of these two terms, we may reply by citing the judgment of Lionel Trilling, who has defined psychoanalysis as "one of the culminations of the Romanticist literature of the nineteenth century."

Like the more rational romantics, the theoreticians of surrealism and the interior monologue conceive of consciousness and thought in terms of nonconsciousness and nonthought. This leads us back again to the problem of cerebralism, which can be defined as an attempt to reduce intelligence itself to the passivity of biological nature. That means that the nemesis of avant-garde cerebralism, in analogy to the case of voluntarism, is to be resolved and annulled by its own opposite. According to the usual nomenclature, we may say that cerebrality exercises the antagonistic function on a level at once psychological and aesthetic. It works by virtue of the attitudes or faculties to which it is opposed; it constitutes in respect to them a dualism which is more apparent than real. Just as no genuine antithesis exists between voluntarism and automatism, neither is there a genuine antinomy between cerebralism and the intellectuality of avant-garde art. This leads us once again to deny (although from a different point of view) the existence of a polarity between the geometric abstraction of the cubists and the mechanistic dynamism of the futurists, on one hand, and the biological and psychic vitalism of the surrealists and expressionists, on the other. Here, again, extremes meet. In a slightly abstruse phrase, Massimo Bontempelli, ends up reducing that opposition to a simple juxtaposition: "Perhaps for now we are the sons of the antithesis between the cubist and the futurist spirit (that is, the supersolid ultrarational and the ultraillogical superfluid)."

Most worth noting in this citation is the substantive adjective, "the ultrarational." The ultrarational, an authentic intellectual agonism, basically aims to surpass, and thus kill, reason. It is only a step from the ultrarational of cubism and abstractionism to the irrational of futurism, expressionism, or surrealism. And the step was taken by André Breton when he asked himself and his own contemporaries, "when will the arbitrary be given the position it deserves in the formation of works and ideas?" Without stopping to show that this citation also confirms the hypothesis that voluntarism is resolved in its opposite, that is, in arbitrariness, it will suffice to say that at least it shows that avant-garde intellectualism is for-

mulated by way of an antithesis to itself, which leads to a negation of the intellect. Amédée Ozenfant perhaps sensed this antapodosis, or generation of contraries, which is why he is one of the contemporary prophets of abstract art: "Absence of thought has become so admired a quality that no written work is accepted as modern by the majority of extremists, unless it satisfies this particular condition." If this is true, we can then say that of two opposed titles, Valéry's *Monsieur Teste* and Tristan Tzara's *Antitête*, the second is perhaps more significant than the first as evidence of the deeper impulses of the avant-garde spirit.

Tzara, whose bizarre and arbitrary recipe we have cited, formulated with great clarity (in a London lecture, "Le Surréalisme et l'Après-guerre") the dominant avant-garde intuition regarding the relation between instinct and consciousness in the sphere of art. In that lecture, after asserting the existence of an anonymous and cosmic poetic-ness that invades the world and life (an idea that makes one think of Herder's concept of "natural poetry"), after also contrasting that with the poetry of art (what Friederich Schlegel would have called the "poetry of poetry"), Tzara concludes by affirming the conscious inclination of the poetry of art to reduce itself to the condition of unconsciousness and spontaneity typical of cosmic poetry: "But there exists, beyond latent poetry, a manifest poetry, that which is written and has its limits, a tradition and evolution of its own. It, so to speak, is regulated poetry (*dirigée*) in a sense analogous to that by which latent poetry is *not* regulated. The tendency of the first poetry is to regain the stage of nonregulated poetry. We have here a subtle dialectic, though this is not the place to demonstrate its workings."

Furthermore, such a title as *Antitête*, polemically negative in form, shows again that kinship rather than opposition exists between voluntarism and automatism. The same relation had already been established by Rimbaud in his famous private manifesto, "le poète se fait voyant par un long, immense et raisonné dérèglement de tous les sens." And from the more or less conscious sense of that relationship, there originated among romantic and avant-garde artists the

illusory hope of being able to attain to aesthetic ecstasy, a mystic state of grace, by means of certain physiological and psychological stimulants: opium in the cases of De Quincey, Coleridge, Novalis, and Nerval; alcohol in the case of Poe; hashish in Baudelaire's case; absinthe in Verlaine's and Rimbaud's—in short, those drugs which give easy access to the "artificial paradises" found in other heavens than that of art. Another commandment of Rimbaud's demonstrates that voluntarism and automatism have a second family tie to cerebralism: "Il s'agit de se faire l'âme monstrueuse." As we have seen, the nemesis of this relationship leads cerebralism to be resolved or annulled in its own contrary, leads it to reach an animal state, however sublimely pure, a state of blind folly, however sacred. Furthermore, the interest that the modern critical and artistic consciousness shows for works of art dictated by fancy, inspired or frenetic, and by dementia or madness is noteworthy: we have a series of more or less famous instances from Hölderlin to Dino Campana. Like Rimbaud, not only the artist but the man of our culture and time is often inclined to "trouver sacré le désordre de *son* esprit."

Hence it is all too natural that voluntarism and automatism, cerebralism and irrationality, should re-enter the polemical argument of critics, under the customary, generalized, and negative phrase "dehumanization of art." Once again the apostles of traditional classicism show themselves unfaithful to themselves, neglecting in this regard to refer here (as elsewhere they are always doing) to the classical Terentian citation *homo sum: humani nihil a me alienum puto*. It seems quite undeniable that the *ésprit de géometrie* of cubism and abstractionism and the *ésprit de finesse* (in the sense of the preference given to spontaneity and intuition), toward which, at least as a distant ideal, other avant-garde movements aspire, are no more than equal and diverse aspects of the constant presence in modern art of a cycle of experiments and experiences, of the element Nietzsche called the "human, all too human."

Certain avant-gardes "of strict observance" base their distinction between pure and impure art on the differentiation of these two tendencies; but their parallelism instead shows that the ten-

dencies aspire diversely to two analogous ends: one, art understood as pure expression; the other, art as pure feeling. Hence the need to study in its internal logic the myth or concept of *pure art*. That, however, we cannot do without first examining certain of the most important ideas of avant-garde aesthetics (especially applicable to the word arts), that is to say, the three synonymous concepts of *metaphor, image,* and *symbol.*

Metaphysics of the metaphor

Modern poetry, to a great extent, is a real and true *metaphysics of metaphor.* Significantly, two independent movements, in two different countries, within a few years' time chose the word and the idea of "image" as the root from which to draw their name: British-American imagism and Russian imaginism. What we have already said about the denigrating image and the hyperbolic image will make it much easier now to study the effect of the image on the structure of modern poetry. About this we need only add here that Louis Aragon acutely perceived images as instruments of black humor, expressions of the agonistic and nihilistic impulses: "The image is a vehicle of humor . . . every image ought to produce a cataclysm . . . for every man there must be found an image which annuls the whole universe."

Furthermore, the metaphysics of the image is not a doctrine belonging only to the movements that made a banner of it. In fact, it found even more intense and knowing expression in surrealism and dadaism. Indeed, as an avant-garde commonplace it has survived the decline or extinction of those movements. "The image is a pure creation of the spirit," declares Breton; in terms of the same doctrine Tzara asserts, "all that one looks at is false"; or Aragon proclaims, "I have thrown away my eyes to put in new ones." The modern image is a thing-figure, independent of the pretext-object: a metaphor with only one term. "Aristotle excellently observed in his *Rhetoric,*" observed Chamfort, "that every metaphor founded on analogy ought to be equally appropriate even when inverted.

Thus one says old age is the winter of life. Invert the metaphor and you will find it equally appropriate to say winter is the old age of the year." This citation alone suffices to show for how many years the classical stylistic ideal has remained alive in poetry. The analogy upon which the modern metaphor is based is a hermetic and occult affinity, dreamed up by some wee devil like Mallarmé's *demon of analogy*. In it, every interior link is eliminated by means of a fantastic process tending to confound dimensions and categories. In the course of that process, felicitously adumbrated by the futurists as *imagery without strings*, the image often aims at making itself an emblem or hieroglyphic, cipher or seal—briefly, it aims at realizing what Ortega defines as the *algebra of the metaphor*. The reversability which Aristotle and Chamfort recommend comes to be carefully avoided, finally even made impossible. The modern metaphor tends to divorce the idea and the figure, to annul in the last-mentioned any reference to a reality other than its own self.

Rimbaud gave the recipe: "I have habituated myself to simple hallucination; I have clearly seen a mosque in the place of a gasworks." Later Mallarmé, too: "I cancel the word 'like' from the dictionary." Still later again, in the wake of the same ideas, the Russian imaginist Vadim Shershenevich proclaimed "the victory of the image over meaning and its liberation from content"; he declared that "the image ought to devour meaning" and ultimately recommended "the overturning of the word—from this head-over-heels position, which is natural for it, there ought to gush forth new imagery." Ideas like this come from a metaphorical conception of language, considered not as the figuration, but as the transfiguration, of the real. Poetry and language aspire to transcend the world of the senses, to attain a superreality which is at once a sublimation and a negation of human and terrestrial reality. From this we get an affirmation like Aragon's: "Life is a language; writing is a completely different one. Their grammars are not mutually interchangeable." Hence the desire to create new languages, attempts like that of young Stefan George or old James Joyce, or of the Russian poet Velimir Chlebnikov throughout his career. Each man constructed his own artificial and

private idiom, conventional and arbitrary, based on onomatopoetic and etymological criteria, on the suggestiveness of ambiguity and equivocation, on semantic illusionism and phonetic impressionism: a combination characteristic of the so-called *transrational language* of Chlebnikov and other Russian cubofuturists. Such a search for new languages, especially for a speech which aspires to make itself the verbal equivalent of music, which attempts to elevate metaphor to symbol and myth, is perhaps the most striking inheritance left to modern poetry by French symbolism and its numerous offshoots in Europe and America. This is enough to prove that symbolism was something more than a cenacle or a sect; indeed it was the principal poetic movement, the richest source of modernism in the field of literature. Futurism and surrealism, which stemmed directly from it, are only the continuation or vulgarization of its teaching, even when they delude themselves into believing they negate or transcend it. Enough to think of the magisterial and exemplary position which Mallarmé has assumed in the Pantheon of modern poetry; he has influenced posterity more than any other modern poet.

After all, symbolism's work of renewal did not solely consist of rendering to poetry "son bien" or "son dû" (as it seemed to Mallarmé and Valéry); that is, symbolism did more than merely to reintroduce the musical and dionysian spirit prophesied by Nietzsche or to lead poetry back to Pater's "condition of music." Nor did symbolism limit itself to the mystical sublimation of metaphor or to deciphering, through symbols and correspondences, what Baudelaire had defined, after Swedenborg, as "the universal analogy." Each of the symbolists cherished truly cosmic ambitions and assigned to poetry "the orphic interpretation of the earth" (to use Mallarmé's phrase). In terms of this doctrine, symbolism exemplified, to an extreme, the avant-garde reach toward the infinite and absolute; symbolism truly conceived of poetry as a metaphysical agony, even though deprived of a genuinely transcendental content.

We have already said something about symbolist technical and stylistic experimentation; here we shall mention only the contribution of symbolism to the so-called *poetics of the Word*, a doctrine

dominating contemporary poetry. This contribution is absolutely fundamental, as we can show even by examples limited to Italian lyric poetry. With its symbolistic concept of the word as synthesis of sound and symbol, that poetry re-enters, actually and potentially, with excess and defect, into a dialectic of often extreme and antithetical alternations: D'Annunzio's word-sensation and Pascoli's word-dream; Saba's word-passion and Quasimodo's word-sentiment; and, a final paradox, Montale's word-object and the word-incantation of Ungaretti. Enough to show that, in the poetics of the Word, it is not God who is made Word, but Word made God. In a certain sense, we may say that this poetic thus answers the rhetorical question, both ingenuous and profound, which Shakespeare's Romeo asks when love makes him doubt the wisdom of partisan feuds that would give Juliet's name a connotation of hatred: "What's in a name? That which we call a rose / By any other word would smell as sweet." Few of symbolism's standard bearers, very few, would give Romeo the answer he desires, precisely because, for them, the *nomen* is, in itself, *numen*. Among the few, the only one who counts would perhaps be the Russian Nikolai Gumilev, who founded the movement he called acmeism precisely as a reaction against symbolism. If we read in an acmeist manifesto, signed by his companion Sergei Gorodecky, that a rose is beautiful *in* itself "not because of its mysterious analogy to mystical love," by compensation the majority of contemporary poets still repeat with Gertrude Stein, "rose is a rose is a rose," meaning that the word "rose" is an object as valid as the flower which bears that name and even holds a sweeter and more real perfume. In other words, for modern poetry the word is not sound-sense, but idea-thing; in its vision the Word is not spirit which became flesh, but flesh which became spirit.

The Mystique of purity

From the immediate precedent of symbolism, ideally represented by Mallarmé, the myth of *pure poetry* arose in France, just as in the figurative arts Cézanne's example carried over into cubism

and abstract art, into pure painting or pure sculpture. Thus the avant-garde aesthetic came to culminate in a real and true mystique of purity, with its particular dialectic and even its own dogma. The universality of such a principle is easily shown by the fact that the concept of poetic purity, sometimes in the psychological sense of pure sentiment, sometimes in the aesthetic sense of pure form, was welcomed even by writers with prevalently ideological interests. It is well known, for example, that Jean-Paul Sartre, even while putting literature into the service of quite other ideals, continues to conceive of it as education and action in the manner of the eighteenth-century *philosophes*. Nonetheless, Sartre also holds that verse, the lyric, and the poet are absolutely free from the bond of an ethical, social, or political message; he recognizes their privilege of exemption from what he defines as *engagement*, that is, the practical and doctrinary task he rigorously assigns as the supreme duty of the prose writer, not only the critic or essayist but even the novelist. And the fact that, even for Sartre, the concept of pure poetry parallels that of abstract art is demonstrated by his extending the same privilege of gratuitous liberty to figurative creation, as well as to the artistic personality of painter and sculptor.

Another French writer who understands even more fully the meaning and scope of the mystique of purity is André Malraux, who has recognized the mystique as a form of aesthetic agonism. "To conceive of painting as only painting, that is, as pure painting, meant transforming the function of painting." The author of *The Psychology of Art* has equally well noticed, on the opposite side from Sartre's, the parallel of abstract art and pure poetry. He understands that both tend to violate the revolutionary canon, already postulated by the romantics, of *the confusion of genres*, or the even more revolutionary *syncretism of the arts* postulated by the symbolists: "To demand of painting and poetry the primacy of their specific means of expression means to demand a poetry-more-poetry, or a painting-more-painting, which is to say, less poetry."

Lest these suggestive pieces of evidence lead one to believe that the mystique of purity, undoubtedly originating in French

literary theory, was a tendency unknown or neglected outside of France, it will suffice to cite the case of Czechoslovak poetism, which was completely intent on affirming theoretically and realizing in practice a poetry chemically reducible, as to a single element, to its own essence. The frequent attempts in every European country to mold a theatrical performance which would be pure theater, as well as the discussions and experiments tending toward what is called pure cinematography, prove that the phenomenon has extended even to the realm of the applied or minor arts.

The ideal toward which the mystique of purity tends has nothing to do with *purism* in the traditional linguistic and stylistic sense— that form of purism served the classical and neoclassical need for elegance and correctness and formulated a series of rigid norms applicable only to the grammar of art. The modern mystique of purity aspires to abolish the discursive and syntactic element, to liberate art from any connection with psychological and empirical reality, to reduce every work to the intimate laws of its own expressive essence or to the given absolutes of its own genre or means; in the literal sense of the terms, it is ultra-ism or hyperbolism, an extension of the agonistic spirit to the realms of style and form.

It must not be forgotten that when Mallarmé used *hyperbolic* to designate the paradox of the work of art, he was playing with the double meaning of that word and making use of both its rhetorical and its mathematical significance. Even before him, or beyond his influence, the purity of art had been conceived of in terms of the rhetorical concept of hyperbole, as a verbal and formal drive that accentuated the distinction between the immaculate artificiality of the artistic creation and the impure naturalness of the real. Such a concept had in fact already appeared in numerous romantic and decadent doctrines, even if it was there maintained for ends that were not merely stylistic, as a way to challenge the authority of good sense and the commonplace. "Art itself," said Oscar Wilde in *The Decay of Lying*, "is really a form of exaggeration; and selection, which is the very spirit of art, is nothing more than an intensified mode of over-emphasis." But the more extreme avant-garde sometimes

preferred to conceive of the mystique of purity precisely in the geometric sense of the image—as a hyperbolic or parabolic curve which transcends the limits not only of reality but those of art itself, to the point of annihilating art in attempting to realize its deepest essence. More recent avant-gardism has carried this notion to further limits; it postulates the attainment of purely theoretical positions by an ever increasing process of distillation and condensation. Ozenfant has quite justly defined these idealized states as "the need for extreme liberty and extreme intensity of feeling," and he enumerates them in this series of utopian formal ideals: super-geometry, super-poetry, super-painting, super-music.

We have reaffirmed the parallelism between pure poetry in literature and abstractionism in the arts of design; now it is time to translate this parallelism into its concrete equivalents. In this regard there is an obvious analogy between the function of the word-metaphor, word-symbol, and word-idea in poetry and the function exercised by lines and planes, masses and volumes, blots and colors, in the figurative field: in other words, a plastic style which no longer puts its trust in the suggestions of light and shade, but in the severe beauty of form contemplated in eternal and absolute space. By these means, which reflect a new vision more than a new technique, the figurative arts seem to tend toward the creation of an isolated and autonomous reality, generated by parthenogenesis, without any mingling into surrounding reality. Just this ambition of freeing art from the prison of things, and even of forms, has led to terms like *nonobjective art* and, more recently, *art brut* or *formless painting*.

The significance of such names is not diminished by their lack of validity on theoretical grounds. In the area of aesthetics, each of them sounds like a contradiction in terms. Particularly so, *art brut* and *formless painting*: one may immediately object that there is no art where material remains refractory to formal exigencies. *Nonobjective art* would mean an art representing ideas rather than objects, a definition that will not work in the aesthetic area and will not work in logic either, because the represented is neither idea nor object but simply form and figure. On a more empirical plane, it is still an

equivocal definition because that negative epithet can be understood as a synonym for subjective, whereas nonobjective art aims precisely at depersonalizing the work and author, and reacts in an extreme manner to any sort of subjectivism, romanticism, and lyricism. As for the phrase *nonrepresentational art*, that is an honest-to-goodness non sequitur. It is in fact evident that, if you take "representation" as synonymous with creation, then even traditional art is nonrepresentational; whereas if you take it as a synonym for expression, then even nonrepresentational art is representational. "Representation is a mode of style; not style a mode of representation," declares Malraux. Or we might say, in Berenson's language, that illustration is so subordinate as to lose function, essence, and value in the face of decoration. But terms like raw art and formless painting, nonobjective art and nonrepresentational art, are valid only in connection with the states of mind they emphasize. These states and mentalities are in their turn determined by the dehumanizing tendencies, iconoclasm and deformation. These, then, are nothing but the procedure by which abstract art reduces the forms of living nature to the status of *une nature morte*, with the precise aim of attaining once again a condition of absolute expressive purity or perfect innocence.

As within the modern word arts there is more than the ideal of pure poetry, the panorama of figurative arts is not uniquely reducible to abstractionism, to what Mondrian called "neoplasticism." As already noted, within the avant-garde there also triumphs a less hygienic and antiseptic art. Certain poetic currents originating from the surrealist experiment are enough to demonstrate how, in contact with and contrast to the mystique of purity, what is actually an opposite mystique at times affirms itself: an exalting of impurity and hybridism which is not limited to a mixture of materials or an eclecticism of forms. Besides, syncretism of the arts is a factor not to be neglected in avant-garde experimentation, where it subsists as one of the many inheritances from symbolism (whence also stems the concept of pure art and poetry). Doubtless syncretism of the arts is opposed to the primary symbolist exigency, that reduction of

poetry to music which, despite all contrary appearances, recommends the return of poetry to itself, to its own music. But symbolism has also tried other ways and has walked, in theory at least, another road—contamination of techniques and confusion of genres—by way of which it meant to oppose to pure art and pure poetry a quite diverse absolute. If pure art and pure poetry aspire to attain a state of beatitude and grace, a condition of perfection and stasis fixed forever, by the severe ethos of form, then surrealistic act and poetry (and expressionist, for that matter) in fact aim to realize themselves in a state of permanent revolution, a series of commotions and permutations which have only the pathos of experience as cause and norm.

From this point of view, surrealism is at once the continuation and negation of decadent aestheticism, precisely because it mixes art and life, reduces the first to the laws of the second. Hence, in better cases, the neoromantic character; in poorer cases, the neo-futuristic character of its inspiration. The latter is apparent in the sympathy for experiments tending to fuse the practical and the aesthetic, such as the "stroll poetry" and "postcard poetry" which Apollinaire projected; tending to what Blaise Cendrars called "telegram poetry," "photograph poetry," "newspaper poetry," and "radio poetry."

To be sure, despite its chaotic and hybrid nature, surrealist poetry also aspired, in its better moments, to attain a state of grace and purity or, better, of purity and innocence. By its own nature, surrealism was led to conceive such ideas in a prevalently psychic sense, as being ingenuous in sentiment or genuine in experience. It often deluded itself in believing it had found the road to the paradise of innocence by way of another hyperbolic curve, what might be called, using the title of a book by André Breton, "la trajectoire du rêve." In fact we cannot speak of surrealist poetry, and the poetic tendencies deriving from it, without mention of *dream poetics*, understood as psychic hallucination or illumination. From this poetics derives what is called oneiric art, poetry, and painting. A dream poetics is not in itself anything new. Certainly the identifica-

tion of aesthetic vision and oneiric vision is not new. But that earlier identification was only understood as an analogue or a figure of speech, whereas the surrealists conceived of it in a literal and immediate sense. The ancient idea of the parallelism between the oneiric and the poetic is taken up again all the more readily since it became, in our time, almost a scientific doctrine. The theoreticians of psychoanalysis in fact define the artistic faculty as the capacity to organize, in an order or system, those dreams which mystics considered prophetic visions, which modern psychology considers intimate and private symbols of the soul's crises.

Dream poetics has perhaps become the most important of all surrealist doctrines, so much so that Breton used it to argue the recondite sense of his movement's name, as we see in the following passage: "I believe in the future resolution of these two states, dream and reality, in a new species of absolute reality, superreality, so to speak." Breton also defined the dream as "a never-ending stroll through the dead of a forbidden zone," that is to say, as an intimate revelation, or violation, of the most jealously guarded secrets of the consciousness. Conceptions of this type furnish further clarification for the problem of avant-garde cerebralism. Breton himself established an identity between the two objects of his own faith, which were "the omnipotence of the dream" and "the disinterested play of thought": the relation of one to the other fundamentally subordinates the second term to the first. Thought so conceived is reduced to a quasi-mechanical product, a passive reflection, a fantasy or reverie—in brief, it becomes a sort of open-eyed dream.

Dream poetry was anticipated by Apollinaire, who postulated an "oneiric heuristic," aesthetic in character, the idea of art as dream interpretation, the dream as the hermeneutics of art. And it was following in his footsteps, as well as Freud's, that the surrealists introduced, along with the theory and practice of automatic writing, the theory and practice of oneiric language. But it would be erroneous to limit dream poetry to the lyric alone, or only to surrealism. According to Valéry, as he maintained in an essay on Proust, that poetics had stormed the last bastion of nineteenth-century realism

(the novel, that is), now no longer treated as mirror-work but as dream-work.

Sometimes dream poetics transcends every norm and postulates hallucination itself as the end and means of artistic vision. Even when it does not go that far, it remains a poetry of the chimerical and absurd—just as abstractionism often exhausts itself in a poetry of cipher and caprice, arbitrary and abstruse. It is not only the dream of reason (to use the inscription on the famous etching by Goya) but also the reason as a dream which produces monsters; produces, that is to say, the paradoxes and portents (in the etymological sense of the word) so profusely spawned by one and the other of these two poles of avant-garde art.

10. HISTORY AND THEORY

Historical parallels

We open the final phase of our inquiry with a critique of a few of those parallels by which some less-informed observers intend to find historical precedents for avant-gardism, or pretend to show that avant-garde art has always existed. The first of these parallels (it would be better to say "anachronistic contrasts") attempts to put the art of our time in the family line of baroque art. Although some critics believe they see a return of the baroque in our culture, others choose to recognize an anticipation of avant-gardism in the baroque (potentially at least). Such connections (especially the second) tend to be made by a criticism equally hostile to both parties. The baroque for Irving Babbitt, who condemned all modern art as "romantic," is nothing but a form of "romantic intellectualism." An almost identical formula is used by Julien Benda to combat intellectualist abstractionism in contemporary art; in fact he defines that abstractionism by an analogous formula, quite as anachronistic, the "romanticism of reason."

The judgment implied by these two apparently interchangeable terms at times coincides paradoxically with the opinions of the opposing party. It is well known that some exponents of the modern

movement have suggested this same relation between modern and baroque art, even though they do so in praise of modern art. Many contemporary poets in England and Spain have done this, making the school of Donne and Góngora their model, seeing it as a historical precedent for their own vision and method. When, understandably from the viewpoint of poetics and the history of taste, the English and Spanish representatives of the new lyric invoke metaphysical poetry and Gongorism, their allegiance is as uncritical and unhistorical as their adversaries' charges. To show how unhistorical these analogies are, we need only the simplest form of proof, the terminological, which may also be called the semantic or nominalistic.

Metaphysical poetry and Gongorism are partial and local manifestations of the universal stylistic manifestation (especially triumphant in the visual arts) which has long been called baroque. That is, it was given a name, pejorative in origin, which has acquired a positive value only in our time or, better, has acquired a neutral and descriptive function. The name *secentismo*, precisely because it underlines the temporal limits and determinations of the phenomenon, shows itself as a posthumous label without further question, at once historical and anachronistic. Continuing the semantic and terminological examination, we shall see that the first followers of what seems to us a simple variant of the figurative baroque called that variation the *modern manner* (*maniera moderna*), a suggestive term but empty of the notions we may be tempted to read into it. With terms at least as ancient in origin, the same literary baroque in Spain and Italy also took the names of culteranism and conceptism: the first, symptomatic of the permanence in baroque taste of the classical predilection for a refined and virtuoso art, erudite and learned; the second signifying the extreme intellectualism of the phenomenon that the name takes as a banner and precept. All these designations reveal that, despite the breadth of its influence, the baroque functioned more as a school than as a movement. Similar conclusions may be drawn from the French term *précieux*, where the notion of the school is extended to that of the salon or coterie. Finally, terms like Marinism, Gongorism, and euphuism, the first two with

reference to two supreme masters, the third to the title of a typical work, confirm the hypothesis of the baroque as a school or academy.

All nominalistic proof is worthless if not submitted to the test of facts and ideas. So it will be useful to look again at the term *conceptism*, which seems to justify the reduction of the baroque to "intellectual romanticism," as Babbitt would have it. Now critical and historical examination easily demonstrate that, despite any verbal similarity, baroque conceptism has nothing to do with romantic intellectualism and nothing to do with avant-garde cerebralism. It is nothing but an exaggerated and peculiar variant of classical intellectualism, even of scholasticism. Added to this, the concept of form that baroque artists and poets had was classicizing in the Renaissance way. If the relation was clearly established in the field of visual and plastic arts, with due distinctions, by the German critic Heinrich Woelfflin, the Italian Guiseppe Toffanin was able to show the existence of the same connection in the literary arts. To Toffanin we owe the felicitous definition of the baroque as an attempted "overcoming of the classics," which corresponds to the interpretation given by Woelfflin to Vasari's formula of the "modern manner."

If they are appropriate labels, *maniera moderna* and the "overcoming of the classics" cannot but betray the intent, on the part of the classical culture to which they refer, to regain a classicism even more perfect than that of the ancients and their modern successors. Such an intent is in clear relation to the myth of the fullness of time. That myth, a secure belief in such an age as that of Leo X or Louis XIV, was a belief no less dear to the eras immediately following, such as the Italian Seicento and the French eighteenth century. The certainty of having regained a culmination seems firmest just when decline is imminent, when the new golden age is in the process of showing itself to be a silver age (or worse). This is the historical nemesis of any classicism: its ideal is only a paradox, because it consists of the wish to remain at the summit of an unalterable perfection, the pinnacle of an incorruptible maturity. Nothing is more opposed to the myth of the golden age than the romantic notion of

Zeitgeist, or the postromantic one of decadence; nothing more contrary to it than the agonism and historical futurism of the avant-garde. Hence the impossibility of recognizing a potential or anticipated avant-gardism in baroque art, which depends on the golden-age myth. On the same myth depends a diverse and later manifestation, the so-called quarrel of the ancients and the moderns, a more apparent than real debate, in which some want too easily to see an anticipation of the controversy between the classics and the romantics, and even of the controversy between traditionalists and modernists.

This erroneous interpretation stems from an incomprehension of the presuppositions upon which the moderns, in the course of the quarrel, based their own assertion of modern primacy. That presupposition was the idea, already cherished by Bacon, that the moderns were the true ancients: first in quality and experience because later in time and as such more mature and "ancient," more expert and sage. Nothing could be more remote from such a concept than the romantic and avant-garde cult of novelty and youth, that apocalyptic anguish, that anxious longing for palingenesis which distinguishes our culture. On the other hand, nothing is more classically traditional than the wish to rival the ancients and the ambition to vanquish them by winning the same game, the game for which the ancients called the rules and fixed the examples. That wish or ambition was no less natural to the baroque artist than to the neoclassical artist. Even in the sphere of style, one type of artist as well as the other aimed at the same goal: to attain a new mode of perfection while remaining within the circle of traditional art. Even in the baroque tangent, centripetal force is greater than centrifugal and keeps that art at the perimeter if not in the center.

Naturally there are historians or philosophers of culture, Eugenio d'Ors, for example, who consider the baroque as a constant recurrence in history, and those inclined to accept such a principle tend no less equally to treat even avant-garde art as an "eternal return" of the spirit. That is what the scholars have done who, say, have discovered and identified an abstract phase even in prehistorical

art. If they have yielded to such a temptation, however, it is only because they started from two arbitrary presuppositions: first, that avant-garde art is as a whole reducible to abstractionism alone, at least in the visual area; second, that abstractionism has the same motivation, the same purpose, an always unique and equal meaning, in whatever culture or civilization it makes its appearance. All we need do to suggest the falsity of such a preconception, and the consequences derived from it, is to observe that prehistoric abstractionism, like the archaic and primitive, seems tied up with a symbology the key to which we have lost, but which must have been an integral part of the beliefs and fantasies of the collective soul. Avant-garde abstractionism, on the contrary, even when it claims to be absolute and objective, is the direct expression of a private and personal vision, relative and subjective.

Other critics have wanted to find historical precedents for avant-gardism which are only apparent, since their substance is that of a more or less permanent psychological idiosyncracy. Thus, for example, the attitudes here called agonism and antagonism have been traced back by some to the cynical mentality in ancient history and to the nihilistic one in modern history. As states of mind, cynicism and nihilism are as old as the world; hence they are general facts of history and custom rather than of culture and art. But it is precisely in the transposition of these states of mind from the passive sphere of custom to the active sphere of cultural and artistic consciousness that they become historical facts; there is no doubt that the modern instruments of that transposition were romanticism and avant-gardism. If there is an avant-gardism *ante litteram*, farther back than romanticism itself, it must be seen at the very most in the immediate harbinger of the latter—that is, in the *Sturm und Drang*, also called the age of genius (*Geniezeit*) precisely because, on the traces of Rousseau and his concept of genius as originality of the psyche rather than originality of intelligence, it introduced to the cultural area those psychological, personalistic, and vitalistic factors that the classical tradition considered alien to the work of art.

For reasons similar to those already given, the customary com-

parisons with primitive art, or even with the decadent work of other epochs, again seem quite worthless. The primitive artist identifies vision and representation; the classical artist subordinates one to the other; the avant-garde artist treats them as if they were in a state of opposition. Thus we cannot admit the parallel with the decadent art of the ancient world, the Hellenistic or Alexandrian, which is classical par excellence, meaning only neo- or pseudo-classical. It is self-conscious and complex but, contrary to avant-garde art, bound to a canon of unique and permanent tradition. What characterizes avant-garde art is the myth of the new. It is often said that the taste or cult of the new is not a new thing, and that is very well said. There is no great difference in the concrete concept that the ancients and the moderns have of the new; but there is an enormous difference in their respective evaluations of it. Whereas the ancients considered the new as at most a relative value, the moderns almost always treat it as an absolute. That the sense of tiredness with the old and the repeated is a universal psychological impulse, recurrent or permanent, is a 'commonplace verity. But characteristic of the classical fatigue in the face of the already-done and already-said is also the doubt that one can find a "new" truly worthy of taking the place of the "old." At the end of that confession he entitled *L'Esperienza futurista*, composed precisely at the moment he decided to abandon that experience and, at least in part, to deny it, Giovanni Papini cited the lamentations of an ancient Greek poet, that Homer and his successors had already exhausted the founts of poetry. The intent of that citation was to prove that futurism was as old as the world, or at least that the desire for the new had always and everywhere existed. It is a false argument, for the cited lamentation is an exemplary expression of that classical skepticism which begins with the proverbial "nihil sub sole novi" and closes with La Bruyère's "tout est dit." And it is a lament inconceivable to modern genius, which tends to consider the spirit as impossible to use up or use out.

Therefore nothing is more new and modern than the modern cult of the new. As Berenson felt obliged to note: "The lust for otherness, for newness, which seems the most natural and matter-of-

course thing in the world, is neither ancient nor universal. Prehistoric races are credited with having had so little of it that a change in artifacts is assumed to be a change in populations, one following another." There we have it: the ancients and the classical writers tended to give a lucid and pitiless criticism of the new; but the moderns almost always yield to the temptation to seek, without truce or peace, the unknown zones of art and culture. To discover unheard-of zones, the modern spirit is disposed to scale heaven and violate hell, to descend, according to Baudelaire's verse, "Au fond de l'inconnu pour trouver du nouveau."

In no document does this will to search out the new within the unknown, and the unknown beyond the new, find so intense and so sincere expression as in the text of Rimbaud which posterity has named the *Lettre du voyant:* "Je sais qu'il faut être voyant, se faire voyant" (I know one has to be a seer, make oneself a seer). It is clear that by being a *voyant* he means revealing and discovering, on the far side of art and history, values and realities which the eye of man and the mind of the poet have not yet seen or conceived. The poet's very function, or the artist's mission, in general, consists of the attempt that Rimbaud describes as "inspecter l'invisible et entendre l'inouï" (to inspect the invisible and hear the unheard-of). Even when the work of art is conditioned by the consciousness of his own Zeitgeist, the poet must always express that sense of the unknown by which the genius of the epoch transcends itself: "Le poète définirait la quantité d'inconnu s'éveillant en son temps, dans l'âme universelle" (the poet would define the quantity of the unknown waking in his time, in the universal soul). Hence the need for experimentation, even in technique and form, always tending toward the unknown and the new: "les inventions d'inconnu réclament des formes nouvelles" (discoveries of the unknown call for new forms). Poets and artists of the present generation will prepare the soil, at least, for the aesthetic epiphanies of the future: "En attendant, demandons au poète du nouveau, idées et formes" (as we wait, let us ask the poets for the new, ideas and forms). No other work, public or private, in the course of the last hundred years has revealed the credo

of avant-garde art with the lucid violence of this text, which the circumstances of an extraordinary career destined to leave unpublished for almost half a century. It is enough to read its pages to prove the novelty of the modern idea of the novel, as well as the modernity of the new idea of the modern. Just as the classical or neoclassical spirit is perfectly expressed in Alexander Pope's warning to the proponents of the new in the quarrel between the ancients and the moderns—"Moderns, beware"—so too the avant-garde genius was never 'more effectively expressed than in Rimbaud's exhortation, in the same letter: "Il faut être absolument moderne."

Modernity and modernism

Among the objections most frequently raised to avant-gardism, the best grounded would seem to be the denial that art must express, more than the new, the modern. Implicit in that objection is the view that, in its own day, all art is modern: *une vérité de La Palice*, as the French say. Yet that truth loses its validity unless one admits that in every case the modernity involved is a different quiddity, which the current historical consciousness feels in different ways and to a different degree. At times, the sense of being modern is almost nonexistent, or does not rise to the level of a clear awareness; then it becomes a reality only posthumously, *ex post facto* or at least retrospectively. The wiser historians and critics know, moreover, that unoriginal work, the mediocre or *manqué*, reveals the spirit of its own times in a sharp and direct way precisely because it remains a document and not a monument. But this type of revelation brings to light not the *modernity* of this or that epoch, but its *modernism*. Both modernity and modernism go back etymologically to the concept of *la mode*; but only the second agrees with the spirit and the letter of it. It is not in fact the modern which is destined to die, becoming a modern thing that no longer seems so because its time has passed, but the modernistic. About this we must admit, without further ado, that the avant-garde as much as any other art current, even perhaps more extremely and intensely, is characterized not

only by its own modernity but also by the particular and inferior type of modernism which is opposed to it.

According to what we have said so far, every civilization has a peculiar, albeit sometimes unconscious, feeling of its own cultural and artistic modernity. There is a humanistic version of the notion of modernity, for example, conceived of as a return, at once spontaneous and willed, to eternal values, long forgotten or buried but which a reborn or renewed historical memory makes once again present: a concept that assigns to antiquity the role of the classical and exemplary age, to modernity, the role of a renaissance or a restoration of the classical and ancient. In such a historical dialectic, the civilization that preceded the renaissance or the restoration then under way, and which had made revival all the more necessary by its own neglect in conserving and handing down the eternal values of classical antiquity, comes to be blamed as ignorant and uncultured, repudiated as gothic or barbaric. Hence the name given it, the "middle ages," meaning an interval of decadence, not an intermediary or transitional age. And there exists, on the other hand, the romantic version of the concept: the new and the modern are seen in terms of a birth rather than a rebirth, not a restoration but an *instauratio ab imis fundamentis*, a construction of the present and future not on the foundations of the past but on the ruins of time.

These two versions, the humanistic and the romantic, precisely because they are from particularly alert and cultivated periods, are easily transformed into polemical and tendentious arguments. But there are ages in which the feeling for modernity remains a sentiment without turning itself into a passion for propaganda. Such ages are pervaded by a vague intuition of the youth of man and the world, by an expectation of a maturity near at hand, an imminent flowering: such a sentiment is further proof of the fundamental difference between an authentic primitivism, one which sees the golden age in the near future, and modern primitivism, which instead searches for it in an irrevocable and immemorial past. The ingenuous dream of a new and close golden age is, however, alien to the romantic and avant-gardistic feeling for the modern. The

latter feeling, only an extreme and corrupted variation of the romantic Zeitgeist, is afflicted by the unstable relativity of a quasi-nihilistic historicism. On that account, precisely, the faith of the avant-garde in its own modernity all too often degenerates into heresy, into the corruption of a facile modernism.

What is modernism then? We know that the term became the positive program and particular teaching of a Spanish literary movement (better, a Hispano-American movement) at the beginning of this century. That movement, paradoxically, may be described as one of the most discreet, timid, or moderate avant-garde tendencies to appear since the end of the nineteenth century. But the nature of modernism in general is anything but timid, moderate, or discreet; it naturally leads to exaggeration and disequilibrium and must even be defined as an unconscious parody of modernity, an involuntary caricature. Modernism leads up to, and beyond the extreme limits, everything in the modern spirit which is most vain, frivolous, fleeting, and ephemeral. The honest-to-goodness nemesis of modernity, it cheapens and vulgarizes modernity into what Marinetti called, encomiastically, *modernolatry*: nothing but a blind adoration of the idols and fetishes of our time. There we have the reason for accepting as fair the severe judgment of Aldous Huxley: "Modernity-snobbery, though not exclusive to our own age, has come to assume an unprecedented importance."

To exemplify the degeneration of modernity into modernism, all we have to do is refer to the failure of the attempt to express what the surrealists, following in the footsteps of Gautier and Baudelaire, called the *modern marvelous*. In itself, the idea was felicitous and potentially effective. Why not look ingenuously and freshly, with sympathy and enthusiasm, at certain aspects of modern life and draw from them a new poetic magic, new fables, and fantasies? The attempt, anticipated by Walt Whitman and Verhaeren and already begun by the futurists, measured by its deeds, ended up in almost complete failure. This failure suggests the hypothesis that the modern imagination is congenitally impotent when it comes to mythic and legendary creation. Perhaps an obscure aware-

ness of that impotence has led to the wistful and nostalgic mytho-
logism which attracts so many of the artists and critics of the modern
age. Such critics should not nourish those illusions; they ought to
realize that ours is not a mystical-minded period. Self-delusion in
this regard may possibly, in some cases, be helpful to an artist, but
it is almost always harmful to critics.

The failure of the attempt to realize a *modern marvelous* (almost
always scientific in content, almost exclusively urban in ambiance)
was also due to the fact that the marvels of technology are now dis-
counted by men of the new times; the poets and artists themselves,
in the very great majority of cases, reduced the fabulous to the level
of the extravaganza and the apparent, superficial, and fleeting.
Bontempelli sensed as much when he recognized that the myth of
aviation had already been exhausted, some thousands of years
before the airplane was invented, by the myth of Dedalus and Icarus,
and when he asked what poet, contemporary with the discovery
of the New Atlantis that is America, or afterward, had ever succeeded
in drawing from this event a vision even remotely comparable to
the voyage of Ulysses in Dante.

From the *modern marvelous*, starting with the romantic *Märchen*
and moving on to Bontempelli's *magic realism* (the same phrase was
independently used by the editors of *transition*), we have had nothing
but the interpretations of fable or of rhetoric. Rather than being a
wellspring of new myths, its resources have been exploited as a call
for new settings or a repertory of new themes; often, on the tracks
of Poe, as an attempt to introduce scientific methods into the sphere
of art. That turns our thought to scientificism and experimentalism.
The more ambitious and recent modernism in fact tends, as already
said, to technical experimentation in a scientific rather than aesthetic
sense. The adoption by so many recent writers of the methods and
effects of the movies and radio will do as one example out of many.
But what counts is that most writers have limited themselves to
expressing the contemporary marvelous not in the perspective of
modernity, but in that of the modish, taking for subject and model,
sports and the circus, the bar and jazz, the music hall and the film.

We are then dealing with an external and vulgar modernity, more of matter than of spirit, a modernism considered only as a snobbist variant of romantic "local color." This local color of modern life, which shows itself more at the periphery than at the center of the Western world, sometimes takes the paradoxical form of Americanism—a fact belonging more to the sphere of custom than to art. Such a wretched modernolatry is a form of regression, just as Americanism is only a sort of provincialism. Provincial too appears the contemporary passion for urbanism and the urbanistic, the exaltation of the tentacular city, the great capitals and industrial metropoles, where the crowd deludes itself into believing it lives a richer and more real life. From this cult comes, in Italy, the myth of the Stracittà (the supercity), which was no less provincial than the myth of the Strapaese (the supercountry) it was meant to oppose.

The overcoming of the avant-garde

Fortunately, the most recent avant-garde seems definitely to have freed itself of the dross of that ridiculous and cheapened modernism which afflicted Western culture just before and after the First World War. Still, strange to say, the more literal and ingenuous-minded observers believe they see in exactly this cure for the modernistic malady what they call the crisis of avant-gardism. Other observers (in this case the less perceptive ones) go so far as to affirm that the process in which we are assisting is the liquidation, or at least the overcoming, of the avant-garde. Our task in these final pages is to criticize that view. It is obvious that the very dialectic of movements and the effect of fashion cause every avant-garde to be able (or to pretend to be able) to transcend not only the academy and tradition but also the avant-garde preceding it. Sometimes a movement fools itself into believing it attains the peak and end point of all avant-gardism in its own action, believing that it realizes and represents, all by itself, the ultimate intention and the ultimate stage of avant-gardism. The Italian Novecento movement thought as much, if we are to believe a declaration of Bontempelli, its coryphaeus.

After paying homage "to those brilliant avant-gardes by whom, in an earlier time, we all were nourished," Bontempelli in fact treats them as a starting point; the point of arrival, which the Novecento was held to have reached, would consist in inaugurating and commencing the "third period," when the avant-garde spirit, certain that it had wholly fulfilled its mission, would cease to function as the presupposition of present and future creation.

When we look more closely, we shall see how avant-gardistic is the idea of the advent of a new golden age through the mediation of the avant-garde. If such an idea makes any sense, it would be as the implicit prophecy of a future culture in which avant-gardism would itself be tradition and would become, instead of the exception, the rule. Basically what is now happening is only a transference of this kind. The crisis of avant-gardism is not, so to speak, a crisis of rule, but only of succession: the king is dead, long live the king! More ingenuous observers see denials and betrayals where there is only a simple change of names and personalities, at most a change of emblems and banners. To tell the truth, transference of power cannot be effected without some defections and secessions; no doubt we have been present at a recrudescence of legitimist nostalgias, the attempt to restore dynasties long since dethroned. We certainly cannot deny that in the latest days there have been recalls to the ancient order, or returns to other and more solemn traditions. But if we look carefully, we see that these recalls to order and returns to tradition come more from the desire to consolidate the modern revolution in art than from the desire to organize a coup d'état or restore the *ancien régime*. Even in the case of T. S. Eliot, the most symptomatic and significant case, we have in fact only the theoretical reinvocation of an historical classicism now irrevocably lost. Just so, whereas that reinvocation has exercised a valid function in the critical field, it has not in the least worked for the creation of art or even for the mere practice of art: a judgment that holds also in the particular case of Eliot himself as an artist.

Besides, even Eliot realized that it could not be otherwise, as may be seen from a passage in his essay on Baudelaire where, after

condemning the romantic and inferior modernism which disfigures Baudelaire's work, he ends up admitting, "It must not be forgotten that a poet in a romantic age [or, we might add, in a modern age] cannot be a 'classical' poet except in tendency." The same reservation is found in Eliot's essay on Joyce's *Ulysses*, formulated by means of the following alternative: "One can be 'classical,' in a sense, by turning away from nine-tenths of the material which lies at hand and selecting only mummified stuff from a museum—or one can be classical in tendency by doing the best he can with the material at hand." Obviously the first is the negative solution of the epigones who fool themselves into believing they have attained to antique grandeur by denying their own Zeitgeist; the second is the progressive solution of the artist who accepts (as Ortega puts it) "the imperative of the work imposed by the period." But all this means that a modern classicism, albeit theoretically conceivable, is impossible in the face of effective aesthetic achievement—a truth Eliot again confesses in the Joyce article when he observes, "It is much easier to be a classicist in literary criticism than in creative art."

This predestined historical dialectic had already been perceived even by Eliot's teacher, the critic T. E. Hulme, failed prophet of a new poetry of which he himself said: "Although it will be classical it will be different because it has passed through a romantic period." Thus, as we have already seen, nothing is more romantic and modern than Valéry's definition of the classical writer as one constantly flanked by a critic: a definition much more suitably applied to three modern masters (rather than to the authentic or ancient classics), Baudelaire, Mallarmé, and Valéry—that is to say, the three classics of avant-garde poetry. This observation reconfirms what we have already said concerning the extraordinary importance assumed by criticism in modern art, where it functions not as an exterior canon but as an integral law. If this is so, it really means that, in modern poetry and art, classicism can operate only as a retrospective utopia, as a logical counterbalance to the futuristic utopia. In any case, the frequency within the recent avant-garde of positions such as Eliot's, along with the rehabilitation and renewal of the very concept of

tradition, has certainly contributed to making new movements and manifestoes more rare and scarce. Thus the appearance of a series of new poetics, neoclassical on the surface, has devaluated experiment as an end in itself. But all this indicates fundamentally that an ingenuous and exacerbated modernism is giving way before a more profound and truer sense of our own modernity.

If there has been an overcoming, it consists of the felicitous transition of the avant-garde in the strictest sense to an avant-garde in the broad sense; of a defeat in the letter and a victory in the spirit of avant-gardism. The onetime fever is, bit by bit, yielding to a controlled lucidity. To those who look on with eyes not befogged by partisan ideologies, this transition appears as clear progress; to those who continue to keep faith in a no longer pragmatic rhetoric, for whom the reading of history is not only useless but noxious, it appears as regression or even as a return of the reactionary. The transition now under way lies in the working of a mutation, not a negation. The modern spirit certainly cannot enslave itself to the conservative instinct. For it, not to renew itself means to die. Otherwise what would happen to it is what the critic Piccone Stella claimed had finished off futurism: "Believing itself always in the avant-garde, in effect it remained in the rear-guard." The case of futurism, because of the ambition of its programs and the extravagance of its claims, the vanity of its works and its incapacity to transform the letter into the spirit, its own attempt to survive itself, proves—as an extreme example—that each specific avant-garde is destined to last only a morning. When a specific avant-garde which has had its day insists on repeating the promises it cannot now keep, it transforms itself without further ado into its own opposite. Then, as happened with futurism, the movement becomes an academy. But this does not mean that the same fate menaces avant-gardism in general; it does not annul the validity of the much vaster ideals that such groups proclaimed. If the real futurism is dead forever, ideal futurism is still living, precisely because it renews itself in the consciousness of each successive avant-garde. This is because, as Stephen Spender said in an essay significantly entitled *What's Modern in*

Modern Poetry, "we who live in 1948 are not as futurist as the Futurists in 1909 thought we would be."

In that way Bontempelli was partially right when he affirmed that the periods of avant-gardism (by which we understand those phases that are truly in crises) correspond to "dead periods, of fragmentary production, decadence and preparation." Right, if for no other reason than his involuntary emphasis on the practical and psychological, if not the creative and aesthetic, importance of the agonistic moment. The same paradoxical juxtaposition of two antithetical concepts, preparation and decadence, indicates that the historical dialectic of avant-garde crisis is resolved in a synthesis of the notions of decay and growth. The cultural phase of the present, what Bontempelli calls the third period, can then be defined, using other images from pathology in a neutral way, as the period when the avant-garde mentality is moving from the epidemic stage into the endemic and chronic. That overcoming of the avant-garde which can appear a real thing in an episodic and anecdotal perspective no longer appears so when contemplated in less superficial or relativist dimensions. As far as the immediate future goes, it does not seem predictable or possible that a mentality which has now predominated for almost a century in the art of the West, which has become more diffuse and less intense, growing more effective in inverse proportion to the decrease in its radical and aggressive tendencies, can disappear. Thanks precisely to this extension of the concept, we now see works and artists whose greatness and modernity cannot be doubted, and whose modernism may easily be denied, re-entering with full rights into the *idea* of the avant-garde. This is a question of works and artists for whom originality of message counts more than novelty of experiment, who subordinate experiment to experience and, precisely because of this, now seem to have issued from the margins rather than the center of the avant-garde. Not only Eliot and Pound, Joyce and Bely, Stravinsky and Picasso, Klee and Henry Moore, but also Yeats and Saint-John Perse, Pasternak and Blok, Ungaretti and Montale, Guillén and García Lorca, Despiau and Rouault, all these, both groups, prove that the modern genius is essentially avant-gardistic.

But that does not mean (indeed means the very opposite) that the supporters and enthusiasts of avant-garde art are right in believing that it is enough to say "avant-garde art" to mean art without an adjective. Such a claim is no less ridiculous than their adversaries' claim that it is enough to say "avant-garde" to deny *a priori* any aesthetic value. To be sure, the second position has less validity than the first; the adversaries of the avant-garde do not realize that the doors upon which they pound are closed forever, even if a few not ignoble talents still seek to open them. On the other side, the left wing of contemporary artistic opinion refuses to recognize that rhetorical and programmatic avant-gardism is now an all-too-open door, and it leads only to a void and a desert. Precisely because it has almost become a main thoroughfare, the avant-garde ought to lead the artist up to that narrow gate which opens onto the paradise of art. Empty exaltation as well as empty protest serve nothing; the only valid opinion, the only one worthy of acceptance, accepts the aesthetic condition which history assigns. It is not the business of the artist or the critic to idolize or reject what Ortega felicitously called the imperative of the work of one's own time. Thus it is in a spirit quite different from that inspiring fanatic supporters and fanatic attackers, by disdaining the bravos of the one and the catcalls of the other, that this essay ends with an affirmation, once more, that the avant-garde is a law of nature for contemporary and modern art.

The validity of such an opinion cannot be confirmed or weakened by quantitative criteria, by the statistical calculation of how many supporters there are and how very, very many adversaries. In any case, the very multitude of adversaries, both relatively and absolutely greater than in any other controversy in the history of culture, underlines the singular novelty of the phenomenon here described.

Epilogue

By means of diverse perspectives—historical, philological, sociological, psychological, aesthetic, and critical—we have come through this book gathering up various series of ideas which we

have thought and spoken about, and articulated into a theory. That these ideas, treated sometimes as single items, sometimes as parts of larger complexes, have come to form (if I do not fool and deceive myself) a chain whose every link holds and is held, has been made possible by the system of analogies that has here been presented for concepts both like and unlike. These concepts are activism, antagonism and nihilism, agonism and futurism, antitraditionalism and modernism, obscurity and unpopularity, dehumanization and iconoclasm, voluntarism and cerebralism, abstract and pure art. Almost all have been summed up in the central formula of alienation, as reflected in one or another of the variants of that alienation: social and economic, cultural and stylistic, historical and ethical. If we have spoken of the last pair only by implication, the first (the historical) has been discussed frequently and from many points of view. As we said at the proper place, the feeling of historical alienation does not deny, nay rather reaffirms, the bond that joins avant-garde art to the modern myth of historicism. But so far we have perhaps somewhat neglected to emphasize the concrete historicity of the avant-garde. This is the reason for closing my essay with a brief historiographical inquiry, of an empirical sort—that is to say, with an attempt to trace in broad outline the course of its development, the way the avant-garde will perhaps appear to a future historian.

Any historical synthesis of avant-gardism will begin with its prehistory, with the study of its first seeds in *Sturm und Drang* and the earliest romanticism, where there had already appeared the phenomenon later and elsewhere to be called the *bohême* or *scapigliatura* (the rumpled-hairs). Passing on to the preparatory or initial phases, in a reconstruction both theoretical and chronological, we must emphasize the precedence, exemplarity, and preponderant influence of the French contribution. Those movements of the second half of the French nineteenth century called the Parnasse and art-for-art's-sake will in fact be seen as the required and immediate precedents of decadence and symbolism. Outside France, analogous perspectives will serve, for example, to shed light on the message

handed down by the Pre-Raphaelite Brotherhood to the aesthetic movement at the *fin de siècle*.

Turning to France and the great general currents, destined to spread over the old and then the new continent, we see that the initial phase of the avant-garde experience actually coincided, perhaps without anyone's realizing it, with certain of the positions reached by naturalism. But we also see that, at least on the European continent, the triumph of naturalism was so rapid and general as to become the standard of a quasi-public faith, in the wake of the propagation of the positivist credo—hence the necessity of overcoming naturalism for those new and more aware avant-gardes which took the names of aestheticism, decadence, and symbolism. It is with this last that the first phase closes. Perhaps it closes even more clearly in a movement in painting, impressionism, which represented in the field of the figurative arts the fusion of naturalism and symbolism that remained an impossible ideal in the field of literature, where it was realized only in a few rare and vague alliances between naturalism and decadence.

The symbolist teaching, after a brief crisis at the beginning of the century, was destined to live on not only in the work of that generation of European poets which Maurice Bowra collected under the label of "the heritage of symbolism" (Valéry, Yeats, Eliot, Rilke, Blok), but also in the work of that group the same critic called "the creative experiment" (Apollinaire, Eluard, García Lorca, Mayakovsky, Pasternak): generations that theoretically followed, in the first case, Mallarmé and, in the second, Rimbaud (though the former seems to assume ever more authoritatively the role of tutelary genius for all poetry in our time). The figure of Mallarmé finds its only rival, perhaps, in a fellow countryman and contemporary, Cézanne, who almost alone bridged the gap between impressionism and cubism and now appears as the supreme master of modern painting.

The second phase of avant-gardism in fact opened with a brief crisis or pause in the field of poetry: a crisis or pause in which there glitters, like a brief flash-fire, the minor art of Laforgue, who indeed anticipated some of the aspects of Apollinaire's work and some of

the secondary tendencies of surrealist poetry, above all in its senti-
mental, ironic, and grotesque variations. Elsewhere the now over-
come fashion of decadence and aestheticism continued to impose
itself; or there developed an incipient vulgarization of artistic novelty
and the literary modernity of French coinage, as for example in the
South American literary movement calling itself modernism. Much
more elevated and important was the task of mediation or transition
exercised in the field of the arts by such painters as the last of the
fauves, much more valid artists than were the writers of the same
epoch and tendency, with the sole exception of Apollinaire.

Apollinaire's name is in fact linked to the apparition, sudden
and simultaneously in France and Italy, of futurism and cubism,
with which the avant-garde experience enters its second phase, a
phase of simultaneous crisis and development. The universal ambi-
tions of futurism in fact remained only wishful thinking, expressed
more in word than in deed. The best works left to us by Marinetti
and his followers remain the manifestoes they signed and—signifi-
cant fact—composed most often in French. Futurism chose as its
own task the creation of a taste favorable to the actual contents of
modern culture, and in fact formulated the *aesthetic of the machine;*
cubism operated in more speculative and theoretical directions, and
generated further plastic and figurative developments that took the
name of *abstract art.*

In literature the successive movements only consolidated the
positions already attained, reconciled two or more divergent ten-
dencies, favored particular developments. Thus British-American
imagism and Russian imaginism, independent from the point of
view of mutual influence, represent a parallel attempt to establish
an accord between the messages of symbolism and futurism. English
vorticism and Hispano-American ultraism, on the other hand, arose
one from the crossing of imagism and cubism, the other from the
crossing of modernism and futurism.

Meanwhile, rising above the horizon was German expres-
sionism. Basically it was only an apocalypse and palingenesis of
the decadent experience, a new *Sturm und Drang* and a new roman-
ticism. Without the precedence of expressionism, without the ex-

tension to the entire West of the state of mind represented by the German spiritual crisis, dadaism and surrealism would not have been possible in the Europe just after the First World War, for these movements represent a new culmination and reaching out, a third and more violent tidal wave of avant-gardism. New fevers and agitations then convulsed the forms and genres which had remained the most conventional and academic, such as the novel, which adopted for its own syntax the cinematographic style and the techniques of psychoanalysis, reducing itself to the conditions of dream and poetry. The concept of automatic writing was extended even into prose narrative, with procedures which were called *stream of consciousness* and *interior monologue*. That relativity of all values, so cherished by German expressionism, where it had been a form of casuistical and practical ethics, assumed logical and psychological forms in Pirandello's drama and in the so-called *theater of the grotesque.*

The period following the First World War also expressed itself, on the tracks of Bergsonian intuition and Freudian psychoanalysis, in a series of works which made musical invocations, symbolic interpretations, and even an imitation of the psychic life, or reconstruction of the entire intimate and private world of the consciousness: enough to mention writers like Proust, Joyce, Kafka, and Italo Svevo, in whose works the dissolution of the narrative categories and the traditional novel gave place to a new and paradoxical classicism, analogous to what, in differing forms, arts, and directions, had been achieved in the later work of Stravinsky, the new Picasso, and the later Eliot.

In Germany, that ephemeral movement, the "new objectivity," had similar aspirations; the aim was to give classical rigor and naturalistic solidarity to a fluid and fleeting modernity. In the field of figurative arts, in Italy too the ideal was a theoretical analogy between reason and caprice, imagination and form, cubism and surrealism. And it was in Italy, with the movement significantly called Novecento, extending to the visual arts as well as the word arts, that the third avant-garde period ended. That movement was a species of refined and purified futurism, attempting to reconcile

style and fantasy, science and magic; precisely because of its pathetic formalism, it deluded itself that it represented, all by itself, the overcoming of the avant-garde. But in reality that liquidation and overcoming (which were only relative) had already been the unconscious work of dadaism, the effect of which was to correct and moderate the avant-garde precisely by carrying it to the limits of negation and absurdity. By means of that attempted suicide, the dadaist experience, avant-gardism found itself again and was renewed. The claimed overcoming consisted only in the liquidation of the third phase and the inauguration of the fourth, our own, that in which avant-gardism has become the second nature of all modern art.

With terms borrowed from medical science, but here used neutrally and applied—so to speak—to the physiology rather than the pathology of culture, we can say that avant-gardism has now become the typical chronic condition of contemporary art. This is not to say that the acute manifestations of that condition have wholly disappeared; these acute symptoms indeed appear all the more intensely as they are now less frequent and numerous. As far as the current situation goes, we must doubtless recognize how well founded is the suspicion that poetry in our day is agitated by a less constant and febrile spirit of innovation. In compensation, however, the most extreme avant-gardism continues to dominate without truce or exception the whole field of the figurative arts, and a notable part of musical art as well. An analogous spiritual and formal tension is, besides, quite clearly visible at the present hour in certain sectors of literary creation: enough to think of expressions such as the *anti-roman* of Nathalie Sarraute, Michel Butor, and Alain Robbe-Grillet and the *theater of the absurd* of Genet, Ionesco, and Samuel Beckett.

If contemporary criticism seems capable of identifying the works and names destined to persist from the finished phases, only the future critic will be able to determine the values that will live on from present "work in progress." We know now that all roads in art can lead to classicism, even the anticlassical road. The avant-

garde is the extreme anticlassical reaction of the modern spirit; but we have in it a reaction that is also a revolution. As history becomes myth, the illusion of the avant-garde can and ought to become the reality of avant-garde art. The fourth phase, which is one of rest and readjustment, may also be the moment of realization and conquest. That is why the observer should not let himself be deceived, not even by the self-denial apparent in so much of the latest avant-garde art. Thomas Mann once said that art always sprang up in spite of something, not rarely even in spite of itself.

Thus it may also be that the avant-garde is one of those tendencies destined to become art in spite of itself, or even in the out-and-out denial of itself. That is, in any event, a rather frequent case in the history of art—even in the exemplary form of aesthetic dialectics, in which creative synthesis results from a conflict between subject and object, between the thesis of inspiration and the antithesis of history and theory. In *Une Saison en enfer*, Rimbaud defined the chapter mythically meant to sum up his own literary career, and entitled "Alchimie du verbe," as "l'histoire d'une de ses folies." Even one who is tempted to maintain that what is delineated in those pages is not so much a theory of modern art as the history of one of *its* follies, will not wish or be able to pretend that the artist of our time repudiates his own avant-garde experience ("cela c'est passé") before being able to say with Rimbaud, who was then destined to abandon forever the adventure of poetry: "Je sais aujourd'hui saluer la beauté." Certainly James Joyce was not the only artist of the avant-garde to maintain the task of the epoch and the promises of his youth: "I desire to press in my arms the loveliness which has not yet come into the world." And there is no doubt that the greatest poets and the best artists of our own time could address to the masters of the past, and to those who in the present idolize those masters, the proud and pacific words of Apollinaire's verses:

Nous ne sommes pas vos ennemis
Nous voulons vous donner de vastes et d'étranges domaines
Où le mystère en fleurs s'offre à qui veut le cueillir.

Bibliography

The following bibliography is substantially that of the 1963 Italian edition; it indicates Poggioli's gratitudes and enthusiasms. A few items which were missing in the Italian edition have been added by the translator. Italian translations of more use to an Italian reader than to an English one have also been silently omitted.

Albérès, R. M. *L'Aventure intellectuelle du XXe siècle*. Paris, 1959.
Aldington, Richard. *Life for Life's Sake: A Book of Reminiscences*. London, 1941.
Amiel, H. F. *Journal intime*. Geneva, 1948.
Apollinaire, Guillaume. *L'Antitradizione futurista*, Manifesto no. 16, June 29, 1913.
_____ "L'Esprit nouveau et les poètes," *Mercure de France*, December 1918.
_____ *Méditations esthétiques: Les Peintres cubistes*. Paris, 1913.
Aragon, Louis. *Le Paysan de Paris*. Paris, 1926.
_____ *Traité du style*. Paris, 1928.
Arnold, Matthew. "Heinrich Heine," *Lectures and Essays in Criticism*, vol. 3, *Works*, ed. R. H. Super and Sister Thomas Marion Hoctor. Ann Arbor, 1962.
Aron, Raymond. *L'Opium des intellectuels*. Paris, 1955.
Artaud, Antonin. *Van Gogh, le suicide de la société*. Paris, 1947.
Babbitt, Irving. *The New Laokoön: An Essay on the Confusions of the Arts*. New York, 1910.
_____ *Rousseau and Romanticism*. New York, 1919.
Bahr, Hermann. *Expressionismus*. Munich, 1916.

Balakian, Anna. *Literary Origins of Surrealism: A New Mysticism in French Poetry.* New York, 1947.

Barr, A.-H. *Cubism and Abstract Art.* New York, 1936.

——— ed. *Fantastic Art, Dada, Surrealism.* New York, 1936.

——— *What Is Modern Painting?* New York, 1943.

Baudelaire, Charles. "De l'héroisme de la vie moderne" (1846); "De l'idée moderne du progrés appliquée aux Beaux-Arts" (1855); "Mon coeur mis à nu"; "Le Peintre de la vie moderne" (1863). *Oeuvres complètes.* Paris, 1961.

Béguin, Albert. *L'Ame romantique et le rêve: Essai sur le romantisme allemand et la poésie française.* Marseilles, 1937.

Benda, Julien. *La France byzantine ou Le Triomphe de la littérature pure.* Paris, 1945.

Berenson, Bernard. *Aesthetics and History in the Visual Arts.* New York, 1948.

Berti, Luigi, *L'Imagismo.* Padua, n.d.

Billy, André. *L'Epoque contemporaine, 1905–1930.* Paris, 1956.

——— *L'Epoque 1900, 1885–1905.* Paris, 1951.

——— *La Littérature française contemporaine.* Paris, 1927.

Bo, Carlo. *Bilancio del surrealismo.* Padua, 1944.

——— *Il Surrealismo.* Turin, 1953.

Bobbio, Norberto. *La Filosofia del decadentismo.* Turin, 1944.

Boccioni, Umberto. *Estetica e arte futuriste: Testi e documenti d'arte moderna,* vol. 5. Milan, 1946.

——— *Pittura scultura futuriste: Dinamismo plastico.* Milan, 1914.

Bontempelli, Massimo. *L'Avventura novecentista: Selva polemica (1926–1938).* Florence, 1938.

Bowra, C. M. *The Creative Experiment.* London, 1949.

——— *The Heritage of Symbolism.* London, 1943.

Brandi, Cesare. *La Fine dell'avanguardia e l'arte d'oggi.* Milan, 1952.

Breton, André. *Manifeste du surréalisme: Poisson soluble.* Paris, 1924.

——— *Position politique du surréalisme.* Paris, 1935.

——— *Second manifeste du surréalisme.* Paris, 1930.

——— ed. *Le Surréalisme au service de la révolution.* Paris, 1930–1933.

——— *Le Surréalisme et la peinture.* Paris, 1928.

Brion, Marcel. *Art abstrait.* Paris, 1956.

Brodsky, N., V. Lvov-Rogachevsky, and N. Sidorov. *Literaturnye manifesty.* Moscow, 1929.

Brooks, Cleanth. "The Language of Paradox," *The Language of Poetry,* by Philip Wheelwright and Others, ed. Allen Tate. Princeton, 1942.

——— *Modern Poetry and the Tradition.* Chapel Hill, 1939.

Bru, C. P. *Esthetique de l'abstraction: Essai sur le problème actuel de la peinture.* Paris, 1955.

Caillois, Roger. *Babel: Orgueil, confusion et ruine de la littérature.* Paris, 1948.

——— *Les Impostures de la poésie.* Paris, 1945.

Camus, Albert. *L'Homme revolté*. Paris, 1951.

Carrà Carlo. *Pittura metafisica*. Milan, 1945.

Caudwell, Christopher. *Illusion and Reality: A Study of the Sources of Poetry*. London, 1937.

_____ *Studies in a Dying Culture*. London, 1938.

Chamfort (Nicholas-Sébastien Roch). *Maximes et pensées*, vol. 1, ed. Pierre Grosclaude. Paris, 1953.

Cheney, Sheldon. *The Story of Modern Art*. New York, 1941.

Chesterton, G. K. "A Defence of Nonsense," *The Defendant*. New York and London, 1902.

Chiarini, Paolo. *L'Avanguardia e la poetica del realismo*. Bari, 1961.

Chukovsky, Kornei. *Futuristy*. Petrograd, 1922.

Coeroy, André. *Panorama de la musique contemporaine*. Paris, 1928.

Coquiot, Gustave. *Cubistes, futuristes, passéistes: Essai sur la jeune peinture*. Paris, 1914.

Cowley, Malcolm. *Exile's Return: A Literary Odyssey of the 1920's*. New York, 1951.

Day Lewis, C. *Revolution in Writing*. London, 1938.

Edschmid, Kasimir. *Ueber den Expressionismus in det Literatur und die neue Dichtung*. Berlin, 1919.

Erlich, Victor. *Russian Formalism:History-Doctrine*. The Hague, 1955.

Einstein, Carl. *Die Kunst des 20: Jahrhunderts*. Berlin, 1926.

Eliot, T. S. "The Metaphysical Poets" (1921); "Tradition and the Individual Talent" (1919). *Selected Essays*. London and New York, 1932.

_____ "The Modern Mind," *The Use of Poetry and the Use of Criticism: Studies in the Relation of criticism to Poetry in England*. Cambridge, Eng., 1933.

_____ *Notes towards the Definition of Culture*. London, 1948.

_____ "The Social Function of Poetry," *Critiques and Essays in Criticism, 1920–1948*, ed. R. W. Stallman. New York, 1949.

_____ "Ulysses, Order, and Myth," *The Dial*, November 1923. (Also in *James Joyce: Two Decades of Criticism*, ed. Seon Givens. New York, 1948.)

Empson, William. *Seven Types of Ambiguity*. London, 1930.

Esslin, Martin. *The Theatre of the Absurd*. New York, 1962.

Falqui, Enrico. *Il Futurismo, il Novecentismo*. Turin, 1953.

Fénéon, Felix. *L'Art moderne*. Paris, 1919.

Flora, Francesco. *Dal romanticismo al futurismo*. Milan, 1925.

Gaunt, William. *The March of the Moderns*. London, 1949.

Gautier, Théophile. "Charles Baudelaire," *Fusains et eaux-fortes*. Paris, 1880.

Ghil, René. *La Tradition de poésie scientifique*. Paris, 1920.

Gide, André. *Incidences*. Paris, 1924.

Giedion, Welcker, Carola. *Contemporary Sculpture: An Evolution in Volume and Space*. New York, 1955.

_____ *Modern Plastic Art: Elements of Reality, Volume and Disintegration*. Zurich, 1937.

Gleizes, Albert, and Jean Metzinger. *Du "cubisme."* Paris, 1912.

Gombrich, E. H. "The Tyranny of Abstract Art," *Atlantic Monthly*, April 1958.

Graves, Robert. *Another Future of Poetry*. London, 1926.

Greenberg, Clement. *Art and Culture: Critical Essays*. Boston, 1961.

Guillén, Jorge. "The Language of the Poem: One Generation," *Language and Poetry*. Cambridge, Mass., 1961.

Haftmann, Werner. *Malerei im 20: Jahrhundert*. Munich, 1954.

Hauser, Arnold. *Sozialgeschichte der Kunst und Literatur*. Munich, 1953.

Heller, Erich. *The Disinherited Mind: Essays in Modern German Literature and Thought*. Cambridge, Eng., 1952.

―――― *The Hazard of Modern Poetry*. Cambridge, Eng., 1953.

Hiler, Hilaire. *Why Abstract*. New York, 1945.

Hodin, J. P. *The Dilemma of Being Modern: Essays on Art and Literature*. London, 1956.

―――― "Expressionism," *Horizon*, XIX (January, 1949).

Hoffman, F. J., Charles Allen, and C. F. Ulrich. *The Little Magazine: A Bibliography*. Princeton, 1946.

Hoog, Armand. "The Surrealist Novel," *Yale French Studies*, no. 8 (1951).

Hughes, Glenn. *Imagism and the Imagists: A Study in Modern Poetry*. Stanford, 1931.

Huguet, Georges, ed. *Petite anthologie poétique du surréalisme*. Paris, 1934.

Huizinga, Johan. *In the Shadow of Tomorrow: A Diagnosis of the Spiritual Distemper of Our Time*. London, 1936.

Hulme, T. E. "Modern Art and Its Philosophy," *Speculations: Essays on Humanism and the Philosophy of Art*, ed. Herbert Read. London, 1924.

Huret, Jules. *Enquête sur l'évolution littéraire*. Paris, 1891.

Huxley, Aldous. "Selected Snobberies," *Music at Night and Other Essays, Including "Vulgarity in Literature."* London, 1949.

Hyman, S. E. *The Armed Vision: A Study in the Methods of Modern Literary Criticism*. New York, 1948.

Isaacs, J. *The Background of Modern Poetry*. London, 1952.

Ivanov, Vyacheslav, and Mikhail Gershenzon. *Perepiska iz dvukh uglov*. Moscow, 1921. "Correspondence between Two Corners," *Partisan Review*, IX (1948).

Jean, Marcel. *Histoire de la peinture surréaliste*. Paris, 1959.

Jolas, Eugene, ed. *Transition Workshop*. New York, 1949.

Joyce, James, *Portrait of the Artist as a Young Man*, ed. Richard Ellmann. New York, 1964.

Jung, C. G. *Seelenprobleme der Gegenwart*. Zurich, 1932.

Klingender, F. D. *Marxism and Modern Art: An Approach to Social Realism*. London, 1943.

Koestler, Arthur. *The Yogi and the Commissar, and Other Essays*. New York, 1945.

Kruchenykh, A. E. *15 let russkogo futurizma*. Moscow, 1928.

Kuhn, C. L. *German Expressionism and Abstract Art: The Harvard Collections*. Cambridge, Mass., 1957.

Kyrou, Adonis. *Le Surréalisme au cinema*. Paris, 1953.

Laverdant, G. D. *De la Mission de l'art et du rôle des artistes.* Paris, 1845.

Laughlin, James. Preface, *New Directions in Prose and Poetry, 1938.* Norfolk, 1938.

Léger, Fernand. "A propos du corps humain considéré comme un objet," *Fernand Léger: La Forme humaine dans l'espace.* Montreal, 1945.

Lemaitre, G. E. *From Cubism to Surrealism in French Literature.* Cambridge, Mass., 1941; rev. ed., 1947.

Lenning, H. F. *The Art Nouveau.* The Hague, 1951.

Levin, Harry. *James Joyce: A Critical Introduction.* Norfolk, 1941.

_____ "Notes on Convention," *Perspectives of Criticism,* ed. Harry Levin. Cambridge, Mass., 1950.

_____ "What Was Modernism?" *Varieties of Literary Experience,* ed. Stanley Burnshaw. New York, 1962.

Lewis, Wyndham. "Manifestoes"; "Blasts and Blesses"; "Notes." From *Blast,* no. 1 (1914).

Lukács, Georg. *Essays über Realismus.* Berlin, 1948.

_____ *Il Marxismo e la critica letteraria.* Turin, 1953.

_____ *Il Significato attuale del realismo critico.* Turin, 1957.

_____ *Thomas Mann e la tragedia dell'arte moderna.* Milan, 1954.

Lvov-Rogachevsky, Vasily. *Imazinisty.* Moscow, 1921.

MacNeice, Louis. *Modern Poetry: A Personal Essay.* London, 1938.

Mallarmé, Stéphane. *Oeuvres complètes,* ed. Henri Mondor and G. Jean-Aubry. Paris, 1954. Especially "Reponses à des enguettes sur l'évolution littéraire."

Malraux, André. *Psychologie de l'art.* Geneva, 1947–1950.

_____ *Les Voix du silence.* Paris, 1952.

Manifesti del futurismo: Marinetti, Boccioni, Carrà, Russolo, Balla, Severini, Pratella, Mme. de Saint-Point, Apollinaire, Palazzeschi. Florence, 1914.

Marinetti, F. T., ed. *Manifesti del futurismo.* Milan, 1915.

Maritain, Jacques and Raissa. *Situation de la poésie.* Paris, 1938.

Michaud, Régis. *Vingtième Siècle: An Anthology of the New French Prose and Poetry.* New York, 1933.

Mirsky, D. S. "T. S. Eliot et la fin de la poésie bourgeoise," *Echanges,* December 1931.

Motherwell, Robert, ed. *The Dada Painters and Poets: An Anthology.* New York, 1951.

Muir, Edwin. "The Public and the Poet," *The Estate of Poetry.* Cambridge, Mass., 1962.

Myers, Bernard. *Modern Art in the Making.* New York, 1950.

Nadeau, Maurice. *Documents surréalistes.* Paris, 1948.

_____ *Histoire du surréalisme.* Paris, 1945–1948.

Nordau, Max. *Entartung.* Berlin, 1893.

Ors y Rovira, Eugenio d'. *Lo Barroco.* Madrid, 1944?

Ortega y Gasset, José. *La Deshumanización del arte: Ideas sobre la novela.* Madrid, 1925.

_____ *La Rebelión de las masas.* Madrid, 1930.

_____ *El Tema de nuestro tiempo.* Buenos Aires, 1941.

Orwell, George. *Dickens, Dali, and Others.* New York, 1946.

Ozenfant, Amedée. *Foundations of Modern Art.* New York, 1931.
———— and C. E. Jeanneret-Gris. *La Peinture moderne.* Paris, 1945.
Paccioli, Luca. *Divina proportione.* Vienna, 1889.
Papini, Giovanni. *L'Esperienza futurista, 1913–1914.* Florence, 1927.
Paulhan, Jean. *Les Fleurs de Tarbes ou La Terreur dans les lettres.* Paris, 1945.
Pavolini, Corrado. *Cubismo, futurismo, expressionismo.* Bologna, 1926.
Pevsner, Nikolaus. *Pioneers of the Modern Movement from William Morris to Walter Gropius.* London, 1936.
Peyre, Henri. *Les Générations littéraires.* Paris, 1948.
———— "Obscurity and Obscurism in Literature," *Writers and Their Critics: A Study of Misunderstanding.* Ithaca, 1944.
———— "The Significance of Surrealism," *Yale French Studies,* Full-Winter 1948.
Pica, Vittorio. *Letteratura d'eccezione.* Milan, 1898.
Piccone Stella, Antonio. "Precisazione su F. T. Marinetti (1876–1944)," *Poesia quaderni internazionali diretti da Enrico Falqui,* 1945.
Poggioli, Renato. "The Autumn of Ideas," *The Massachusetts Review,* Summer 1961.
———— "Il Creposcolo dell'arte e della poesia in Russia," *Tempo presente,* July 1960.
———— "Definizione dell'utopia," *Inventario,* I, nos. 3–4 (1946–1947).
———— *The Poets of Russia, 1890–1930.* Cambridge, Mass., 1960.
———— "Qualis artifex pereo! or Barbarism and Decadence," *Harvard Library Bulletin,* XIII (Winter 1959).
Pound, Ezra. *A B C of Reading.* New Haven, 1934.
———— *Gaudier-Brzeska: A Memoir.* London, 1916.
———— *Literary Essays,* ed. T. S. Eliot. Norfolk, 1953.
———— *Make it New: Essays.* New Haven, 1934.
———— *Pavannes and Divisions.* New York, 1918.
———— *Polite Essays.* London, 1937.
———— *The Spirit of Romance,* rev. ed. Norfolk, 1953.
Praz, Mario. *La Carne, la morte e il diavolo nella letteratura romantica.* Milan, 1930. *The Romantic Agony.* London, 1933.
Putnam, Samuel. *The European Caravan: An Anthology of the New Spirit in European Literature.* New York, 1931.
Ransom, J. C. *The New Criticism.* Norfolk, 1941.
———— "Poets without Laurels," *The World's Body.* New York, 1938.
Raymond, Marcel. *De Baudelaire au surréalisme.* Paris, 1933.
Read, Herbert. *Art and Society.* New York, 1937.
———— *Art Now: An Introduction to the Theory of Modern Painting and Sculpture.* New York, 1933.
———— *The Philosophy of Modern Art: Collected Essays.* London, 1952.
———— *Poetry and Anarchism.* London, 1938.
———— "Surrealism and the Romantic Principle," *Surrealism,* ed. Herbert Read. London, 1936.

Ribémont-Dessaignes, Georges. *Déjà jadis, ou Du mouvement dada à l'espace abstrait.* Paris, 1958.
_____ "Histoire de dada," *Nouvelle revue française,* June-July 1931.
Riding, Laura, and Robert Graves. *A Survey of Modernist Poetry.* London, 1927.
Rimbaud, J. A. "Lettre à Paul Demeny, 15 Mai 1871" ("Lettre du voyant"), *Oeuvres complètes.* Paris, 1954.
Ripellino, A. M. "Chlebnikov e il futurismo russo," *Convivium,* no. 5 (1949).
_____ *Majakovskij e il teatro russo d'avanguardia.* Turin, 1959.
Rivière, Jacques. "Reconnaissance à dada," *Nouvelle revue française,* August 1920.
Robsjohn-Gibbings, T. H. *Mona Lisa's Mustache: A Dissection of Modern Art.* New York, 1947.
Rognoni, Luigi. *Espressionismo e dodecafonia.* Turin, 1954. Includes writings of Schoenberg, Berg, and Kandinsky.
Rolland de Renéville, André. *L'Expérience poétique.* Paris, 1938.
Rosenberg, Harold. *The Tradition of the New.* New York, 1959.
Ruggiero, Guido de. *L'Esistenzialismo,* with the 1st ed. of *I Filosofi del novecento.* Bari, 1943.
Saba, Umberto. "Scorciatoie 1946," *Prose,* ed. Linuccia Saba. Milan, 1964.
Salinas, Pedro. "Les Pouvoirs de l'écrivain, ou les illusions perdues," *Hommage à Balzac.* Paris, 1950. Original Spanish text: "Los Poderes del escritor o las ilusiones perdidas," *La Responsabilidad del escritor.* Barcelona, 1961.
Samuel, Richard. *Expressionism in German Life, Literature and the Theatre, 1910–1924.* Cambridge, Eng., 1939.
Sartre, J.-P. "Qu'est-ce que la littérature?" *Situations,* II. Paris, 1948.
Seldes, Gilbert. *The Seven Lively Arts.* New York, 1924.
Seuphor, Michel. *L'Art abstrait, ses origines, ses premiers maitres.* Paris, 1946.
Shattuck, Roger. *The Banquet Years: The Arts in France, 1855–1918: Alfred Jarry, Henri Rousseau, Eric Satie, Guillaume Apollinaire.* New York, 1958.
Shestov, Leo. *La Filosofia della tragedia: Dustoevskije e Nietzsche,* ed. Ettore Lo Gatto. Naples, 1951.
Shroder, M. Z. *Icarus: The Image of the Artists in French Romanticism.* Cambridge, Mass., 1961.
Soffici, Ardengo. *Cubismo e futurismo.* Florence, 1914.
_____ *Primi Principi di una estetica futurista.* Florence, 1920.
Spender, Stephen. *The Destructive Element: A Study of Modern Writers and Beliefs.* London, 1935.
_____ "What Is Modern in Modern Poetry," *The Tiger's Eye,* I (June 15, 1948).
Stein, Gertrude. *The Autobiography of Alice B. Toklas.* New York, 1933.
Stravinsky, Igor. *Poétique musicale sous forme de six leçons.* Cambridge, Mass., 1942.
Sydow, Eckart von. *Die deutsche expressionistische Kultur und Malerei.* Berlin, 1920.
_____ *Die Kultur der Dekadenz.* Dresden, 1922.
Tate, Allen. "Tension in Poetry," *Reason in Madness: Critical Essays.* New York, 1941.

Torre, Guillermo de. *Literaturas europeas de avanguardia.* Madrid, 1925.

———— *Problemática de la literatura.* Buenos Aires, 1951.

———— *Qué es el superrealismo.* Buenos Aires, 1955.

———— *Valoración literaria del existencialismo.* Buenos Aires, 1948.

Toynbee, A. J. *A Study of History.* London, 1935–1961.

Trilling, Lionel. "Art and Neurosis," "Freud and Literature," "The Function of the Little Magazine," *The Liberal Imagination: Essays on Literature and Society.* Garden City, 1950.

Trotsky, Leon. *Literature and Revolution.* New York, 1925.

Tzara, Tristan. *Le Surréalisme et l'après-guerre.* Paris, 1947.

Valéry, Paul. "Je disais quelquefois à Stéphane Mallarmé," *Variété,* III. Paris, 1936.

———— *Littérature.* Paris, 1929.

Veblen, Thorstein. *The Theory of the Leisure Class: An Economic Study of the Evolution of Institutions.* New York, 1899.

Vlad, Roman. *Modernità e tradizione nella musica contemporanea.* Turin, 1955.

Wahl, J. A. *Petite histoire de "l'existentialisme," suivie de Kafka et Kierkegaard, commentaires.* Paris, 1947.

Weidlé, Wladimir. *Les Abeilles d'Aristée: Essai sur le destin actuel des lettres et des arts.* Paris, 1954.

Whitehead, Alfred North. *Science and the Modern World.* London, 1926.

Wilde, Oscar. "The Decay of Lying," *Intentions,* vol. 5, *Complete Works.* London, 1923.

Wilson, Edmund. *Axel's Castle: A Study in the Imaginative Literature of 1870–1930.* New York, 1931.

———— *Classics and Commercials: A Literary Chronicle of the Forties.* New York, 1950.

———— "Philoctetes: The Wound and the Bow," *The Wound and the Bow: Seven Studies in Literature.* Boston, 1941.

Wordsworth, William. Preface to *Lyrical Ballads,* 2nd ed. London, 1800.

Wyss, Dieter. *Der Surrealismus: Eine Einführung und Deutung surrealistischer Literatur und Malerei.* Heidelberg, 1950.

Zevi, Bruno. *Storia dell'architettura moderna.* Turin, 1950.

Zolla, Elèmire. *Eclissi dell'intellettuale.* Milan, 1959.

Novel, the new forms in, 229
Novelty, cult of, 50

Obscurity, 226; form of antagonism, 38, 92; problem of, 152–155; in traditional art, 153–154; not helped by exegesis, 154
Oneiric art, 204–205
Ors, Eugenio d', 212
Ortega y Gasset, José: on dehumanization of art, 2, 175, 176, 184; on terminology, 5–6; on conflict of generations, 35, 45; on avant-garde as antiromantic, 49–51; on futurism, 69, 72; on public, 91–92; and scientificism, 138; on criticism, 150, 152, 158; on iconoclasm, 180–182; and infrarealism, 183; on willfulness, 188–189; on image, 197
Orwell, George, 160, 161
Ozenfant, Amédée, 194, 202

Pacioli, Luca, 187
Palazzeschi, Aldo, 35, 62, 142–143, 190
Papini, Giovanni, 53, 93, 214
Pareto, Vilfredo, 4, 117, 137
Parnasse, 226
Parody, 141–142; in music, 142
Partisan Review, 39
Pascal, Blaise, 65
Pascoli, Giovanni, 36, 199
Past, antagonism to, 52–55
Pasternak, Boris, 94, 101, 224, 227
Pater, Walter, 198
Pathology, and art, 166
Paulhan, Jean, 160, 179
Peguy, Charles, 22–23
Periodicals: little reviews, 21–23; romantic and avant-garde contrasted, 23; of the Englightenment, 24
Perse, Saint-John, 224
Petrarch, 43, 153, 154
Photography, influence of, 125
Pica, Vittorio, 3

Picabia, Francis, 138, 181
Picasso, Pablo, 100, 135, 142, 156
Piccone Stella, Antonio, 29, 76, 223
Pindar, 154
Pirandello, Luigi, 34, 229
Pisarev, D. I., 90
Plato, 185
Poe, Edgar Allen, 106, 165, 195, 219
"Poetic pocket," 118–119
Poetics: classical, 162; modern, 162–163; differentiated from art, 164–165; of the word, 198–199; dream, 204–205
Poetry: language of, 38; experimentalism in, 133–134; as metaphysics of metaphor, 196–199; and purity, 199–206
Pointillism, 132, 145
Poland, avant-garde art in, 101
Politics: and activism, 27; and avant-garde, 94–101, 168; influence of fascism on art, 94; necessity for democracy, 95; separation of art from, 96; libertarianism, 97; anarchism, 97
Poncif, 80. *See also* Stereotype
Pope, Alexander, 216
Popularity and unpopularity, 43–46, 56, 131, 226; types of, 43; based on accessibility, 43–44; immediate or mediate, 44–45; accidental and substantive, 45–46
Populisme, 97, 182
Pound, Ezra, 82, 134, 224
Praz, Mario, 46, 66
Precursor, concept of, 70–71
Prejudices against avant-garde: dehumanization of art, 175–183; iconoclasm, 180–181, 183; cerebralism, 183–189, 193; voluntarism, 183–195
Presentism, 73
Primitives, rediscovery of, 176–177
Primitivism, 55
Prokofiev, Sergei, 142